NOTRE DAME'S
HAPPY RETURNS

DUBLIN, THE EXPERIENCE, THE GAME

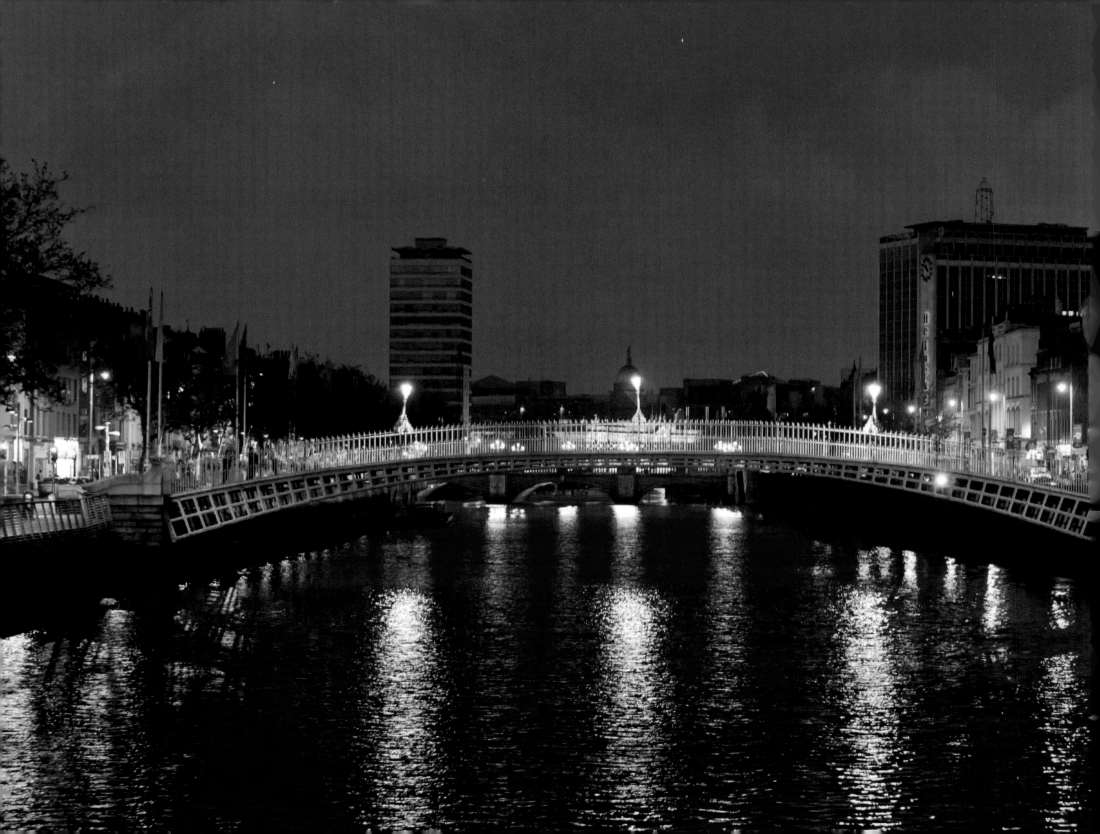

NOTRE DAME'S

HAPPY RETURNS

DUBLIN, THE EXPERIENCE, THE GAME

BRIAN Ó CONCHUBHAIR AND SUSAN MULLEN GUIBERT

PHOTOGRAPHY BY MATT CASHORE

UNIVERSITY OF NOTRE DAME PRESS · NOTRE DAME, INDIANA

Designed by Wendy McMillen

Printed in Canada by Friesens Corporation

Ó Conchubhair, Brian.
Notre Dame's happy returns : Dublin, the
experience, the game / Brian Ó Conchubhair
and Susan Mullen Guibert; photography by
Matt Cashore.
p. cm.
ISBN 978-0-268-02308-9 (cloth : alk. paper)
ISBN 0-268-02308-5 (cloth : alk. paper)
1. University of Notre Dame—Football—History.
2. Notre Dame Fighting Irish (Football team)
3. Football—Ireland—Dublin. I. Guibert, Susan
Mullen. II. Title.
GV958.N6O36 2012
796.3309418'35—dc23
 2012033266

Printed on paper certified by the
Forest Stewardship Council (FSC).

for

Danny & Joan Roche

CONTENTS

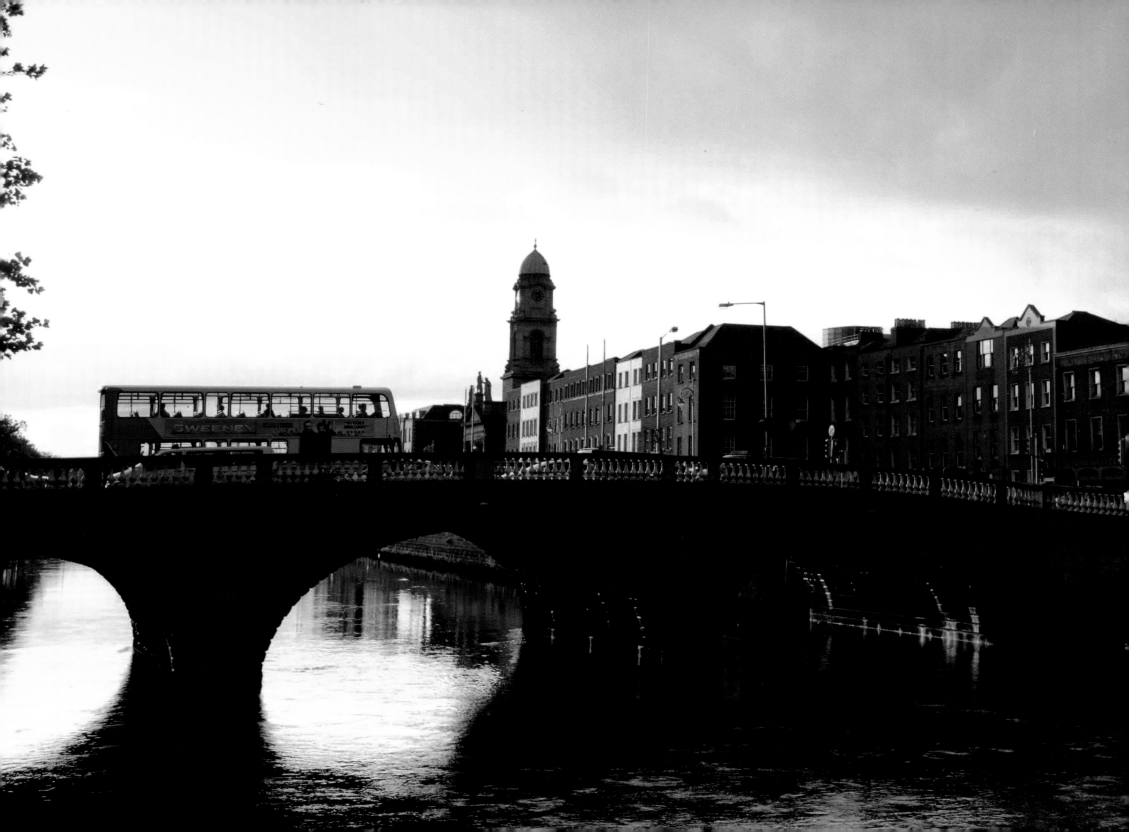

ACKNOWLEDGMENTS

Harriet Baldwin, Alan Bolger, Maria and
Madeline Cashore, Frank Connolly (SIPTU),
Rebecca R. DeBoer, Eimear C. Deleany,
Hugh Fogarty, Christopher Fox,
John Gibney, Cathal Goan, Beth Grizzoli,
Harv Humphrey, Brendan Kane,
Charles Lamb (ND Archives),
Stephen Little, Tara MacLeod,
Jessica Mannen, the McDonough family
of Inishbofin island, Jason McElligott
(Marsh's Library), Wendy McMillen,
Lauri Roberts, Elizabeth Sain, the 2012
Keough interns, and the people of Ireland
who graciously stopped and allowed Matt
to take his wonderful photos.

We would also like to thank Steven Warner
for graciously providing text about the
University of Notre Dame Folk Choir and
Teach Bhríde.

"I reserved a surprise for my father," wrote Thomas J. Dundon, a Notre Dame undergraduate from Clarksburg, Michigan, in the 1860s. "I had studied the Irish language under Brother Patrick, professor of Irish. As I was recounting to my father (during the Christmas Break) the subjects I had studied, I said, 'I can read the Irish language!' He seemed incredulous, so I got my book of poems in Irish and read 'The Bells of Shandon.' When I had finished reading I asked him if I had done well. He made no reply but on looking up I saw a tear glistening in his eye. My father was born within hearing distance of the real 'Bells of Shandon.'"

If this tells us (as Professor Brian Ó Conchubhair points out) that "Irish was a standard feature" in the Notre Dame curriculum from the 1860s on, it also suggests how deeply ingrained was the desire of this Notre Dame student to connect with his roots. This is as true today as it was one hundred and fifty years ago. After the then Keough Institute came into being in 1993

with a gift from Trustee Donald R. Keough, student response soon demonstrated that it was planted on fertile ground. Hundreds enrolled in Notre Dame's Irish Studies classes, including Irish language classes, and the Institute grew from two faculty fellows in 1993 (Professors Seamus Deane and Christopher Fox) to its current roster of twenty faculty fellows, all internationally-known leaders in the field. Our course offerings are also regularly enhanced by distinguished visiting professors, some of whom come to Notre Dame as Naughton Fellows from Irish universities in a reciprocal arrangement that sends Notre Dame professors to Ireland.

In its nineteen years of existence, the Institute has firmly established itself as the premier teaching and research program of its kind in the world. Along with the arrival of the great Irish scholar Seamus Deane as the inaugural Donald and Marilyn Keough Professor of Irish Studies and more recently Professor Declan Kiberd in the same chair, there have been many milestones along the

way. One major milestone was the establishment in 1996 of a program in Dublin. This program was located first at Newman House and later at O'Connell House—both historic Irish sites. Other milestones have included the visits to campus by Nobel Prize winner Seamus Heaney and former President of Ireland Mary Robinson, the award to the Institute in 1998 of a permanent faculty fellowship program by the National Endowment for the Humanities, the creation in 1999 of the Madden-Rooney Lectures and the IRISH Seminar in Dublin, the launch in 2000 of a new minor in Irish Studies and the Keough summer internship program in Ireland, and the sponsorship of a new Archaeology of Ireland course in 2002. In 2003 the Institute hosted a conference on "Irish Catholics: Belief, Practice, and Representation" and oversaw the founding the next year of the first Department of Irish Language and Literature outside of Ireland under the intellectual leadership of the late Thomas J. and Kathleen M. O'Donnell Professor Breandán Ó Buachalla. With the College of Arts and Letters, the Institute later established the Madden Hennebry Family Chair in

Irish American Studies held by Professor Patrick Griffin, who studied the subject at Notre Dame with his mentor, Jay Dolan. On May 21, 2006, the newly-named Keough-Naughton Institute for Irish Studies was dedicated by the then President of Ireland, Mary McAleese. The new name acknowledged the splendid support of Martin and Carmel Naughton.

All this has not happened by accident, but has been accomplished with the combined and coordinated support of Notre Dame's students, donors, faculty, and administration. From its early beginnings, the Keough-Naughton Institute's goal has been clear and unwavering: to bring Ireland to Notre Dame and Notre Dame to Ireland. As director of the Keough-Naughton Institute, I am pleased to introduce a book that shares the same goal and to celebrate Notre Dame's lasting ties to Ireland, ties that have only been made stronger by distance and years.

Christopher Fox
Professor, Department of English
Director, Keough-Naughton Institute
for Irish Studies

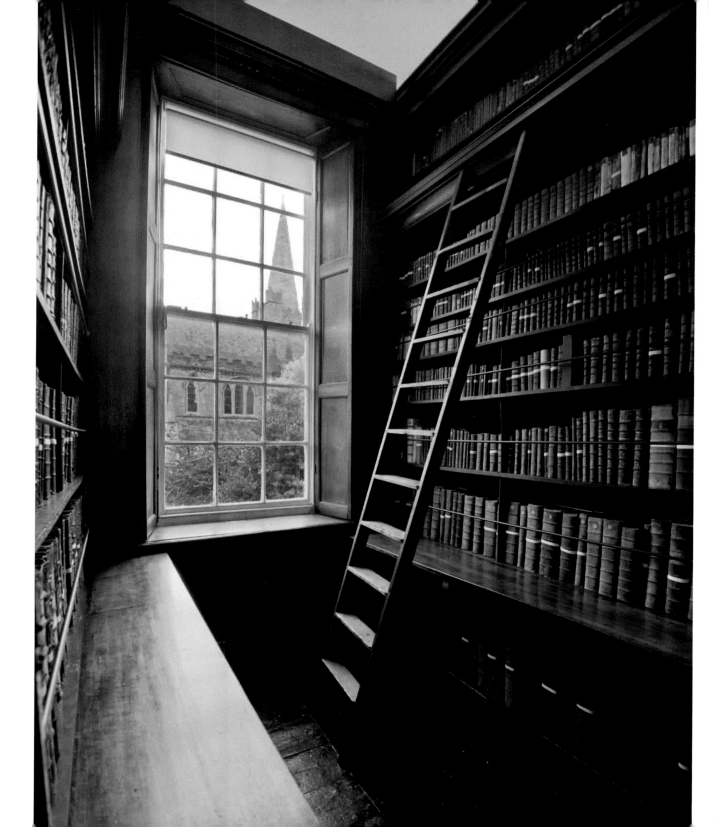

Left: Marsh's Library with a view of Saint Patrick's Cathedral through the window

Pages xiv & xv: Rainbow over the River Liffey as it flows through the center of Dublin city

Pages xvi & xvii: Aviva Stadium, Lansdowne Road, Dublin, on September 1, 2012

Pages xviii & 1: The Baily Lighthouse, Howth Head, Dublin Bay

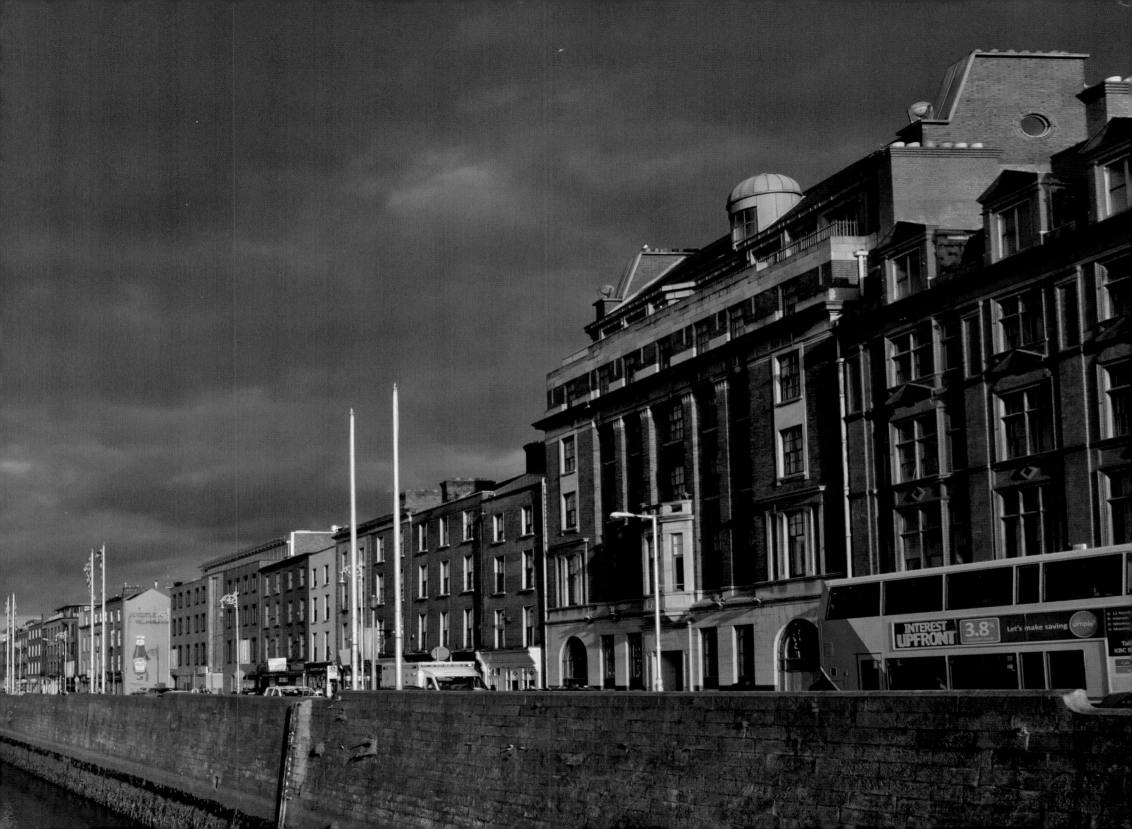

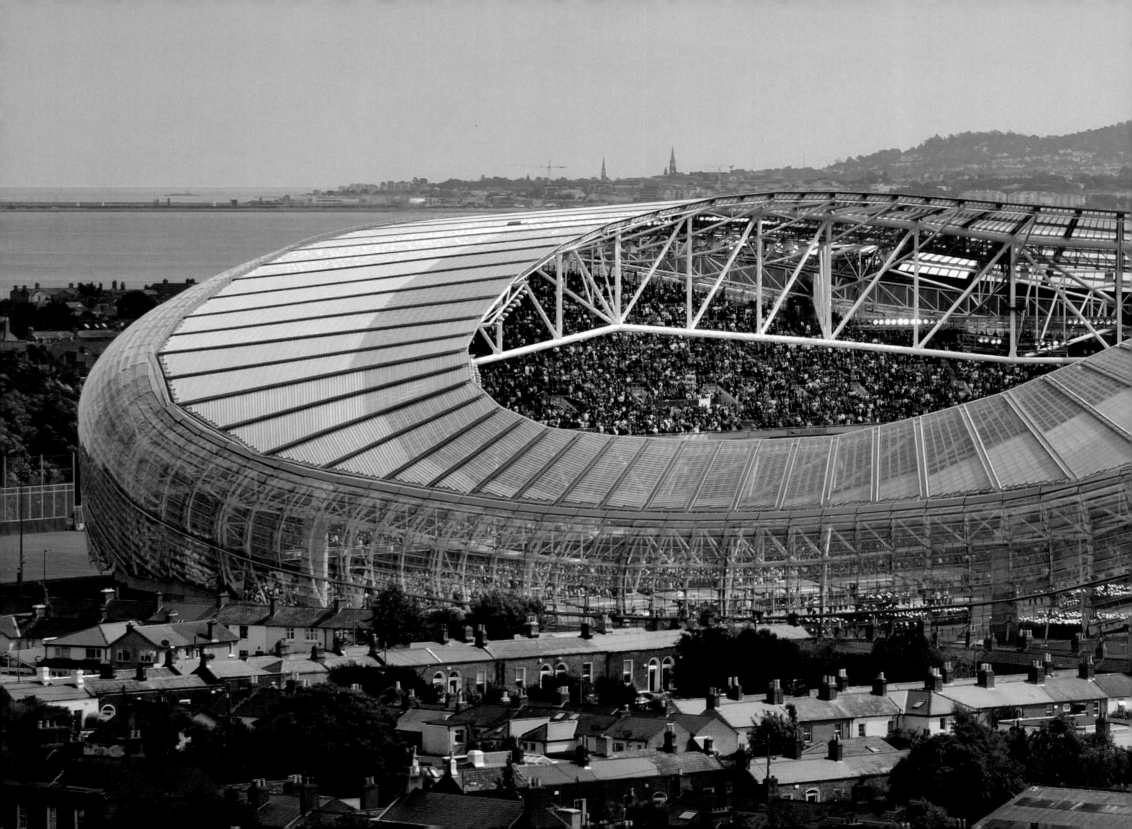

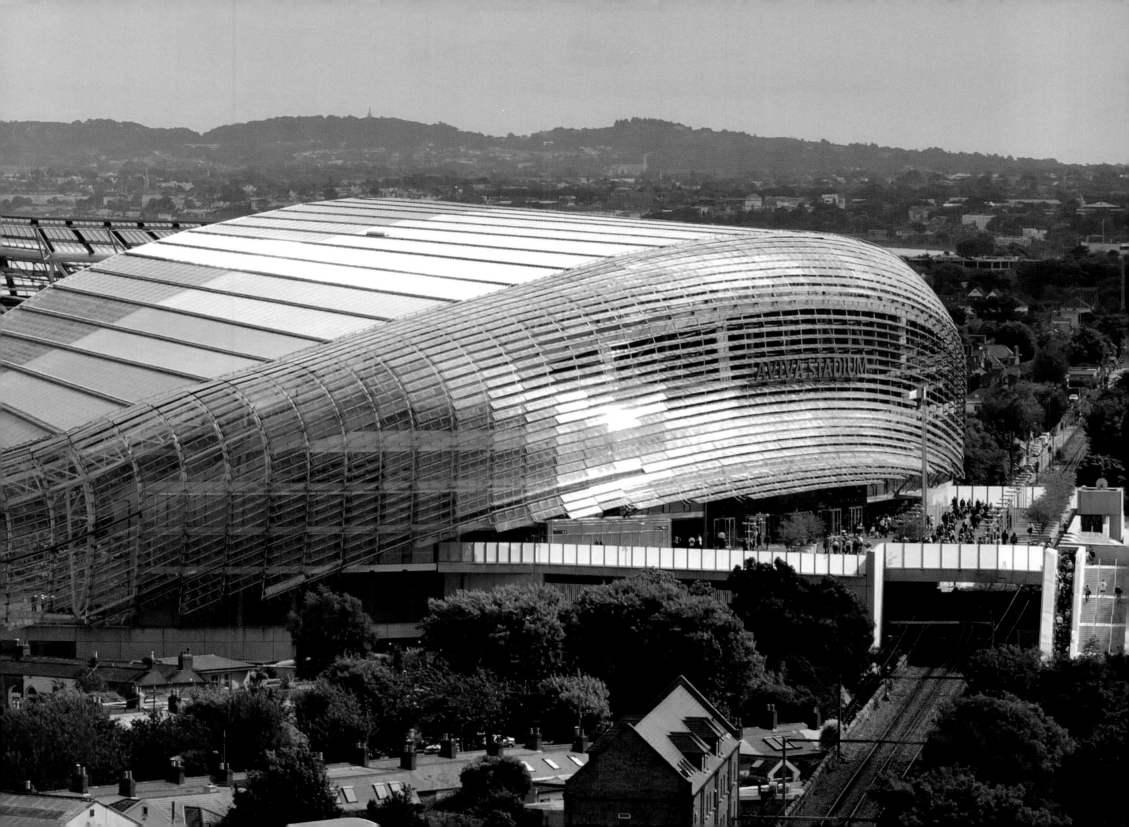

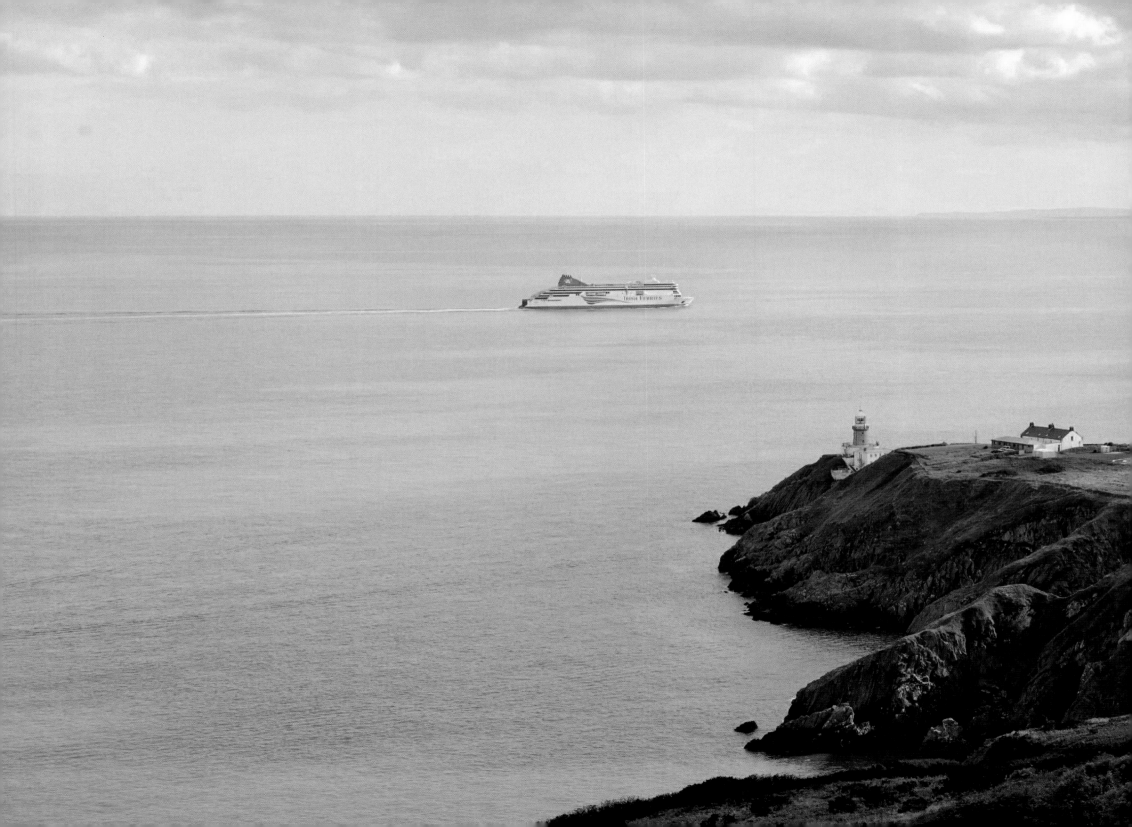

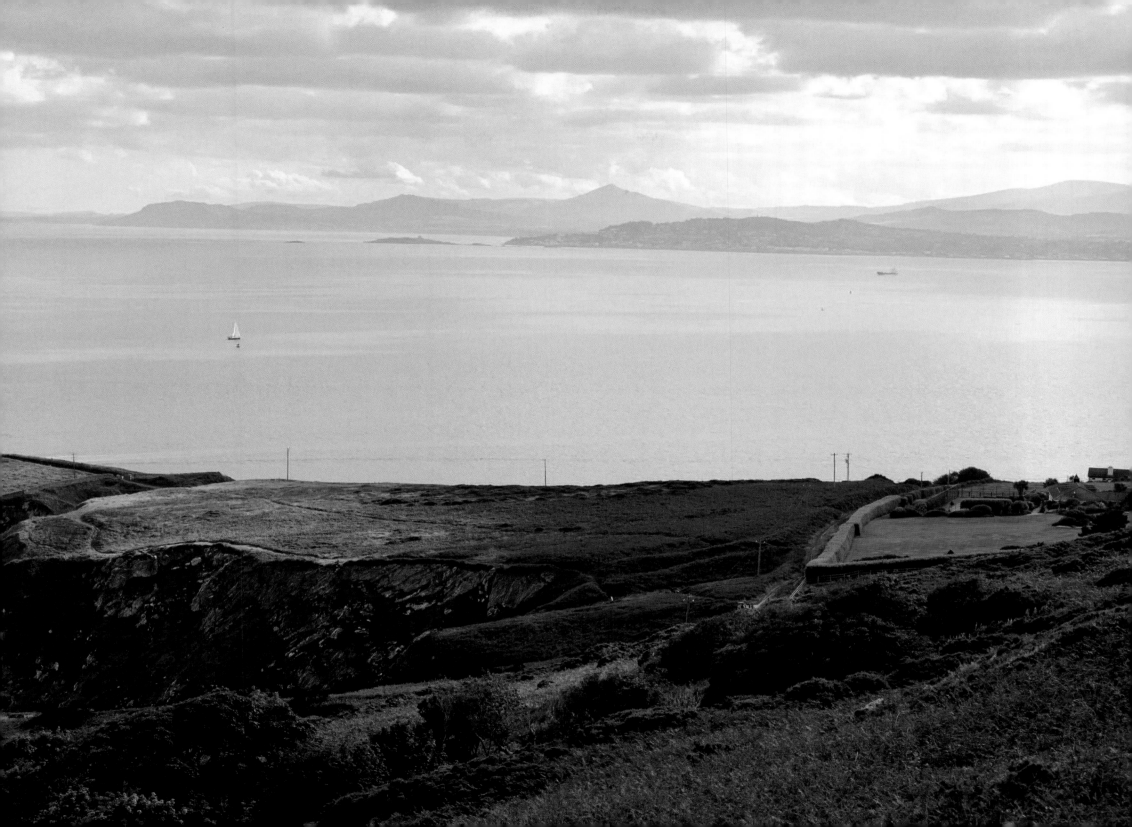

INTRODUCTION

The year 2012 marks the 125th year of Notre Dame football, the 125th year that the Fighting Irish have punted, passed, scrimmaged, tackled, and played ball, thrilling their fans throughout the United States and the world. The year 2012 also marks the Notre Dame football team's return to the city of Dublin in Ireland, a country closely associated with the University of Notre Dame and its renowned football team—the Fighting Irish. *Notre Dame's Happy Returns: Dublin, the Experience, the Game* marks and celebrates the 2012 Notre Dame–Navy game and offers readers a taste of the history and culture of Dublin, Ireland, the links between Notre Dame and Ireland through the Keough-Naughton Dublin Centre and Teach Bhríde (Notre Dame's service program in County Wexford), and the game itself through stunning images and informative text.

The University of Notre Dame du Lac has strong historical connections to both Ireland and the Naval Academy, so it is very fitting for the first game of the historic 2012 football season to be played against Navy in Ireland.

The Naval Academy and the University of Notre Dame share a historic bond of admiration, respect, and gratitude. Their football teams have played annually since 1927, entitling them to claim the longest uninterrupted intersectional series in American college football. Unlike many intense sporting rivalries, the results of these games have often been one-sided and lacked the competitive nature usually associated with major rivalries, but the two teams continue to play each other every year. The reason for the longevity of the series goes back to World War II.

During the war, Notre Dame was, like many other colleges, in financial difficulty. When the U.S. Navy selected Notre Dame, with whom it had had a relationship since 1927,

Right: Naval training units in ranks on South Quad during World War II (Courtesy of University of Notre Dame Archives)

Page 8: Navy ROTC convenes on campus

Page 9: Respect between Navy and Notre Dame

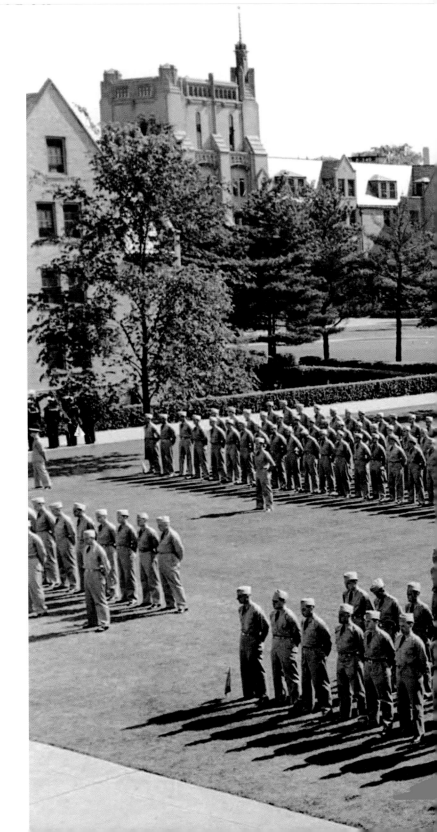

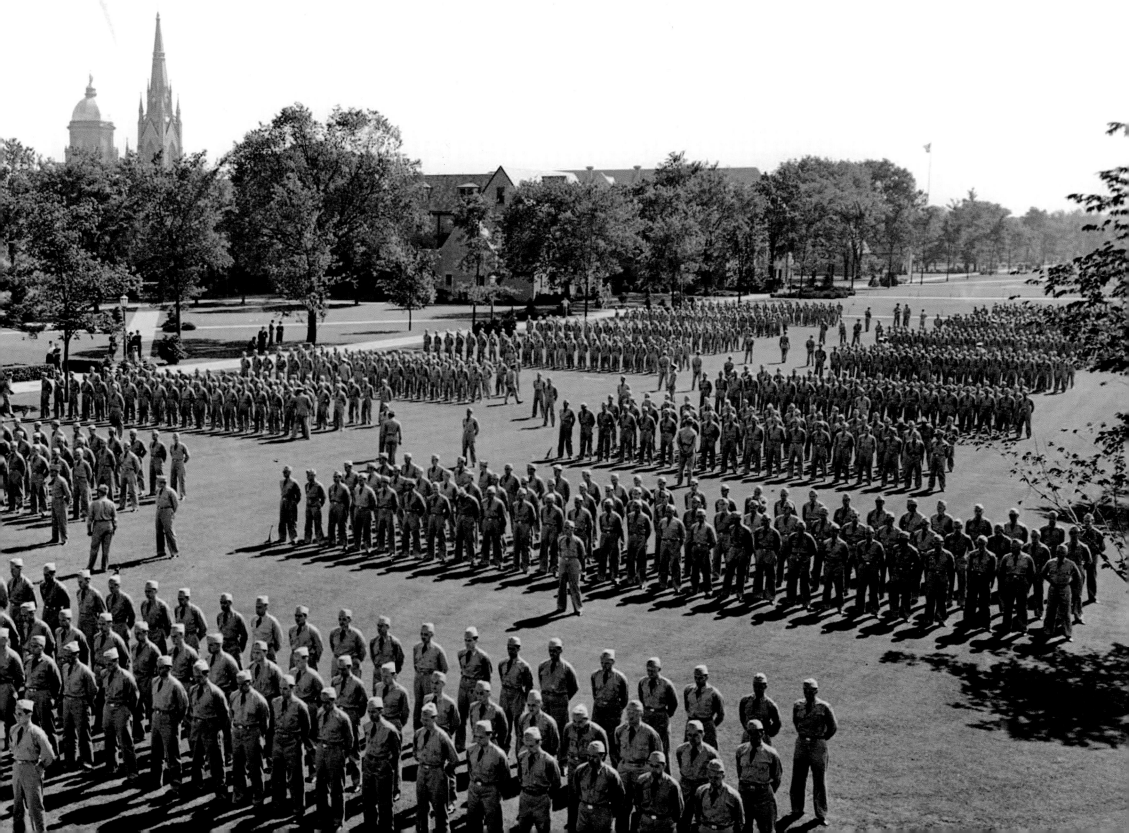

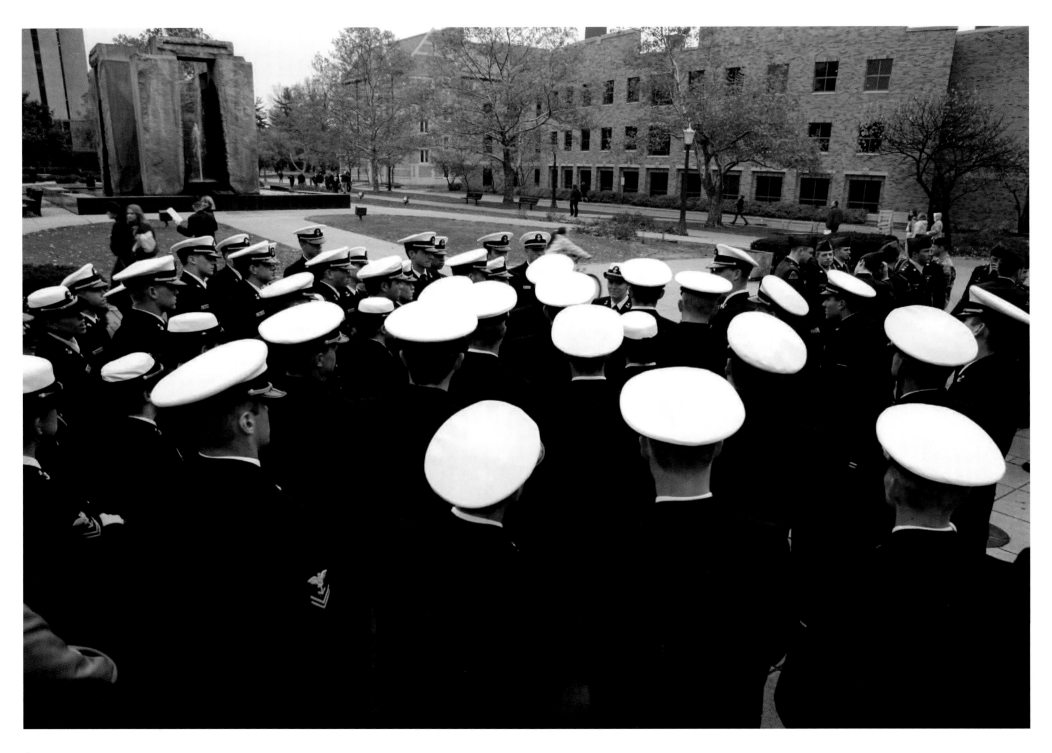

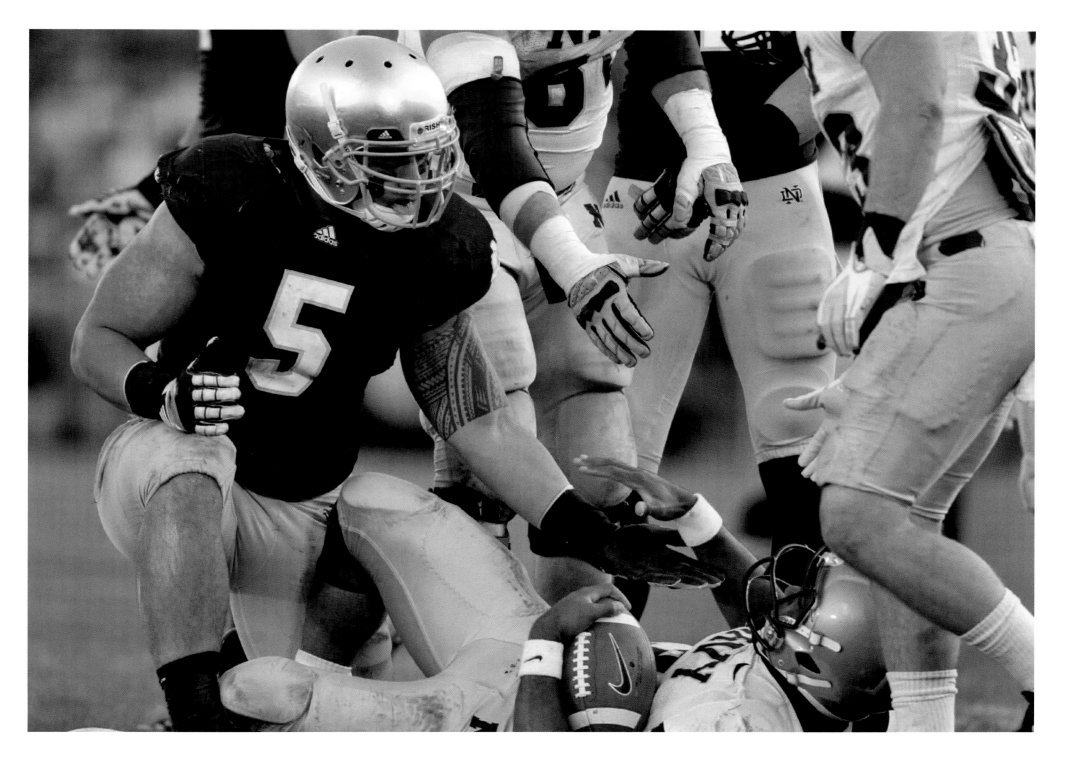

At various stages during the past two millennia, Dublin has served as a Christian settlement, a Viking trading post, a Norman stronghold, the jewel of Ascendancy Ireland, and the British Empire's second city. Dublin city lies in an inlet, stretching from Howth Head in the north to Dalkey Point in the south, on Ireland's eastern coast, and several rivers—the Liffey, the Dodder, the Tolka—and various streams pour into the Irish Sea at Dublin Bay.

Around 841, the Vikings established the settlement of Dyflin by the River Liffey inland from the estuary. Old city walls, buildings, and artifacts have been uncovered on the site at present-day Wood Quay, located in the city center opposite the Four Courts. The Scandinavian settlement Dyflin was centered on the River Poddle in Wood Quay, and the lake/dark pool (known as Dubh Linn/Black Pool) close to where the Poddle merged with the Liffey was ideal for mooring ships. The pool, which survived until the seventeenth century, was located where the Dublin Castle Garden is today, opposite the Chester Beatty Library within Dublin Castle's walls. A native Christian ecclesiastical settlement known as Duiblinn (also referring to the Black Pool) may have preceded the Viking settlement. Further up the River Liffey, near the present-day Father Mathew Bridge, was Áth Cliath ("ford of hurdles"), a settlement located at the original river crossing point.

The Vikings established a Thingmote— a raised mound 40 feet high and 240 feet in circumference—as an assembly area south of the river (adjacent to present-day Dublin Castle), and a large slave market to barter thralls and slaves. The native Irish wrested control of Dublin from the Vikings on a number of occasions during the next three centuries, notably in 1052, 1075, and 1124, but Dublin remained largely in Viking hands until the 1169 Norman invasion when Diarmait Mac Murchada (King of Leinster),

with the help of the Norman mercenary Strongbow, gained control of Dublin. In 1171 the Anglo-Norman Henry II (King of England) expelled the Vikings, and many of the city's Norse inhabitants relocated to the River Liffey's north side, known as Ostmantown or "Oxmantown." The multilingual city became peopled with English and Welsh settlers, as well as native Irish.

Under the Normans, Dublin developed into an important city, reflected in the presence of two cathedrals—Christ Church and Saint Patrick's—and a host of large monastic settlements. Dublin Castle, founded in 1204 by King John as a major defensive work, would become the center of colonial power in Ireland until 1922. The appointment of Dublin's first Lord Mayor in 1229 saw the city expand, and its growing prosperity prompted King Robert I of Scotland to undertake an unsuccessful attempt at capturing the city in 1317. Dublin's prosperity, built on successful maritime trading links, attracted a population of twenty thousand before the onset of the Black Death in 1348, which devastated the city's population.

The medieval city was a small, walled enclave on the River Liffey's southern bank. Despite housing Dublin Castle, the seat of the Irish Parliament, Saint Patrick's Cathedral, Christ Church Cathedral, and Saint Audoen's Church, Dublin remained, until the middle of the seventeenth century, under constant threat of attack by the native Irish/Gaelic lords who ruled small kingdoms in its hinterlands. Two stretches of the original city wall remain intact and visible above ground: at Saint Audoen's Church and at the nearby Cornmarket. The stretch of wall at Saint Audoen's Church includes the sole existing city gate (Saint Audoen's Gate), one of the main entrances into the medieval city.

The sixteenth-century Tudor conquest of Ireland heralded a new era for Dublin.

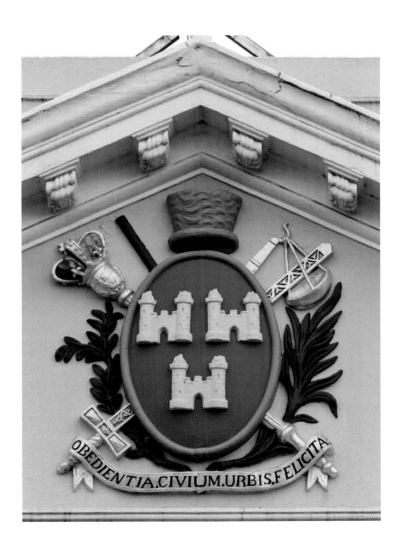

Ireland was declared a kingdom under English control in 1541. Queen Elizabeth I established Trinity College (which later became a Protestant university) in 1592 and converted Saint Patrick's Cathedral and Christ Church Cathedral for use in Protestant services. Oliver Cromwell seized Dublin in 1649 after the War of the Three Kingdoms/English Civil War, at which time it was a dilapidated city with fewer than nine thousand residents. After Cromwell's death in 1660, James Butler (Marquis of Ormond), who had been exiled for his role in opposing Cromwell, returned to Dublin in 1662 for a second term as Lord Lieutenant. His return marked a seismic shift in Dublin's development and saw the city "burst through its medieval walls."

Butler insisted that houses face the river, radically reconfiguring the cityscape and re-orienting it toward the River Liffey. Rather than serving as a sewer for household waste, the Liffey became the city's central focus.

As the city continued to prosper during the eighteenth century, Georgian Dublin became, for a short period, the second-largest city of the British Empire and the fifth-largest city in Europe, with a population around the year 1800 that exceeded 180,000.

The vast majority of Dublin's most notable architecture dates from the eighteenth century. The Mansion House, later home to the city's Lord Mayor, was constructed in 1710. The old city became fashionable; a new park, Saint Stephen's Green, was laid out; and development sprang up around Trinity College and Grafton Street. The Royal Canal and the Grand Canal were dug and marked the city's new boundaries. New bridges across the Liffey eased and increased access and commerce, and the development of streets and quays along the river changed the cityscape dramatically. Quays along the Liffey supported large three- and four-story houses and impressive public buildings. Henry Jarvis developed

the north-side quays and built the Essex (now Grattan) Bridge to facilitate access to Capel Street, the site of his development. The expansion of Dublin Port, the emergence of highly-skilled trades in the city, the development of a banking system, the importance of the courts, and the growth of higher education led to the emergence of a new city.

In 1757, the Wide Street Commission was appointed and encouraged to beautify Dublin. The Commission governed architectural standards and took to remodeling medieval Dublin—designing wide thoroughfares, demolishing warrens of lanes and back alleys, and coordinating the layout of streets, bridges, and buildings. It built the squares and streets of Georgian Dublin, as well as landmark buildings such as the Four Courts, Custom House, Royal Exchange, Leinster House, and Parliament House. Temple Bar and Grafton Street alone survived the wave of Georgian reconstruction and maintain their medieval integrity with winding lanes and crooked alleys.

To the north of the river, a series of small streets gave way to Sackville Street (now O'Connell Street) and an impressive new bridge (O'Connell Bridge). South of the river, D'Olier Street ran into College Green, now boasting the new Houses of Parliament. Dame Street, now widened, led to medieval Christ Church Cathedral, past rebuilt Dublin Castle and the new Royal Exchange. The city's north side had represented the most socially desirable quarter in this Georgian era, but the Earl of Kildare bucked trends by locating his new home, Leinster House, on the river's south side. The finished house, second only to Dublin Castle in terms of size and grandeur, transformed this formerly socially inferior side of the river. New residential squares appeared on the south side—Merrion Square, Saint Stephen's Green, and Fitzwilliam Square—and in these areas the nobility and the gentry resided in great

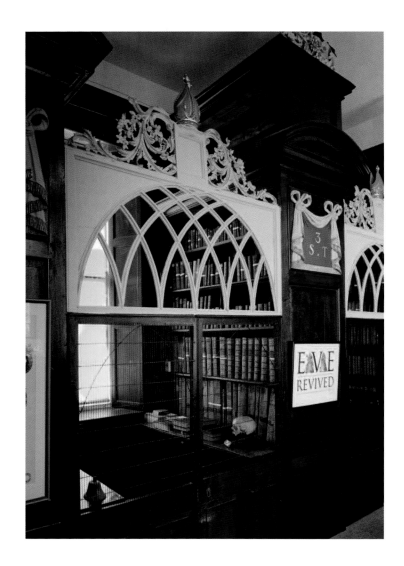

Marsh's Library, founded in 1701 by Archbishop Narcissus Marsh (1638–1713), was the first public library in Ireland. Designed by Sir William Robinson, the Surveyor General of Ireland, it is one of the few eighteenth-century Dublin buildings still adhering to the building's original purpose. It contains over thirty thousand rare books, pamphlets, and manuscripts—including eighty incunabula (books printed before 1501) and works relating to the sixteenth, seventeenth, and eighteenth centuries—covering medicine, law, science, travel, navigation, mathematics, music, surveying, and classical literature. The library's interior, unchanged for more than three centuries, contains dark oak bookcases with carved and lettered gables and three elegant wired alcoves. Scholars come from all over the world to consult the collections.

Georgian houses. On the north side, Henrietta Street—developed in the 1720s as the earliest Georgian street in Dublin—was home to members of the legal profession as well as ecclesiastical and business men. Mountjoy Square (considered among the finest Georgian squares in Europe), Rutland Square, and North Great George's Street were also highly fashionable addresses on the north side of the river.

In 1800, the Act of Union between the United Kingdom of Great Britain and Ireland abolished the Irish Parliament and drastically diminished the city's status, eradicating the need for a slew of peers, lords, and bishops to maintain Dublin residences along with thousands of maids, servants, butlers, and kitchen staff. Many still frequented Dublin for social functions and engagements such as formal balls, masked balls, and court functions hosted annually in Dublin Castle by the Lord Lieutenant, the British King's Irish representative, from January until Saint Patrick's Day in March. Gradually, however, Dublin lost its social prominence. Socialites and the political elite sold their townhouses and redeployed across the Irish Sea to London, and Dublin's economy suffered the consequences.

North-side Georgian squares morphed into slums. Entire families rented and lived in single rooms in the former residences of lords, and wealthy residents fled to the suburbs of Rathmines, Monkstown, and Blackrock. Vacated Georgian houses became tenements. Former fashionable districts of the north side were almost entirely abandoned—Henrietta Street, Mountjoy Square, and Parnell Square became tenements, with the resultant hardship and depravity captured in Sean O'Casey's plays. Monto—a slum tenement located around Montgomery Street off Sackville Street (O'Connell Street)—became infamous as the British Empire's largest red-light district. Monto closed in the mid-1920s, following a campaign by the Legion of Mary. New

suburbs such as Marino and Crumlin were constructed to replace squalid tenements with decent housing, but inner-city slums remained. On the south side, Fitzwilliam Square and Merrion Square survived as elite preserves.

Between 1845 and 1849, the Great Famine severely impacted the west of Ireland, and approximately one million people died of hunger-related diseases. Famine victims fled to Dublin and other cities in hope of finding food and relief. Dublin's population swelled, increasing the number of beggars and paupers and the rage of disease. The Liberties (located on the River Liffey's south bank near Christ Church and Saint Patrick's Cathedrals), in particular, were reputed to be densely populated by cholera victims from Connacht. The quays along the Liffey served as boarding points for the thousands who boarded ships to emigrate to England, the United States, and Canada during and after the Famine.

The Victorian era saw the erection of several landmark statues in Dublin, including Grattan, O'Connell, and Queen Victoria. The repeal of the Penal Laws had allowed Catholics and Presbyterians to practice their religion freely and openly, and the resultant boom in Catholic churches, many built in the Gothic style, is evident in Dublin. Saint Mary's Pro-Cathedral provided a focus for Dublin's Catholics.

In the late nineteenth and early twentieth centuries, increasing wealth prompted many of Dublin's Protestant and Unionist middle classes to move to new suburbs such as Ballsbridge, Rathmines, and Rathgar. The 1916 Easter Rising—when armed nationalists seized key buildings in the city, including the General Post Office (GPO), the Four Courts, and the Royal College of Surgeons, and held them for a week before surrendering—destroyed much of the city center, with large portions of O'Connell Street, Henry Street, North Earl Street,

Eden Quay, and parts of Abbey Street devastated. The Dublin Reconstruction (Emergency Provisions) Act (1916) led to the rebuilding of the damaged areas in a coherent and dignified fashion. Lower O'Connell Street was rebuilt, employing limestone and granite, with a standard cornice line, and the resultant reconstruction with neoclassical features, grand cupolas, and copper domes conveys the street's civic importance. The Civil War (1921–23)—between those who supported and those who opposed the Anglo-Irish Treaty that brought an end to the Irish War of Independence (1919–21) but partitioned Ireland—wrought more destruction to O'Connell Street, its northern end in particular. The terrace north of Cathedral Street to Parnell Square was completely destroyed in the Battle of Dublin (1922).

After independence was achieved in 1921, Dublin became the political, economic, and cultural center of the Irish Free State (in-dependent Ireland). The Irish Free State associated Georgian Dublin—the homes and buildings of former masters and tyrants—with British colonial rule, so whole swathes of eighteenth-century houses were razed and replaced with office blocks. Dublin Corporation (the government authority responsible for the city of Dublin) built large numbers of terraced and semi-detached houses in the 1920s and 1930s, laid out around crescent- and oval-shaped green areas on the city outskirts, as it attempted to clear the inner-city slums.

The 1960s saw profound changes in Ireland. In Dublin, tenements were demolished and formerly tight-knit communities dispersed to new suburban housing developments around the city perimeter. New suburbs such as Tallaght, Coolock, and Ballymun quickly acquired huge populations. Tallaght mushroomed with a population that grew to fifty thousand people, but it had little social planning, few amenities,

and a lack of public transportation and employment opportunities. Irish architecture, such as Busáras/Áras Mhic Dhiarmada (designed by Michael Scott) and Liberty Hall/Halla na Saoirse (which dominates Dublin's skyline), followed international trends maximizing style, space, light, and energy efficiency.

In the 1970s and 1980s, poor application of planning controls permitted property speculators and developers to demolish historic buildings—Gilbey's premises, the Metropole and Capitol cinemas, and the last intact Wide Street Commission buildings, which dated from the 1780s—and replace them with wholly inappropriate monstrosities: fast-food joints, gaming arcades, and convenience stores replete with neon signs, plastic signage, and PVC window fronts. In an effort to preserve Dublin's architectural heritage, Temple Bar, the last surviving section to contain Dublin's original medieval street plan, was developed into a "cultural quarter." The Grafton and Henry Street areas were pedestrianized in the 1980s.

The Celtic Tiger, Ireland's economic miracle between 1996 and 2006, saw the city expand rapidly with the construction of large-scale housing developments and a marked increase in four-, five-, and six-story apartment and office blocks. Towers sprang up on docksides, and shiny new housing estates replaced agricultural land on the outskirts as Dublin expanded into neighboring counties and gobbled up rural towns and villages. The Celtic Tiger also saw many old businesses fall casualty to property speculation and exorbitant rents in the inner city. Thomas Read, a cutlery founded in 1675 and trading on Parliament Street for over two hundred years, fell victim to the property boom that threatened to turn the city into a faceless, nameless zone. It is widely believed that much of the controversial construction, over green spaces as well as historic buildings, resulted from

Private street lighting began in Dublin as early as 1616, when the Candlelight Law "compelled every fifth house to display a light within prescribed hours of the night for the guidance of street-users." By 1697, public lighting was undertaken in certain city areas by contract. The first piped-gas lamp appeared in Dublin in 1825, and gas remained in use until 1957. Pigeon House generating station, which opened in 1903 and replaced the older Fleet Street station, extended electric lighting to many major streets in the city center. The lamps featuring shamrocks date from the 1940s and 1950s.

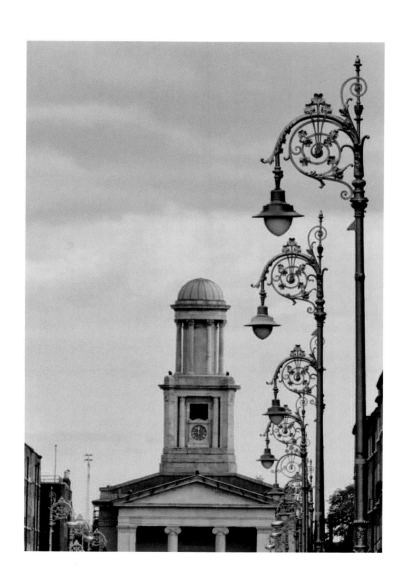

the bribery of corrupt officials and politicians. Since the 2009 financial collapse, it is estimated that there are ninety-seven ghost estates—partially completed or vacant housing developments—in Dublin with some 9,425 units.

In 2002, work began on the city's plan to protect O'Connell Street's architectural heritage and wider historic character. This required the regulation of signage and the decorative state of private property, as well as radical improvements to the public domain including the reduction of road space, the widening of footpaths, and the planting of more than two hundred replacement trees. These improvements included the creation of a central plaza area at the GPO.

Today's Dublin is one of Europe's most vibrant cities. It maintains its rich historical, literary, and cultural heritages through the lens of twenty-first-century sophistication, and continues to provide the same mythical attraction that has drawn poets, pirates, kings, and cobblers to its borders for hundreds of years.

Dublin Castle is situated in the center of historic Dublin, at the junction of the River Liffey and its subterranean tributary, the Poddle. An Dubh Linn (The Black Pool), from which the city is named, lies beneath the present Castle Gardens. In 1204, King John of England ordered the construction of a larger, stronger castle to replace the existing Viking fortress, which was built in the 930s to replace the earlier Irish ring fort structure. The castle was completed by 1230 with high walls and a moat, and was later largely rebuilt after a 1684 fire.

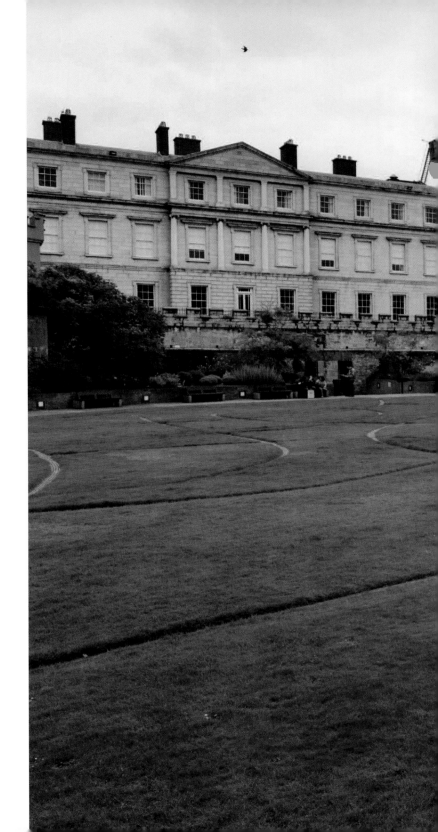

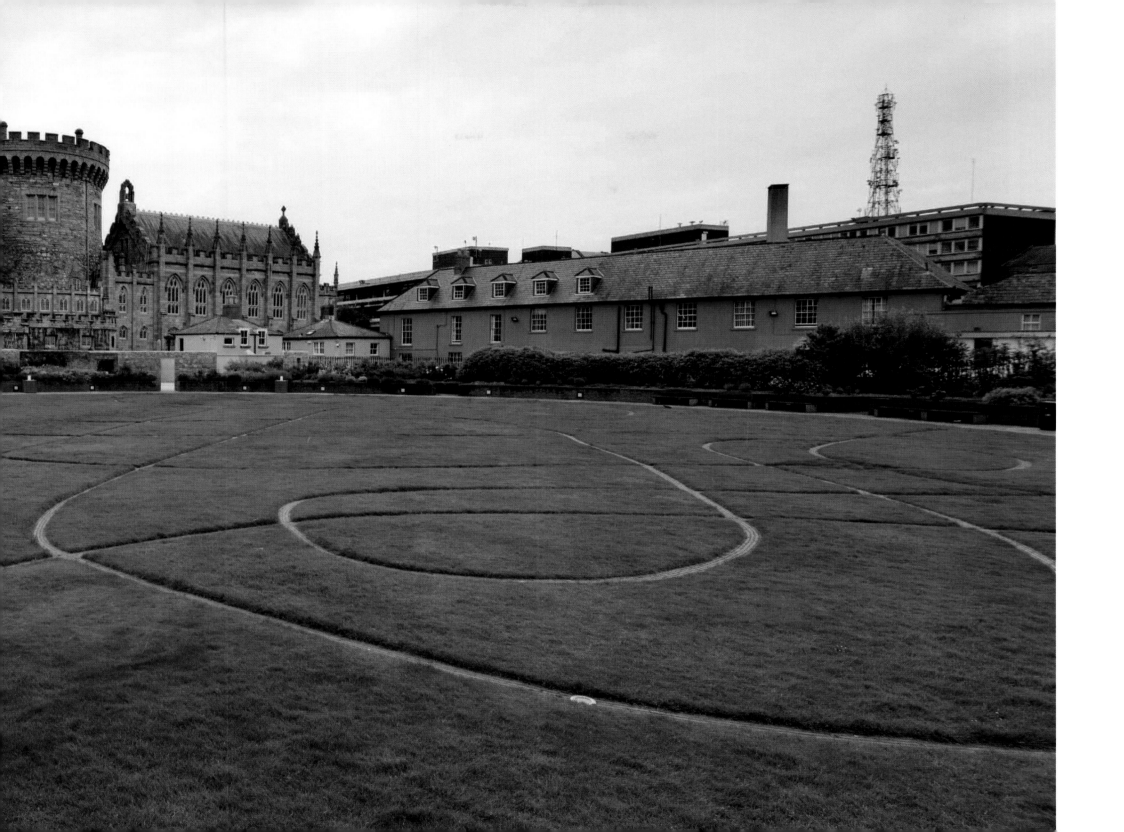

Dublin Castle was the colonial administration center until the Anglo-Irish Treaty brought an end to the Irish War of Independence in 1921. Michael Collins received the handover of the castle in the Upper Castle Yard on January 16, 1922, from Lord Lieutenant FitzAlan on behalf of the Irish Free State. The castle now hosts official state functions and is the site of the inaugurations of Ireland's presidents.

On September 1, 2012, Notre Dame held a mass in the castle courtyard to begin the day of festivities for the Emerald Isle Classic.

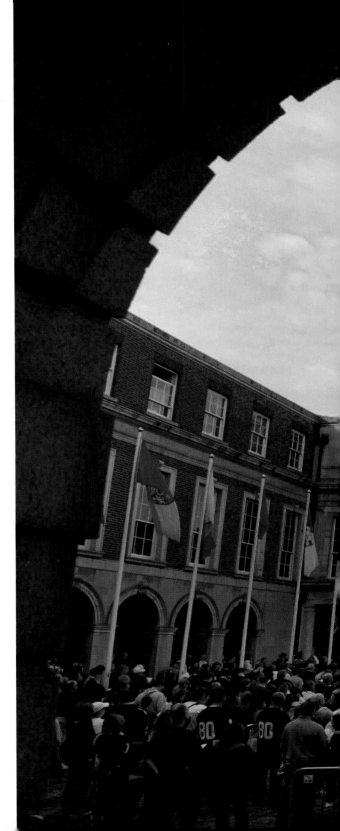

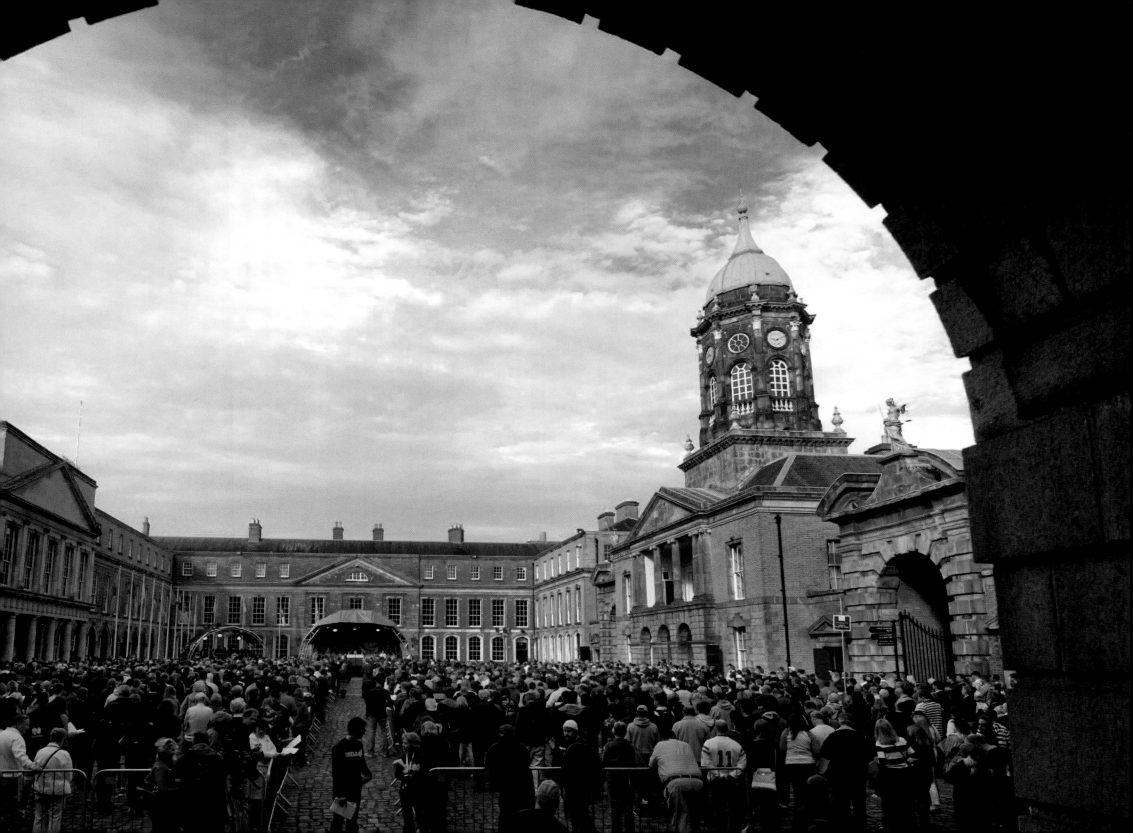

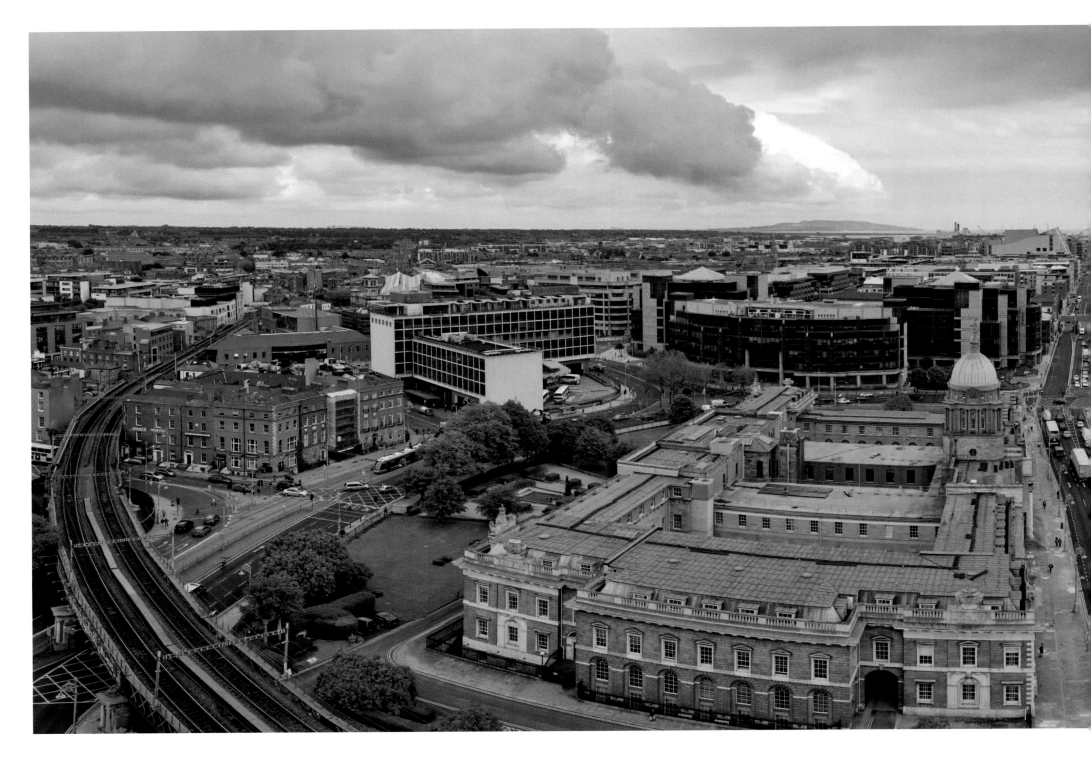

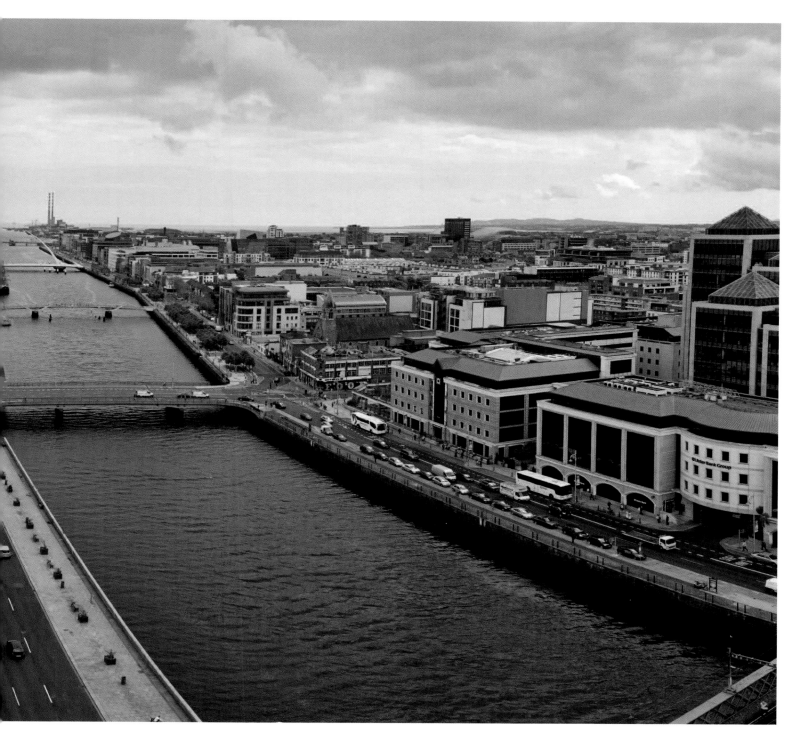

The River Liffey flows through the city center.
Major tributaries include the River Dodder,
the River Poddle, and the River Camac.
The Liffey, also known as the Anna Liffey, is
possibly an Anglicization of the Irish name
Abhainn na Life (The River of the Liffey).

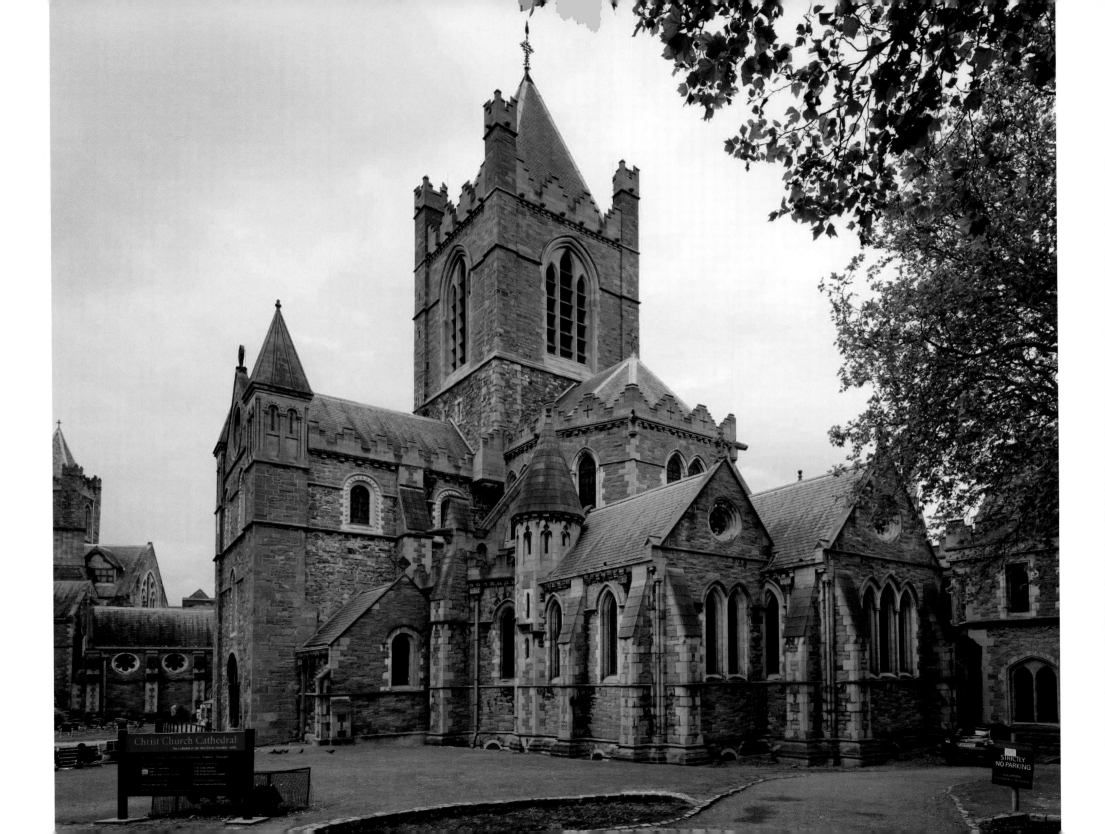

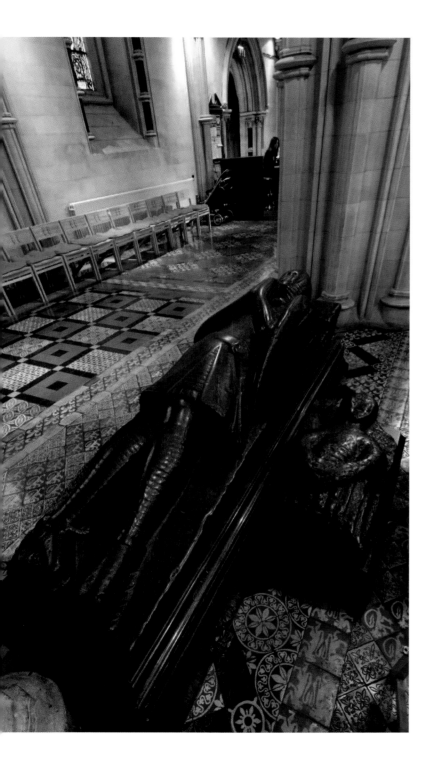

Located in the former heart of medieval Dublin, overlooking the ancient Viking settlement at Wood Quay, Christ Church Cathedral was founded sometime after 1028 when King Sitric Silkenbeard, the Hiberno-Norse king of Dublin, completed a pilgrimage to Rome. The Church of Ireland and the Roman Catholic Church both lay claim to Christ Church as ecclesiastical seat, but in practice it has only been the cathedral of the Church of Ireland since the Reformation. The crypt, dating from the twelfth century, is the largest in Ireland or Britain, and it is believed to be the building's oldest section. The remains of Strongbow (Richard de Clare, 2nd Earl of Pembroke) are interred in Christ Church. The heart of Bishop Laurence O'Toole (patron saint of Dublin) is buried inside. The relic was stolen and subsequently recovered in 2012.

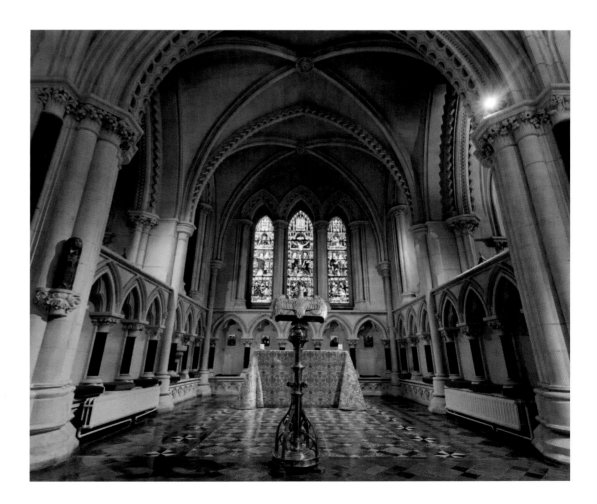

Named in honor of Ireland's iconic patron saint, Saint Patrick's Cathedral is built near the well where the saint is believed to have baptized converts. The present building dates from 1220. In 1560 Oliver Cromwell stabled his horses in the cathedral, and from 1713 to 1745, Jonathan Swift (1667–1745), author of Gulliver's Travels, served as Dean of the cathedral and is now buried on the grounds. The largest church in Ireland and one of Ireland's largest medieval buildings, Saint Patrick's has a 143-foot tower and a famed 100-foot spire that was added during the seventeenth century.

Pages 30, 31: Interior of Saint Patrick's Cathedral

Page 31: Bust of Dean Swift

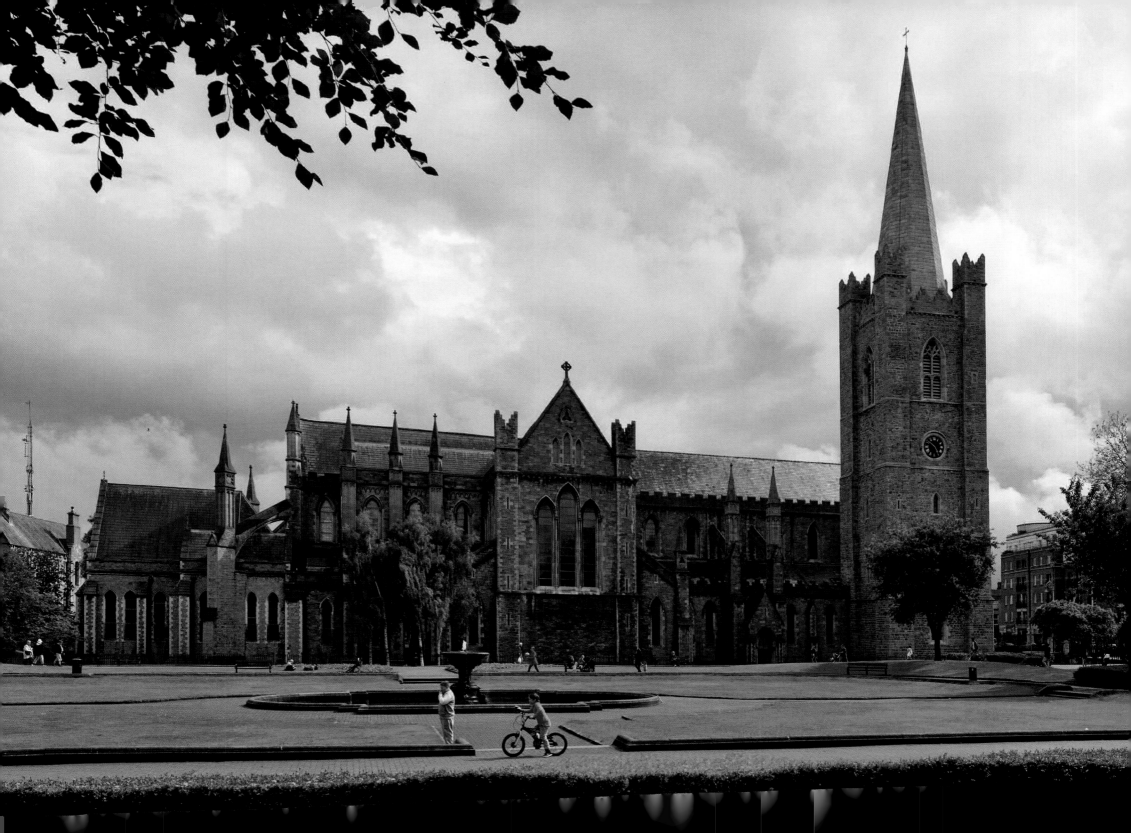

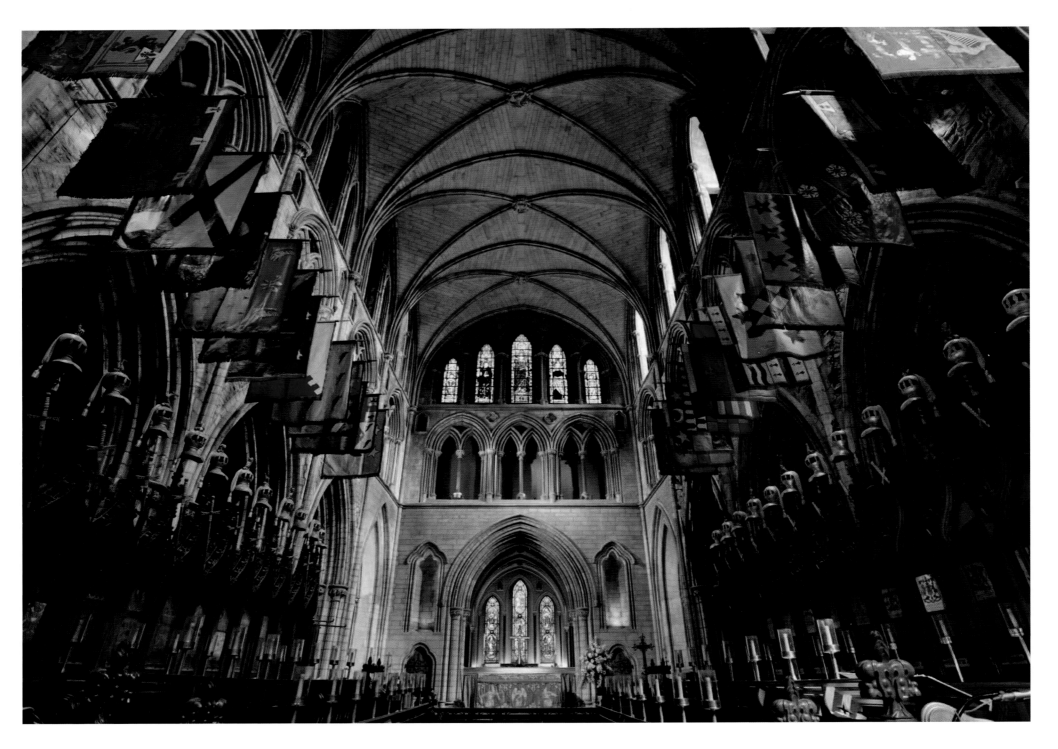

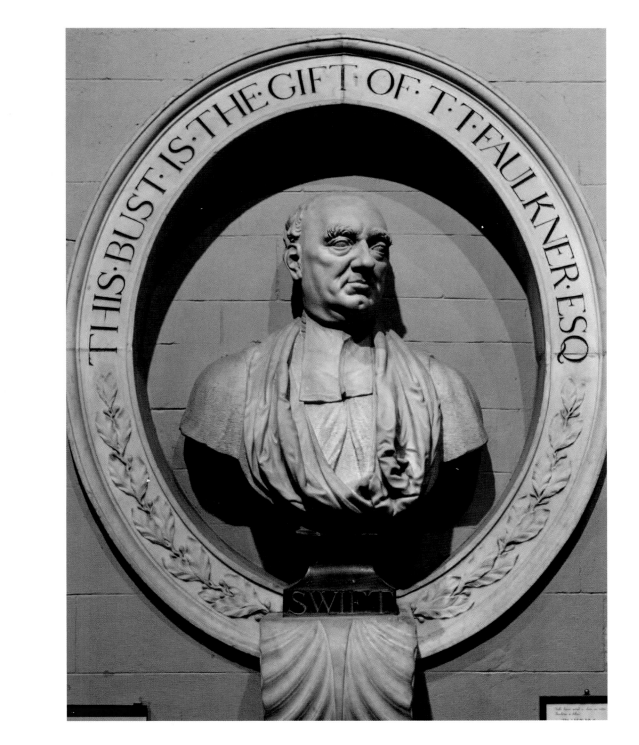

THIS·BUST·IS·THE·GIFT·OF·T·T·FAULKNER·ESQ

SWIFT

The Pro-Cathedral of the Immaculate
Conception of the Blessed Virgin Mary, more
popularly known as the Pro-Cathedral or
Saint Mary's, is Dublin's third cathedral
and serves as the cathedral of the Roman
Catholic Archdiocese of Dublin and the
metropolitan center of worship for Dublin's
Catholics. Construction started in 1815 as
Catholicism in Ireland reemerged publicly
with the relaxation of the Penal Laws.
Designed in the Classical Revival style,
it was never intended as Dublin's main
Catholic cathedral, since Catholics hoped to
reacquire the existing Christ Church
Cathedral. The banners in the pictures were
hung to celebrate the 2012 International
Eucharistic Congress.

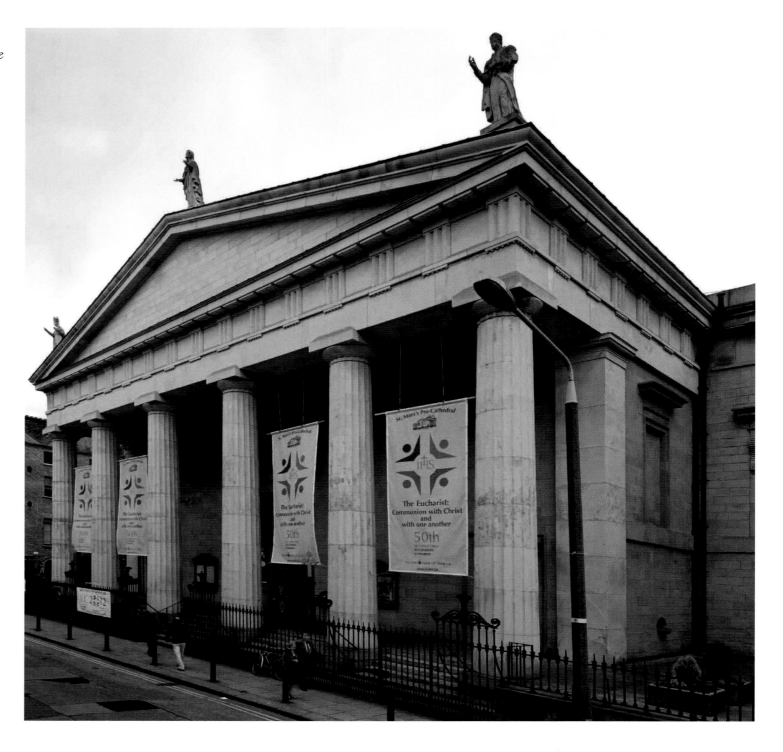

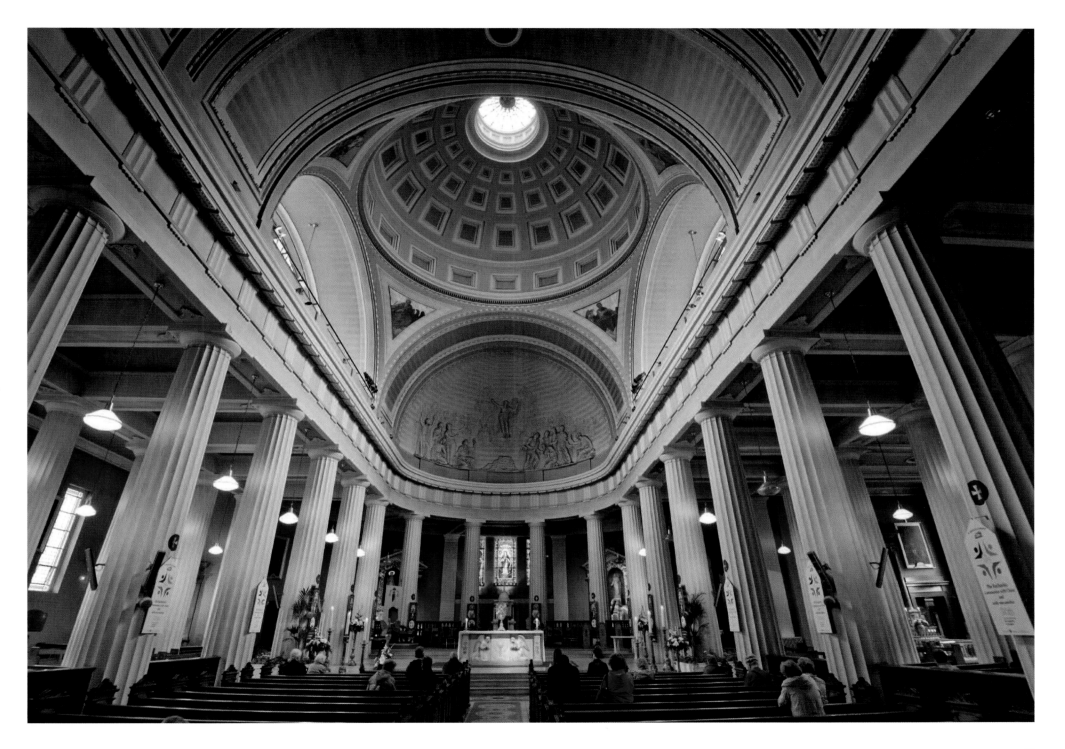

Trinity College is Ireland's oldest and most famous university. Founded in 1592 to consolidate Tudor rule by Queen Elizabeth I, nationalists considered it a bastion of Protestant and Unionist ascendancy for much of its history. Its library houses the eighth-century Book of Kells, *the famous decorated Gospel book made by Celtic monks. Famous literary figures to emerge from Trinity College include Jonathan Swift, Oliver Goldsmith, John Millington Synge, Samuel Beckett, and Oscar Wilde. As early as 1793, Roman Catholics were permitted to enter the university. Notre Dame undergraduates attend classes at Trinity as part of the junior year abroad program.*

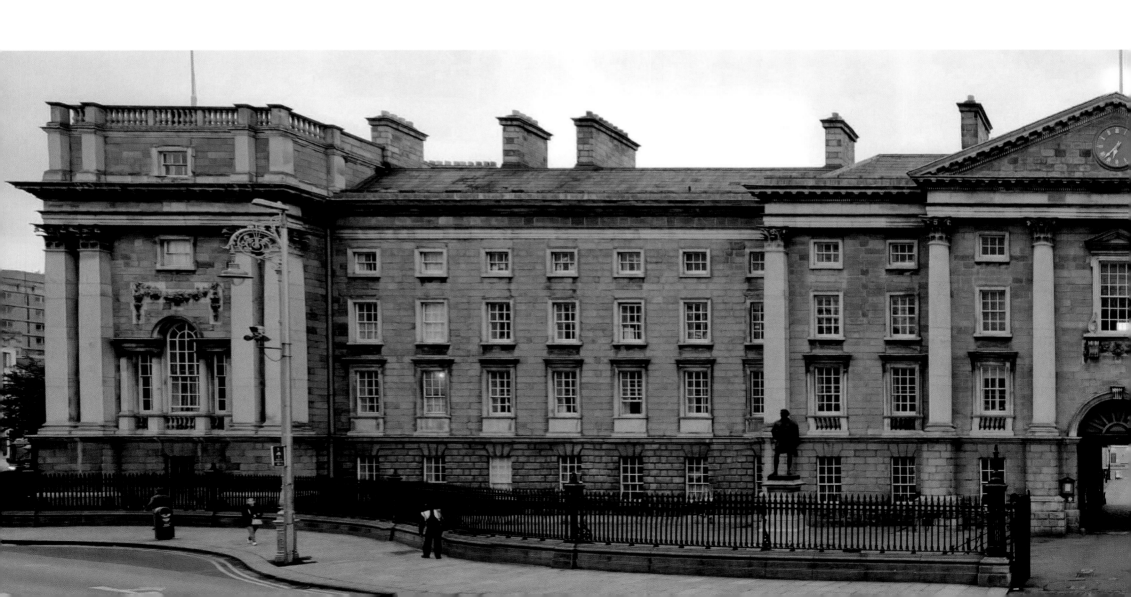

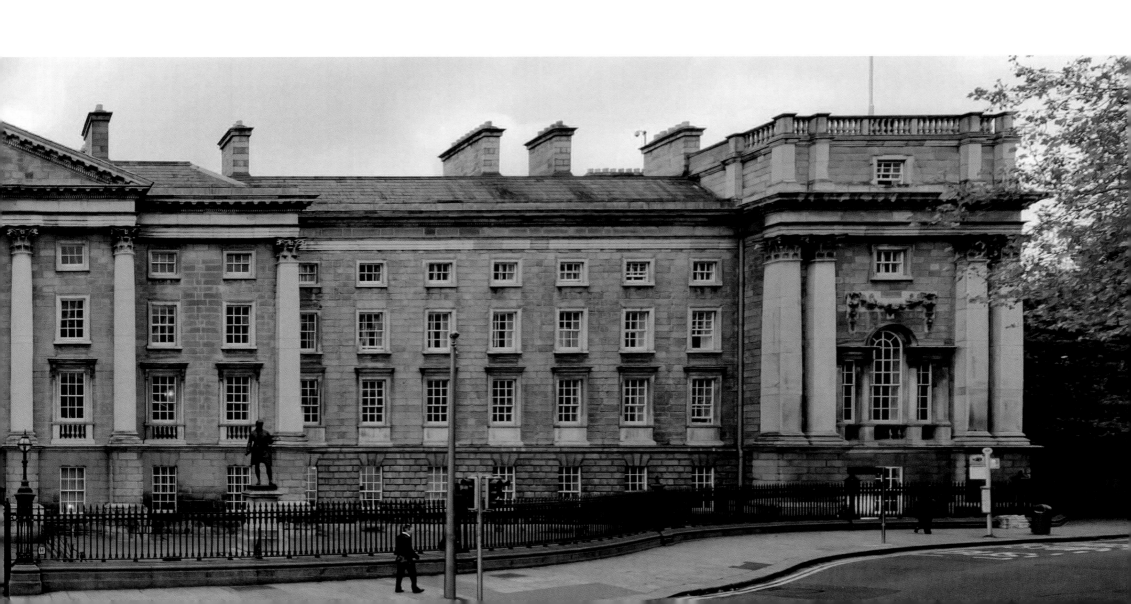

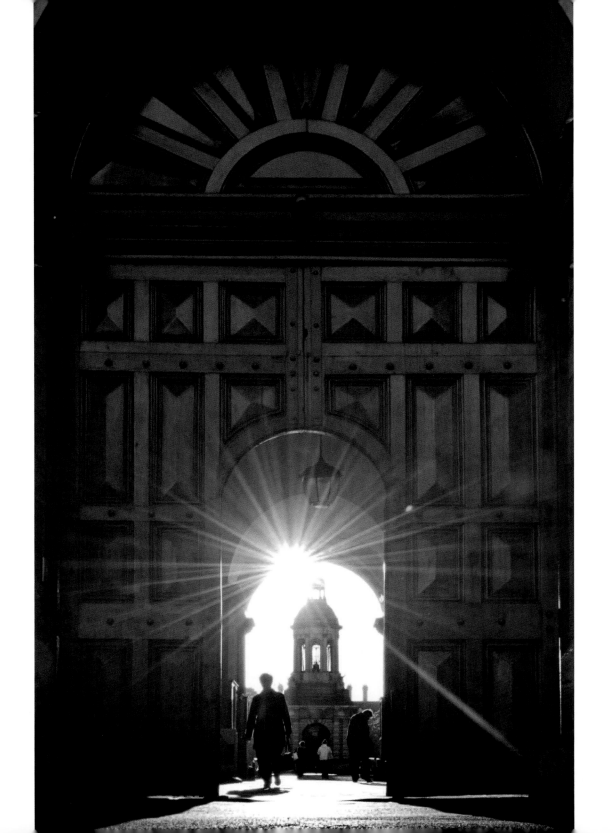

*Left: Main gate, Trinity College,
with view of campanile*

Right: Trinity College buildings

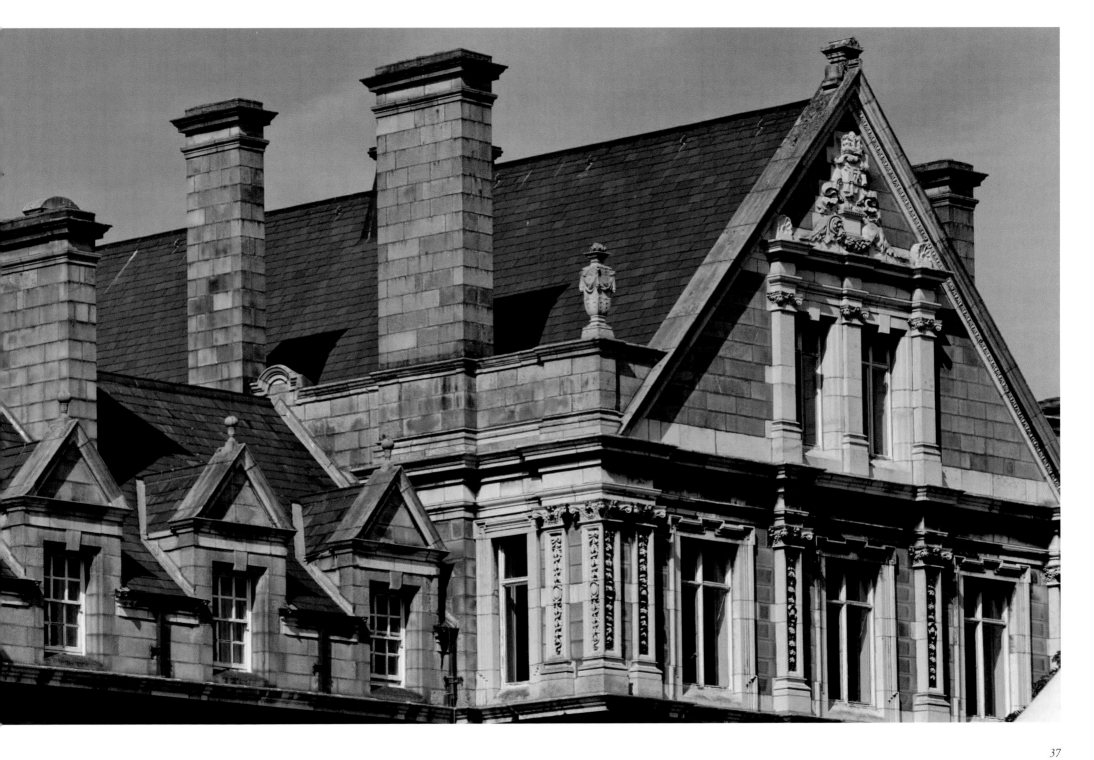

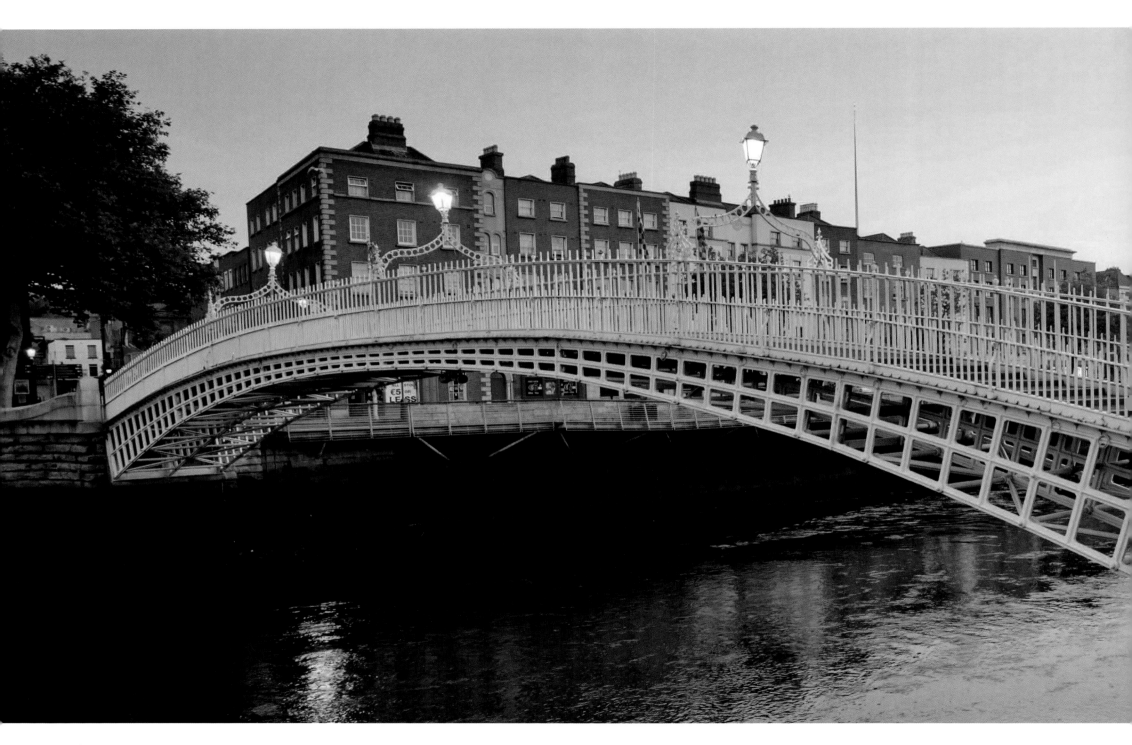

The Ha'penny Bridge (officially the Liffey Bridge), built in 1816, is a pedestrian bridge spanning the River Liffey. Prior to its construction, William Walsh, who operated a series of ferries across the Liffey, faced an ultimatum of either repairing his boats, which were in poor condition, or constructing a bridge at his own cost. Walsh chose the latter option. In compensation, he was permitted—for one hundred years—to construct turnstiles at both ends and charge a ha'penny (halfpenny) toll for access.

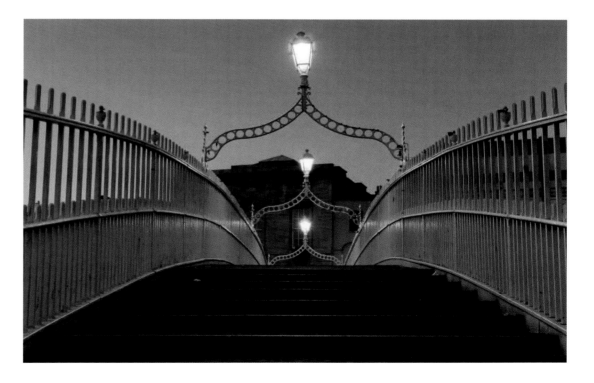

The Daniel O'Connell Bridge was designed by James Gandon and originally named the Carlisle Bridge. Built between 1791 and 1794, it was reconstructed between 1877 and 1880 and renamed O'Connell Bridge in honor of Daniel O'Connell (1775–1847), the Catholic nationalist politician responsible for Catholic Emancipation in Ireland. It is believed to be unique among European bridges as the only traffic bridge to be as wide as it is long.

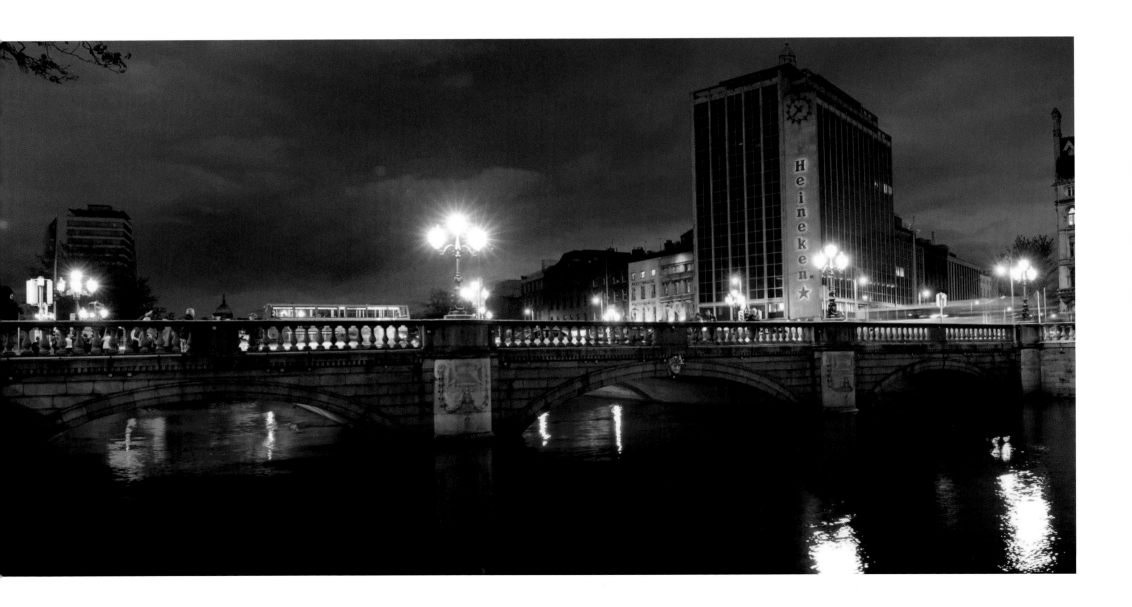

The Samuel Beckett Bridge was designed by Santiago Calatrava and opened on December 10, 2009. It connects Sir John Rogerson's Quay on the south side of the Liffey to Guild Street and North Wall Quay in the Docklands. The design evokes an Irish harp, the official emblem of the Republic of Ireland.

Pages 42, 43: Views of the River Liffey

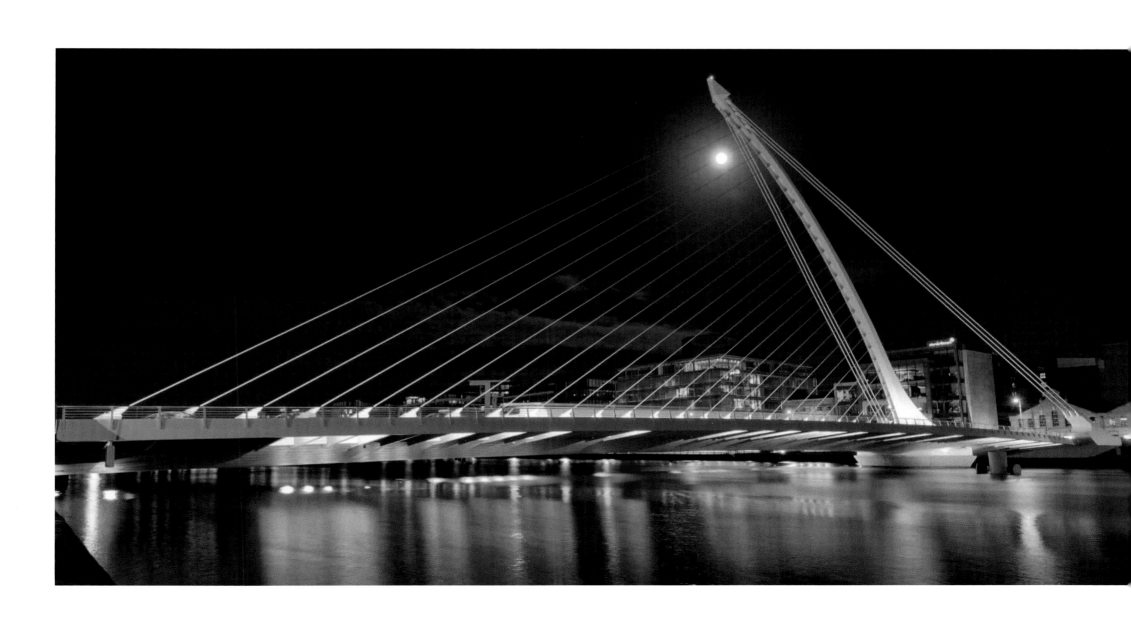

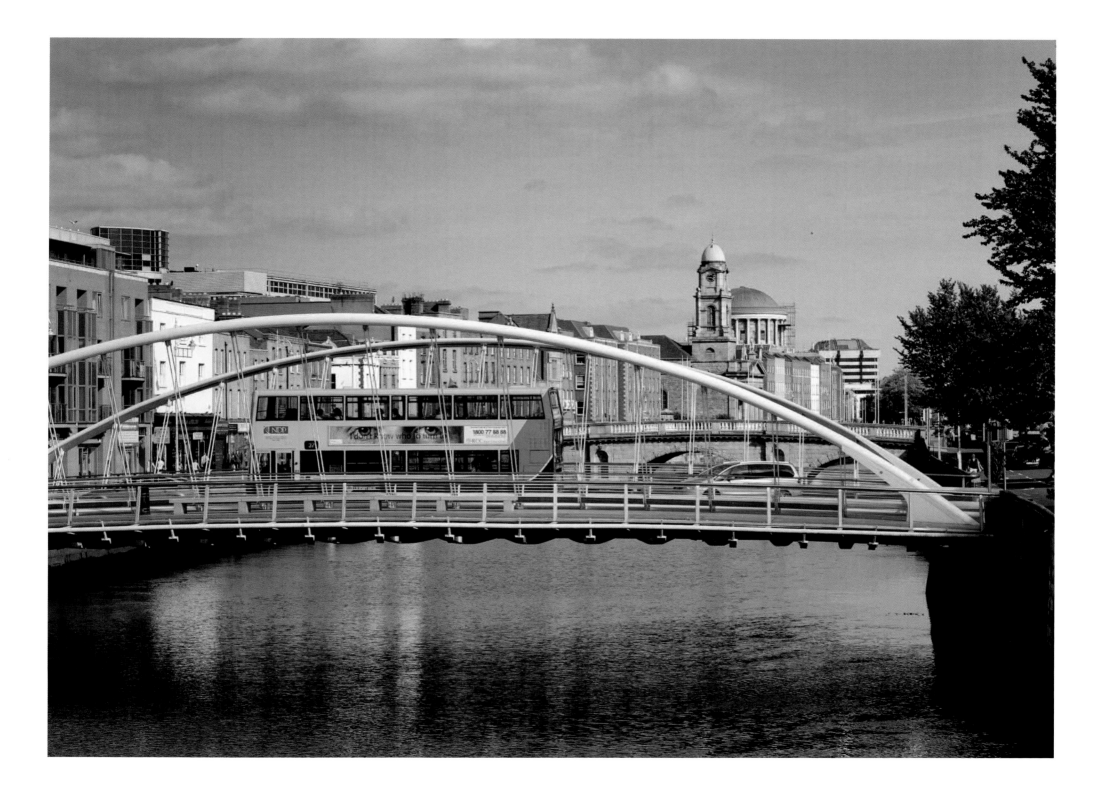

Below: Saint Stephen's Green, a twenty-two-acre city center public park, is the largest of the parks in Dublin's main Georgian squares. After Prince Albert's death, Queen Victoria's suggestion that it be renamed Albert Green with a statue of Albert at its center was rejected by Dublin Corporation. In 1877, Parliament, at the initiative of Sir A. E. Guinness, opened Saint Stephen's Green to the public and in 1889 paid for the laying out of the Green in approximately its current form. During the 1916 Easter Rising, rebels under the command of Commandant Michael Mallin and his second-in-command, Constance Markievicz, seized the Green as a rebel position.

Right: The Grand Canal begins at the River Liffey in Grand Canal Dock and runs to the River Shannon. In 1757 the Irish Parliament granted Thomas Omer £20,000 to construct this canal, but numerous difficulties delayed the official opening until April 1804. The delays prompted a rival venture, the Royal Canal, which started construction in 1790 and opened in 1817. The Royal Canal runs from Dublin to Mullingar, with offshoots running to the Shannon at Cloondara and to Longford.

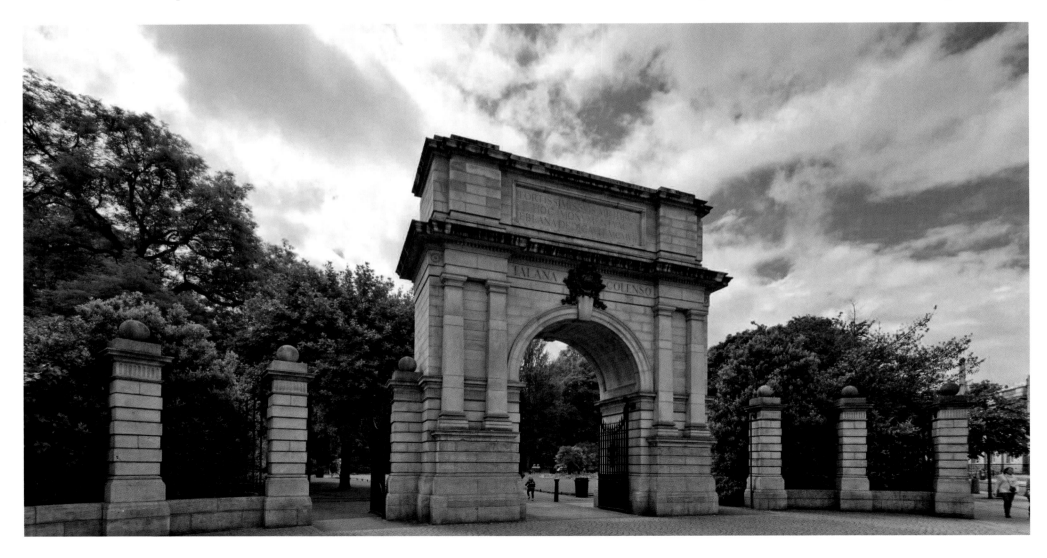

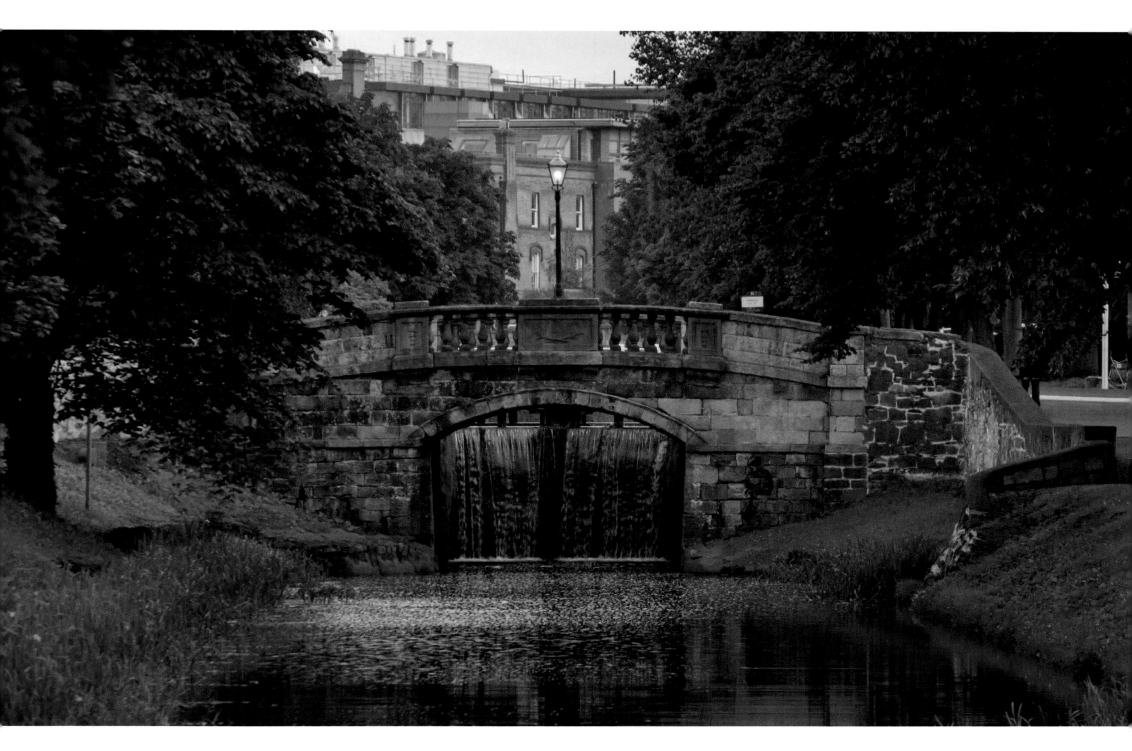

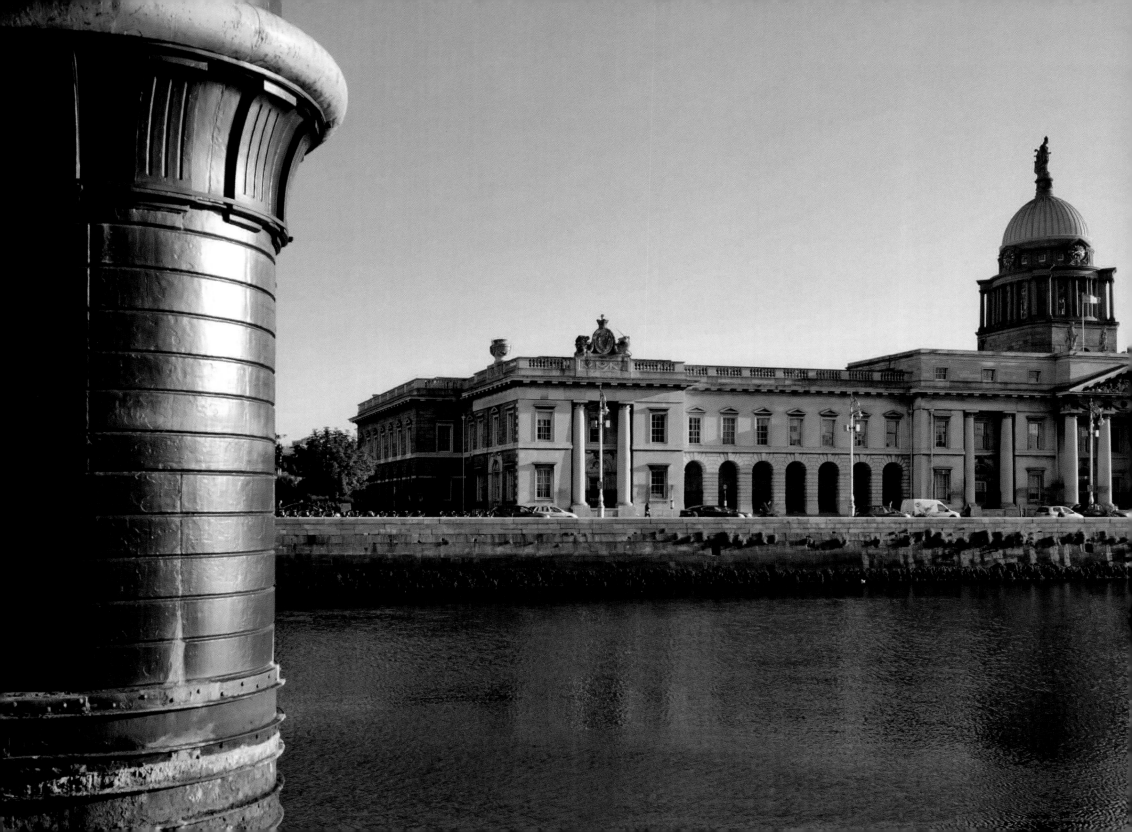

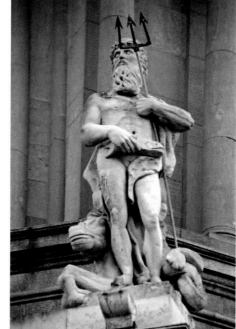

The Palladian-style Custom House was designed by James Gandon and completed in 1791. One of Dublin's finest Georgian buildings, it is beautifully proportioned with a long classical façade of graceful pavilions, arcades, and columns; a central dome topped by a sixteen-foot statue of Commerce resting on her anchor; and fourteen keystones over the doors and windows. Over the south portico's pillars stand statues of Neptune, Plenty, Industry, and Mercury, and within the pediment are the figures of England and Ireland, with Neptune driving away famine and despair. The north entrance is a portico of four columns with no pediment and with statues of Europe, Asia, Africa, and America over the columns. The building is also adorned with the Kingdom of Ireland's coat of arms and a series of sculptures symbolizing Ireland's principal rivers: Bann, Barrow, Blackwater, Boyne, Erne, Foyle, Lagan, Lee, Liffey, Nore, Shannon, Slaney, and Suir.

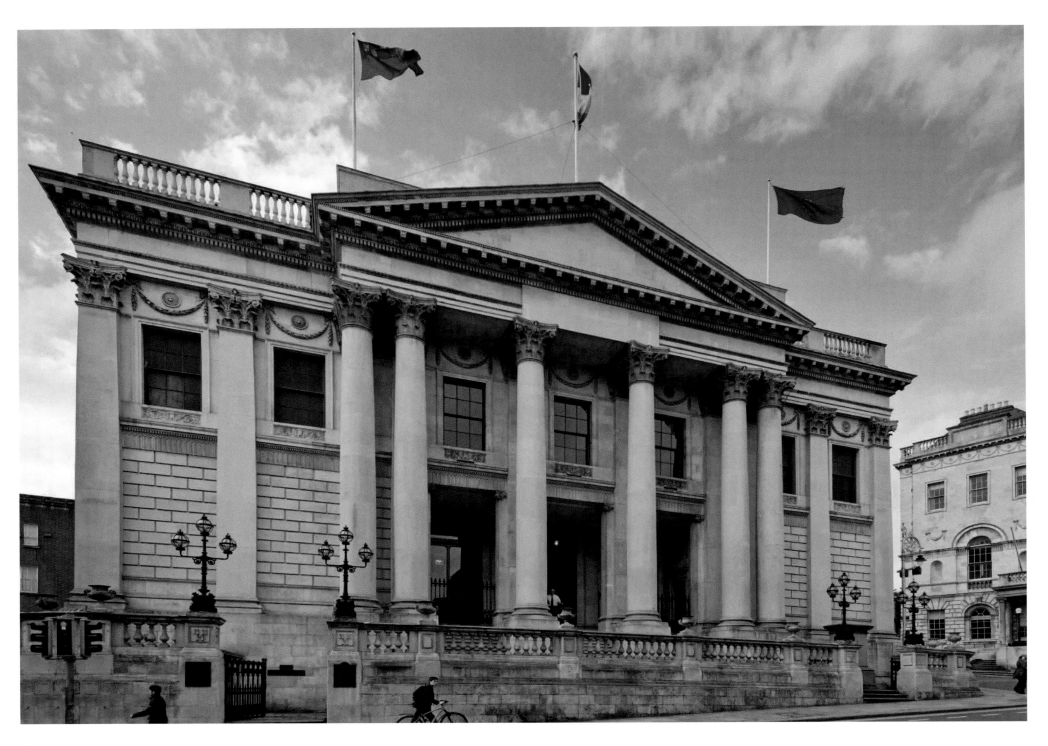

Built between 1769 and 1779, today's City Hall/Hall na Cathrach (originally the Royal Exchange) is a neoclassical building with an impressive rotunda supported by twelve columns. Standing next to Dublin Castle, its fine fittings reflect eighteenth-century Dublin's standing and prestige. Also located adjacent to the old Custom House, it offered Dublin's businessmen a venue to buy, sell, and trade. Dublin Corporation acquired the Royal Exchange in the early 1850s and converted it for use by the city government. In 1852, the Royal Exchange was renamed City Hall at the first meeting of Dublin City Council held there.

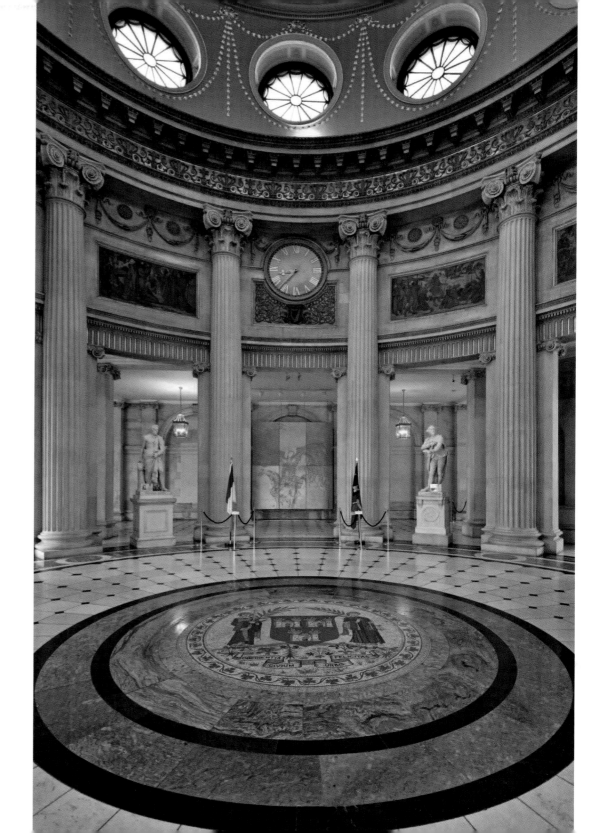

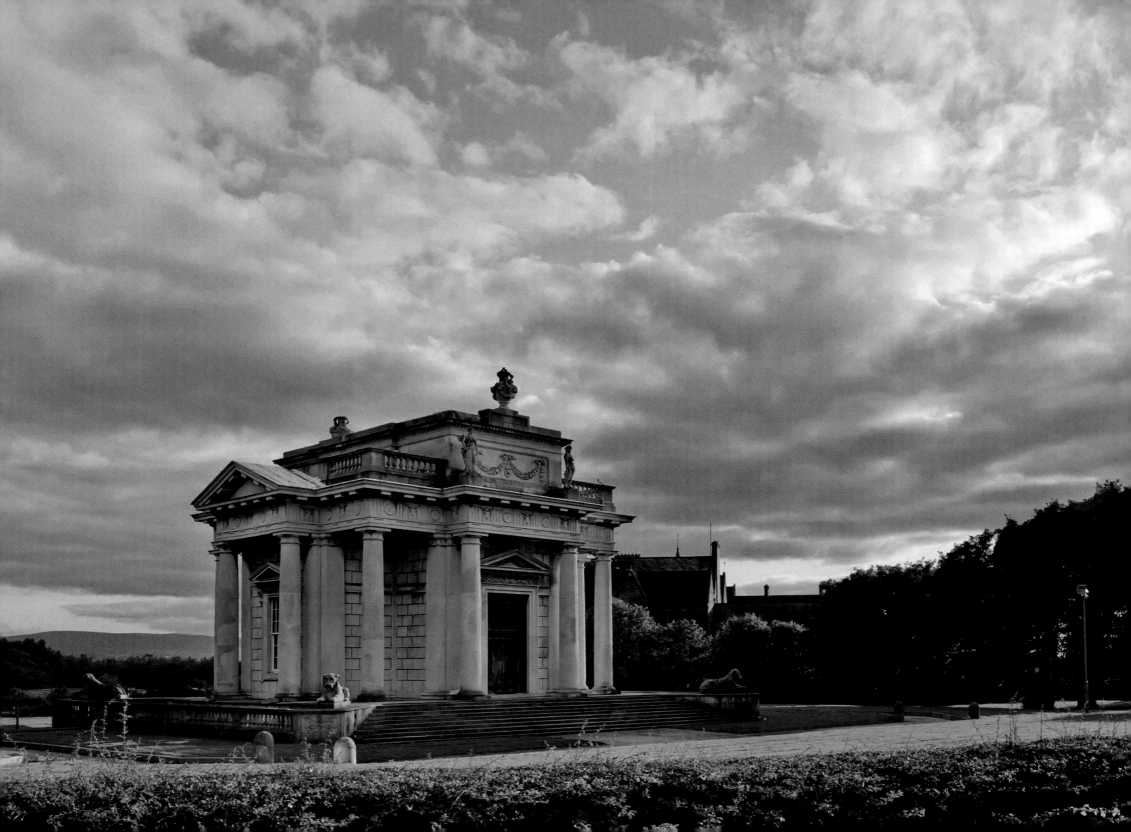

Marino Casino is widely regarded as the most important neoclassical building in Ireland. Designed by Sir William Chambers (1723–96) for James Caulfield, the first Earl of Charlemont, it was finished around 1775 and located on James Caulfield's family estate at Marino outside Dublin. The casino measures fifty feet on each side and contains sixteen rooms on three floors. "Casino" is the diminutive form of the eighteenth-century Italian word "casa" (meaning "house"), so a "casino" is a "little house."

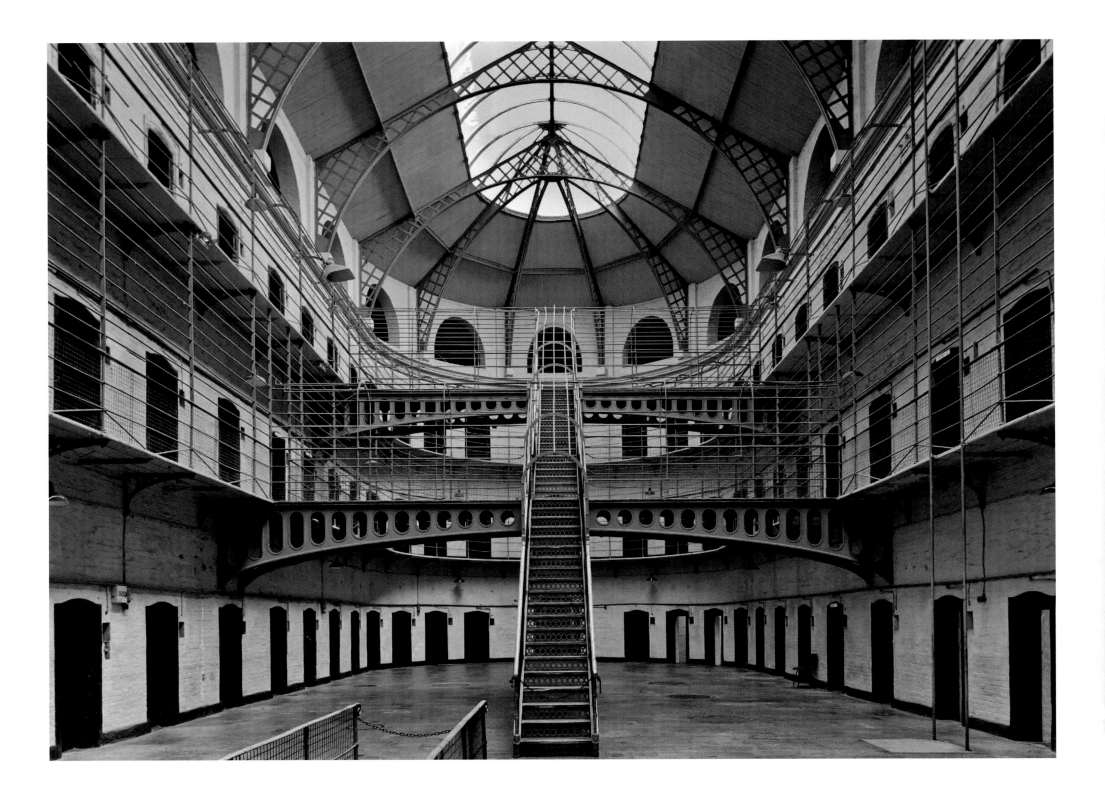

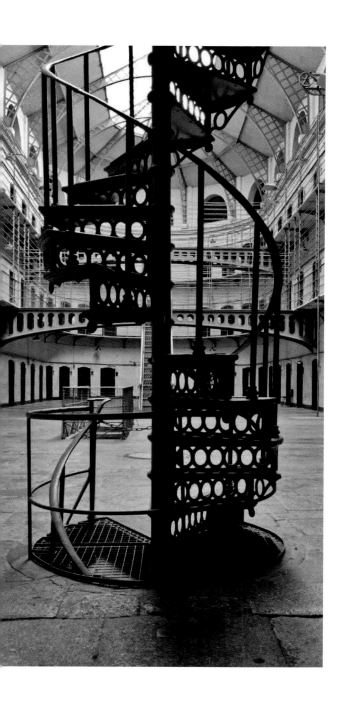

From its opening in 1796 until its decommissioning as a prison by the Irish Free State government in 1924, Kilmainham Gaol has been, barring the notable exceptions of Daniel O'Connell and Michael Collins, the site of incarceration for every major Irish nationalist leader. Prisoners have included the leaders in the rebellions of 1798, 1803, 1848, 1867, and 1916; Irish War of Independence (1919–21) prisoners; and anti-Treaty forces during the Irish Civil War (1921–23).

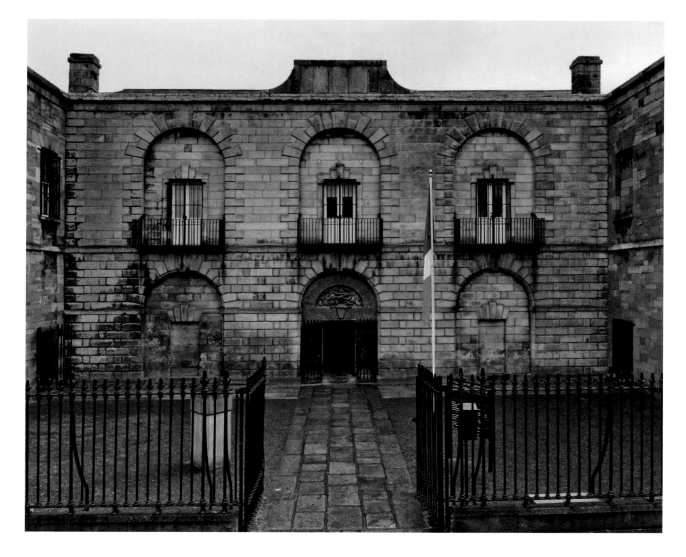

The Four Courts is Ireland's main courts building. Built between 1786 and 1796, it contains the Supreme Court and the High Court of Ireland. It is designed as a single quadrangle with four original courts: the King's Bench, Chancery, Exchequer, and Common Pleas. The building was severely damaged in 1922 during the Civil War, and most of the documents of the Public Records Office were destroyed. This loss accounts for the difficulty of tracing ancestors in Ireland before the nineteenth century.

Georgian architecture developed as a symbol of Dublin's prosperity during the eighteenth century, and it is the city's most characteristic architectural style. Among its primary features is the repetition of geometric figures such as semicircles. This repetition of patterns can be seen in the symmetry and beauty of the Georgian doorways, which are one of Dublin's many charms. Despite the repetition of elements, no two Georgian doors are identical. Georgian house owners used their door's colors and design to distinguish them from their neighbors and add some individual flair. They also added ornate knockers, elegant fanlights, and wrought iron boot scrapers. In the late eighteenth century, muddy streets were common, as were metal boot scrapers outside the front doors of many homes and businesses. Highly elaborate and durable, they remain a feature of the city center. Many houses also retain brass fittings and original fanlights with box-shaped glass recesses in which lamps were placed.

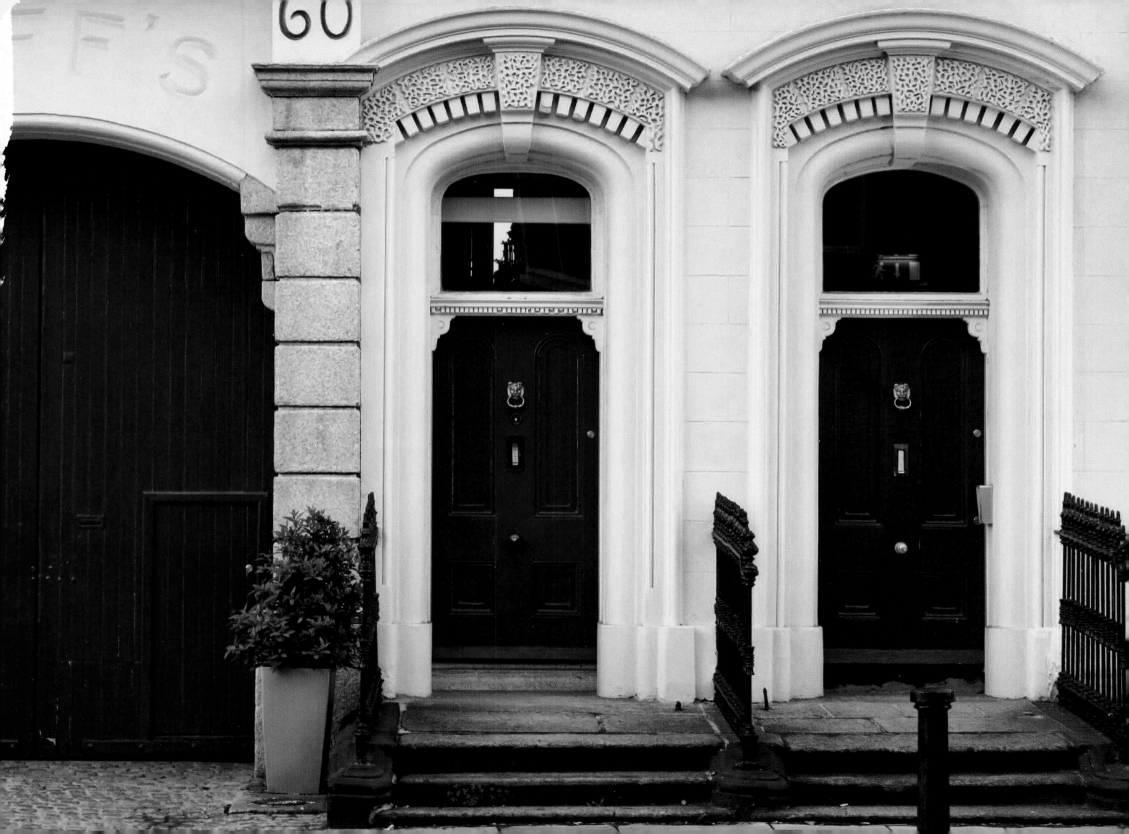

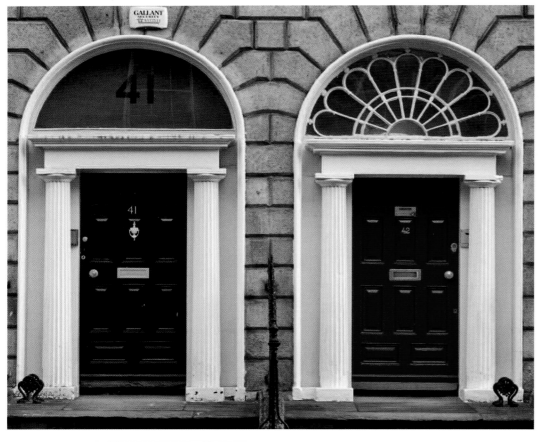
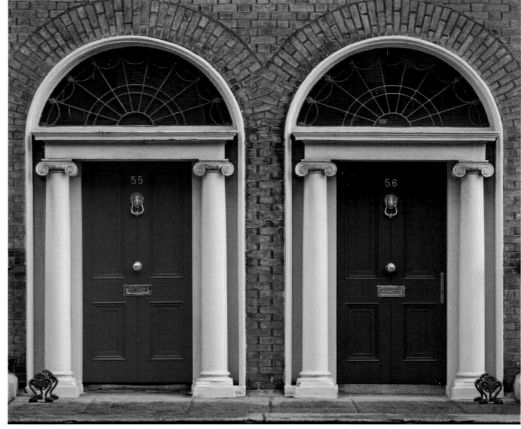
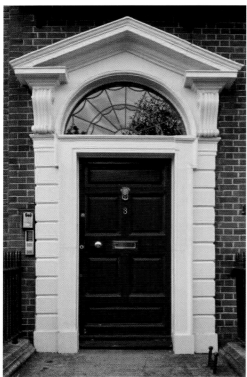
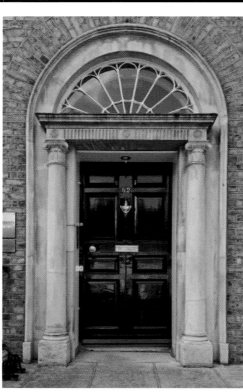
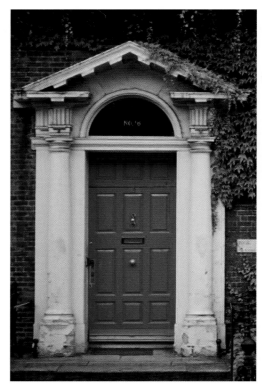
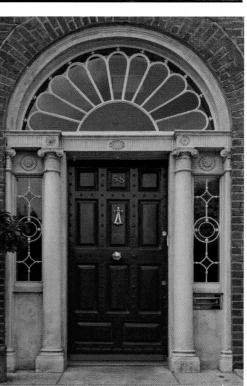

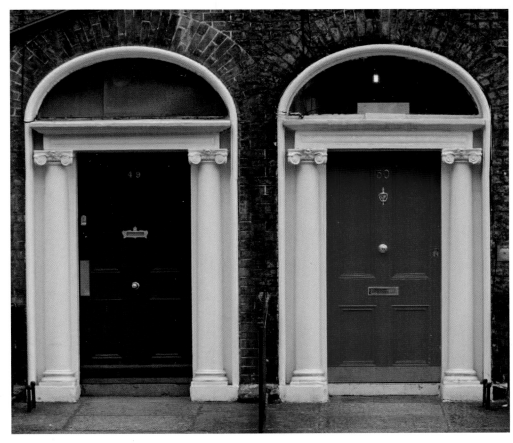

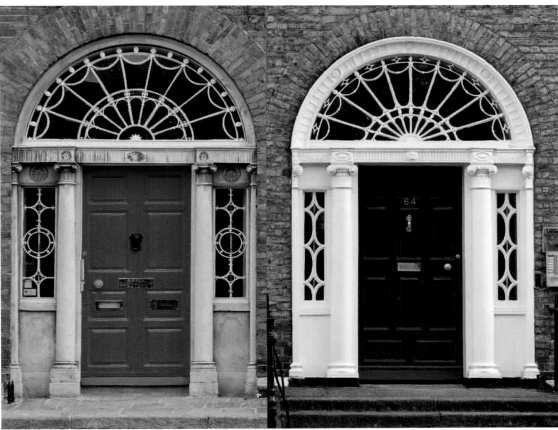

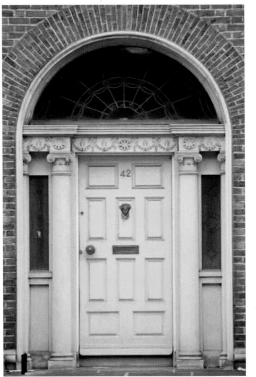

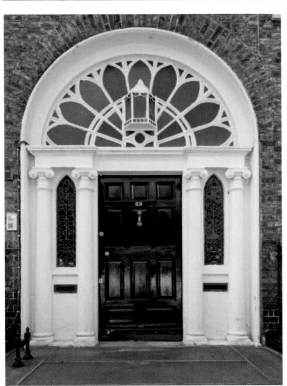

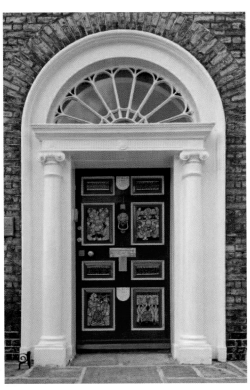

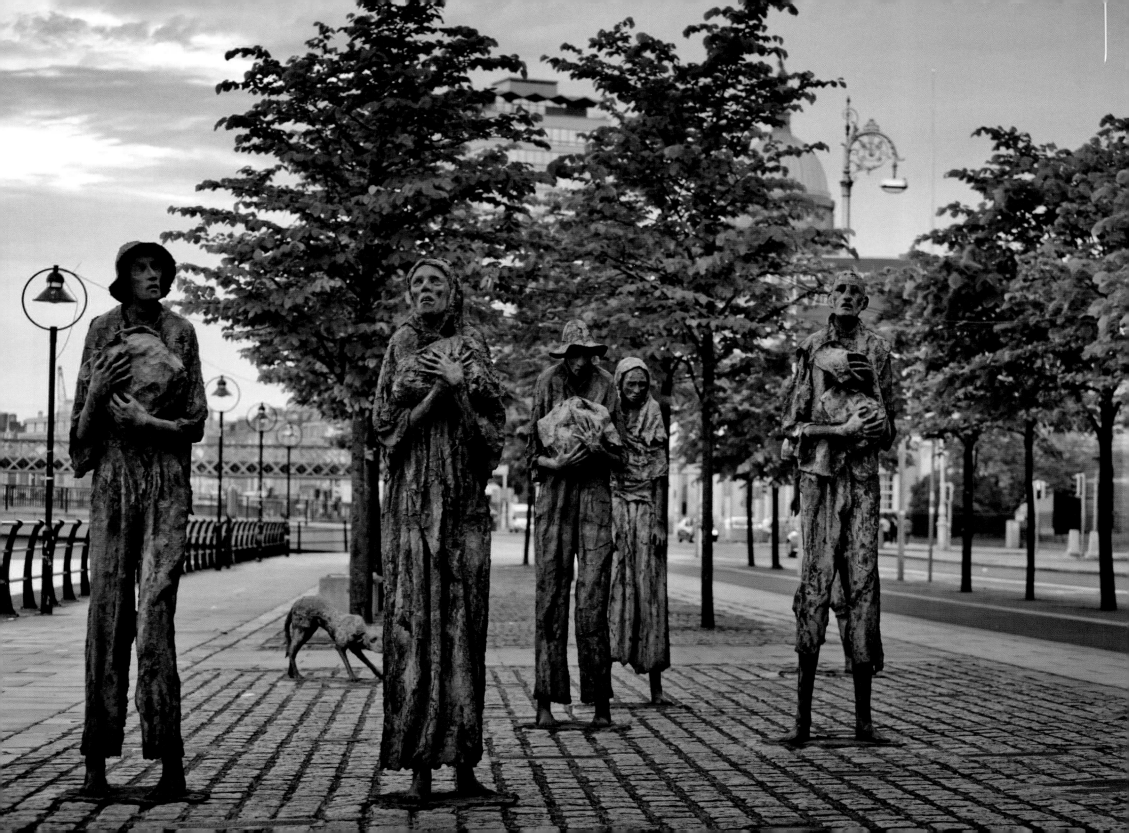

The Famine Memorial is located on Custom House Quay
in Dublin's Docklands. During the 1845–49 famine,
approximately one million people died and one million more
emigrated from Ireland, causing a 20 to 25 percent decline in the
island's population. The Famine Memorial was commissioned
by Norma Smurfit and designed and crafted by sculptor Rowan
Gillespie. The sculpture was presented to the City of Dublin
in 1997.

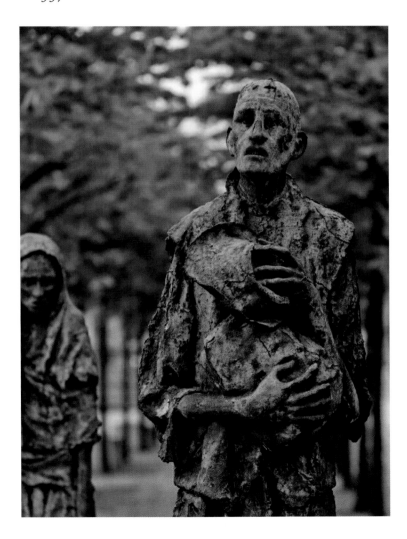

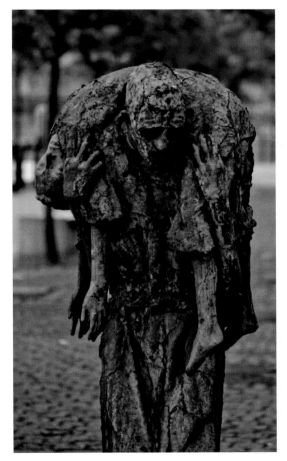

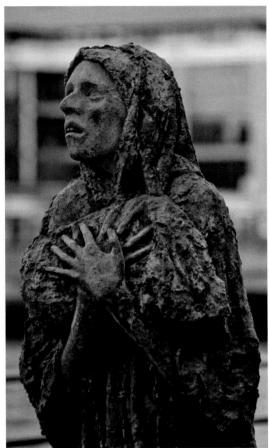

The Molly Malone statue stands at the end of Grafton Street. Unveiled during the 1988 Dublin Millennium celebrations, this statue commemorates the memorialized fictional fishmonger who, according to the popular song "Molly Malone"/"Cockles and Mussels," plied her trade on the streets of Dublin but died young of a fever. The popular song serves as the city's unofficial anthem.

Known for his brilliant wit and flamboyant dress, Oscar Fingal O'Flahertie Wills Wilde (1854–1900) was among the most successful playwrights of late Victorian London and one of the best-known personalities of his day. His ill-advised decision to sue his lover's father, the Marquess of Queensberry, for libel led to his own high-profile conviction for gross indecency. Imprisoned for two years of hard labor, he immigrated to Paris on his release and died there, destitute. Among his best-known works are The Picture of Dorian Gray (1890) and The Importance of Being Earnest (1895).

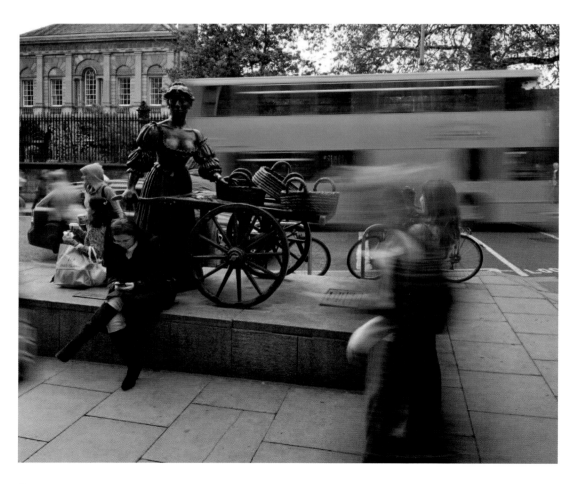

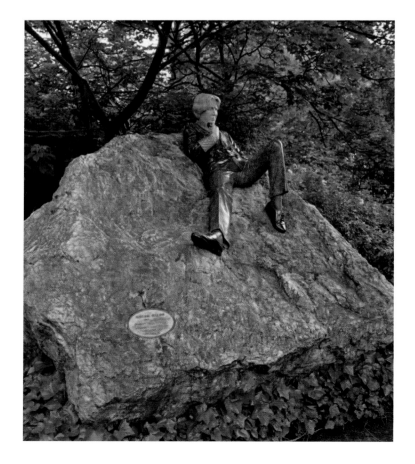

A famous Irish trade unionist and socialist, James Larkin was born in 1876 to Irish parents in Liverpool, England, where he became a full-time trade union organizer in 1905. He founded the Irish Transport and General Workers' Union in 1907 and the Irish Labour Party in 1912. Best known for his role in the 1913 Lockout—Ireland's most severe and violent industrial strike—Larkin went to the United States in 1914, where he joined the Socialist Party of America and the Industrial Workers of the World. As part of the Red Scare, he was jailed in 1920 for "criminal anarchy" and sentenced to five to ten years in Sing Sing Prison. In 1923, Al Smith, Governor of New York, pardoned Larkin, who returned to Dublin and unsuccessfully stood for election in 1932.

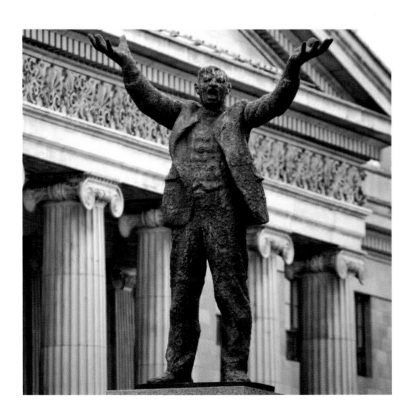

Facing Liberty Hall (the headquarters of Ireland's largest trade union), this statue commemorates James Connolly (1868–1916). Born in an Irish slum in Edinburgh, Scotland, he became secretary of the Scottish Socialist Federation after several years in the British army. Connolly moved to Ireland as secretary of the Dublin Socialist Club, which soon became the Irish Socialist Republican Party. In response to police brutality against strikers during the infamous 1913 Lockout, Connolly cofounded the Irish Citizen Army. He was also involved with the Industrial Workers of the World and shared the organization's opposition to World War I. Connolly served as Commandant of the Dublin Brigade during the 1916 Easter Rising, and after he surrendered, he was tried and found guilty. Unable to stand due to his injuries, he was tied to a chair and executed by firing squad. A statue of Connolly also stands in Union Park, Chicago.

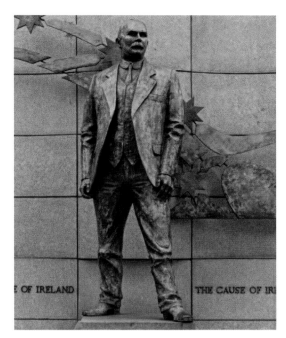

At the junction of O'Connell Street and North Earl Street stands a statue of James Joyce (1882–1941), a Dubliner considered to be among the most important authors of the twentieth century. Joyce is best known for Dubliners (1914), A Portrait of the Artist as a Young Man (1916), Ulysses (1922), and Finnegans Wake (1939).

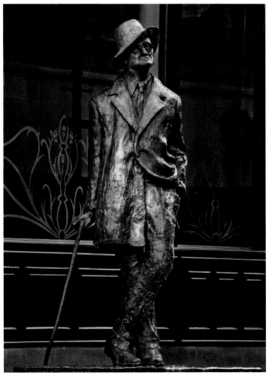

Situated at the midpoint of O'Connell Street, the General Post Office (GPO) is one of Ireland's most famous buildings. The last of the great Georgian public buildings erected in Dublin, it is constructed almost entirely of granite. Three statues designed by John Smyth adorn the pediment's acroteria: Mercury (left) with his caduceus and purse; Fidelity (right) with a key in her hand; and Hibernia (middle) resting her spear and holding a harp. The GPO opened for business on January 6, 1818, as the Irish postal service headquarters and the city's primary post office. Irish rebels seized the building as their headquarters during the 1916 Easter Rising, and the external pillars still bear the bullet marks that resulted from the street fighting and bombardment.

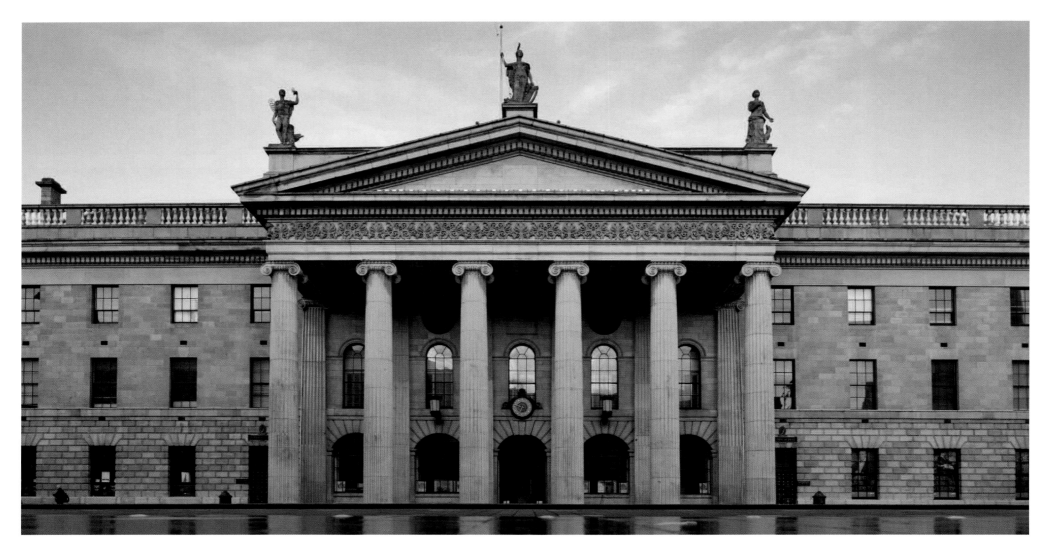

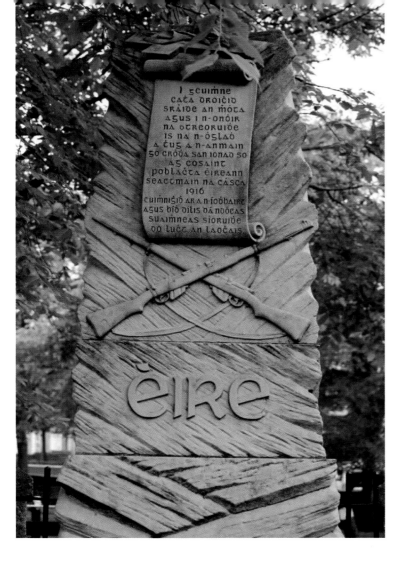

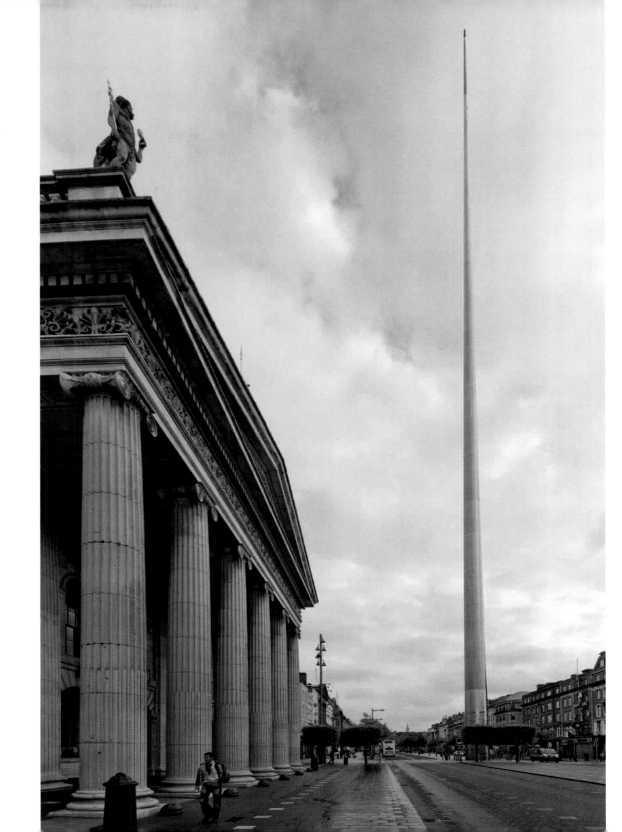

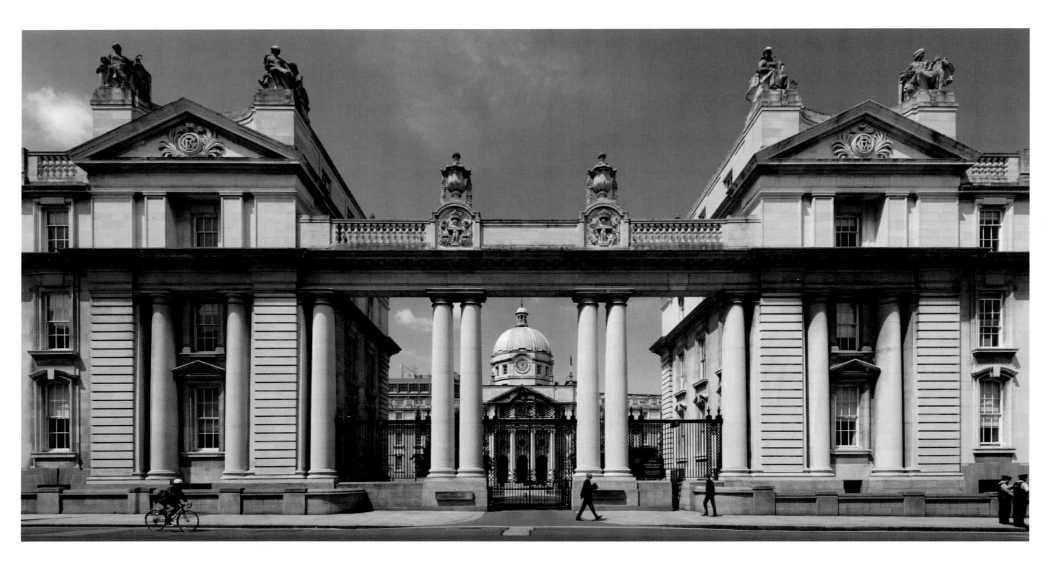

Left: The large Edwardian building called Government Buildings, enclosing a quadrangle on Merrion Street, houses key offices of the Irish government, including the Department of An Taoiseach (the Premiere), the Council Chamber, the Office of the Attorney General, the Department of Finance, and the Department of Public Expenditure and Reform. It was the last major public building built under British rule and was designed by Sir Aston Webb (who later redesigned Buckingham Palace's facade). King Edward VII laid its foundation stone in 1904, and King George V opened the building in 1911.

Right: Plaque on Moore Street marking the final surrender of the 1916 rebels

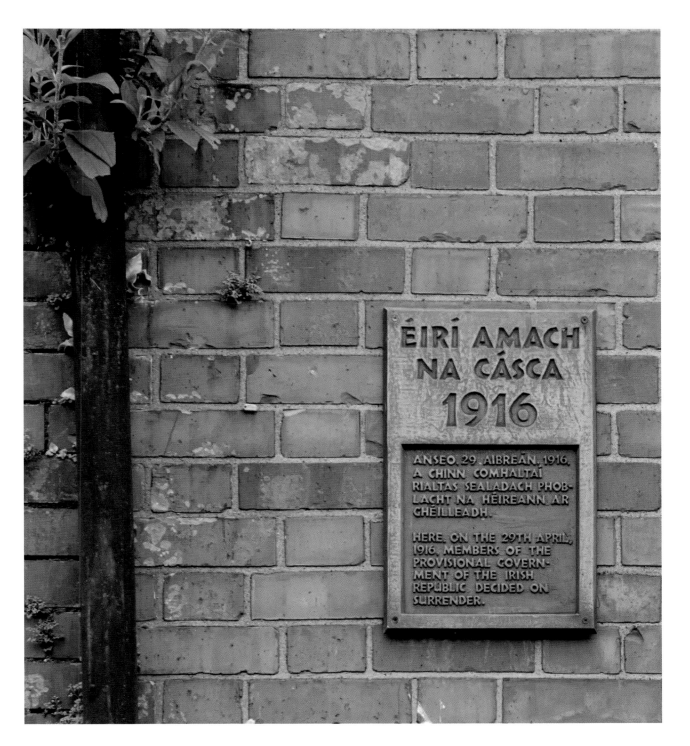

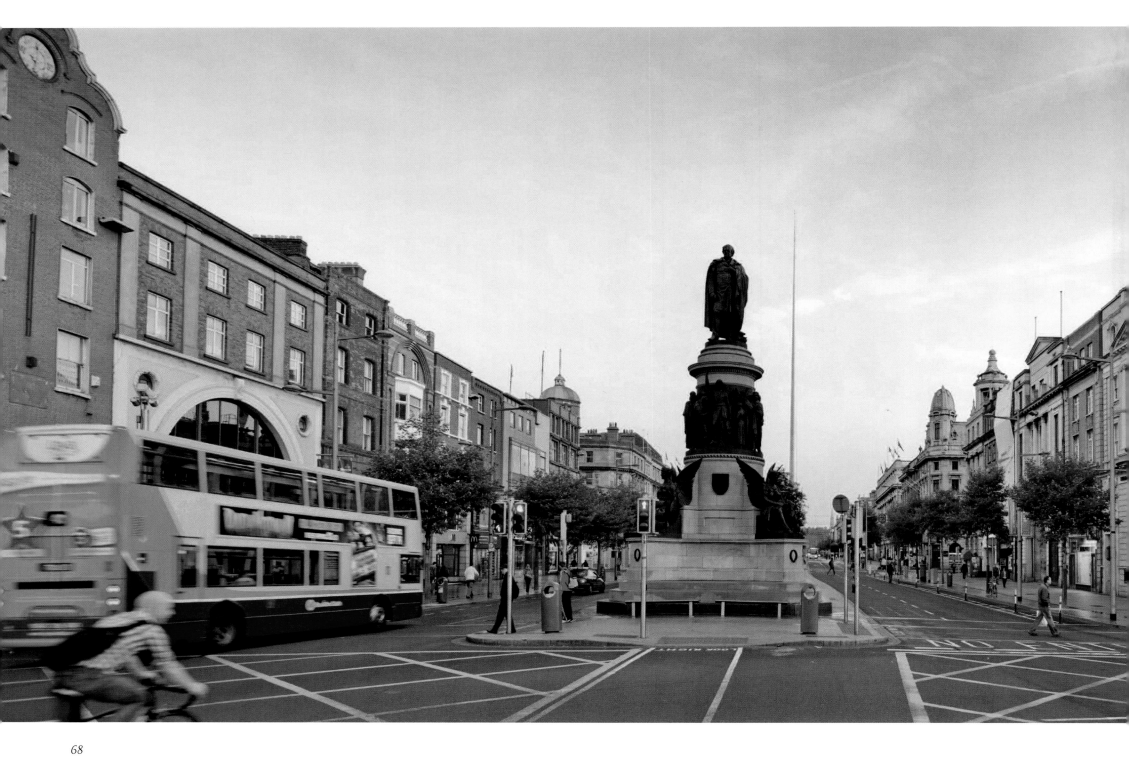

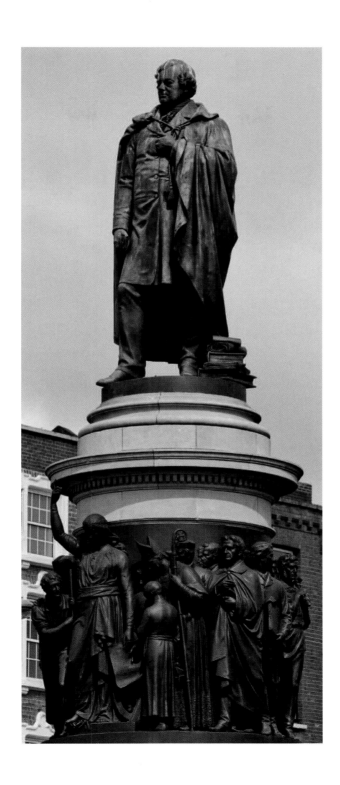

O'Connell Street/Sráid Uí Chonaill (formerly Sackville Street) is Dublin's main thoroughfare. In 1924, the street was renamed by the Irish Free State in honor of Daniel O'Connell (1775–1847), the Kerry man responsible for Catholic Emancipation in Ireland whose statue stands nearby. Many of Ireland's most turbulent dramas have occurred on O'Connell Street: the 1913 Dublin Lockout; the 1916 Easter Rising; the Civil War Battle of Dublin in 1922; the destruction of Nelson's Pillar in 1966; and many public celebrations, protests, riots, and demonstrations through the years. The extensive destruction caused by the 1916 Easter Rising impacted O'Connell Street severely, and Upper O'Connell Street was destroyed again during the Civil War Battle of Dublin. State funeral corteges often pass the General Post Office (GPO) en route to Glasnevin Cemetery, and O'Connell Street is the main route of the annual Saint Patrick's Day Parade.

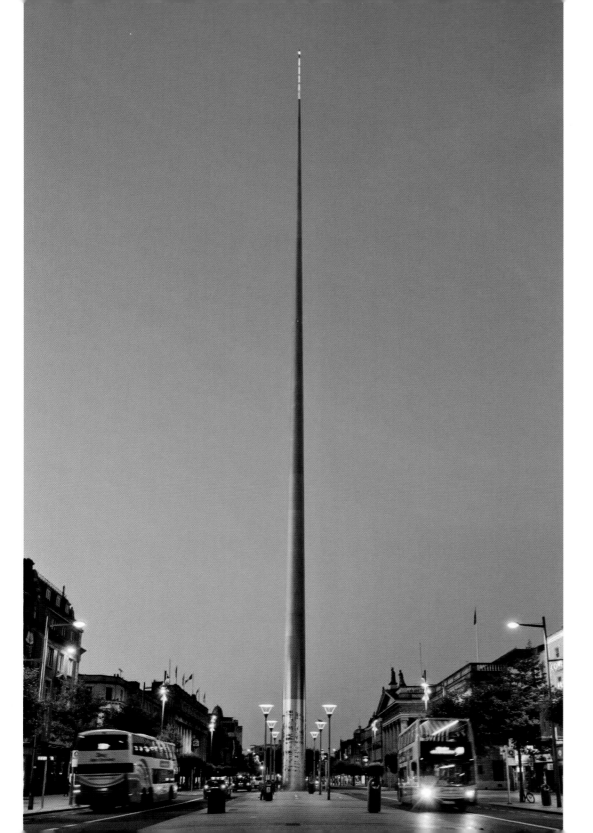

Officially titled the Monument of Light and designed by Ian Ritchie Architects, the Spire was installed in six sections between December 18, 2002, and January 21, 2003. A large, stainless steel, pin-like monument measuring 121.2 meters high, the Spire is situated on the O'Connell Street location where Nelson's Pillar stood before the IRA destroyed it with explosives in 1966.

Left: Dublin Bus/Bus Éireann is the main transport provider in the greater Dublin area. At peak times, it carries 70 percent of all public transport users into the city. The company's fleet of 1,031 buses serves 500,000 passengers a day on average and 150 million passengers a year. An Lár ("the center") is the designation for the city center.

Right: Luas ("speed" in Irish), which commenced operations in 2004, is a light-rail system serving the city of Dublin. The Luas system is not the first light-rail/tram system to operate in the city. The first Dublin tramways system began service in 1872, and at its height was heavily used, profitable, and technologically advanced—by 1901 it had near-complete electrification. In 1913, the Dublin tram system was central to the infamous Dublin Lockout, a violent and vicious strike initiated when Irish Transport and General Workers' Union members walked off over William Martin Murphy's refusal to allow workers to unionize. Dublin trams ceased to operate on July 9, 1949.

Grafton Street, named for Henry FitzRoy, first Duke of Grafton and Charles II's illegitimate son, runs from Saint Stephen's Green to College Green. It was transformed from a country lane by the Dawson family in 1708, and the construction of the Carlisle Bridge (now O'Connell Bridge) in the 1790s made it highly fashionable. Along with Henry Street, it is the city's principal shopping street. Pedestrianized since the 1980s, it is now famous for street performers as well as high-end retail outlets.

Pages 76 & 77: Poolbeg Lighthouse, Dublin Bay, with Bailey Lighthouse and Howth Head in the distance

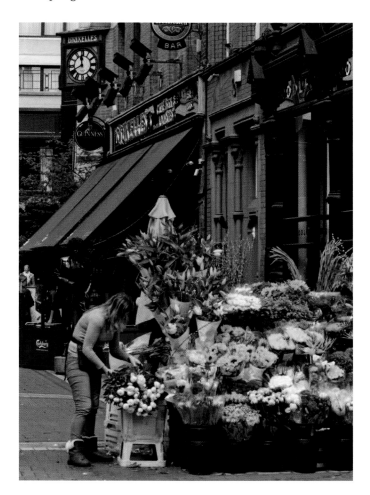

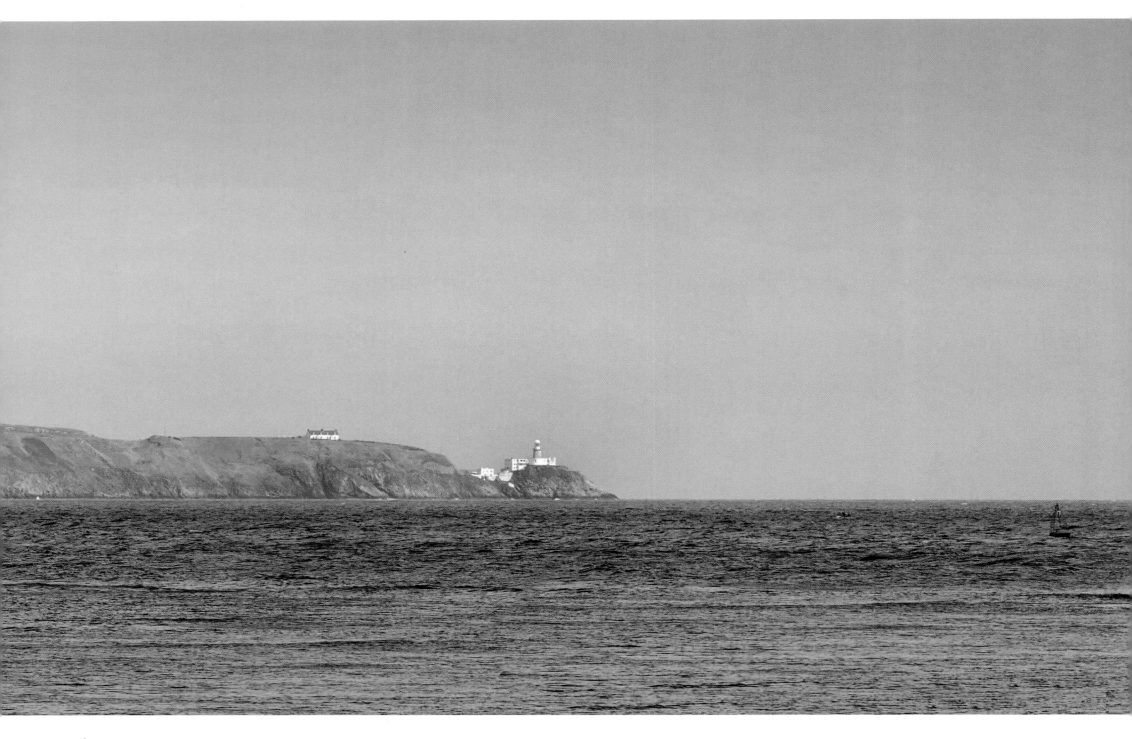

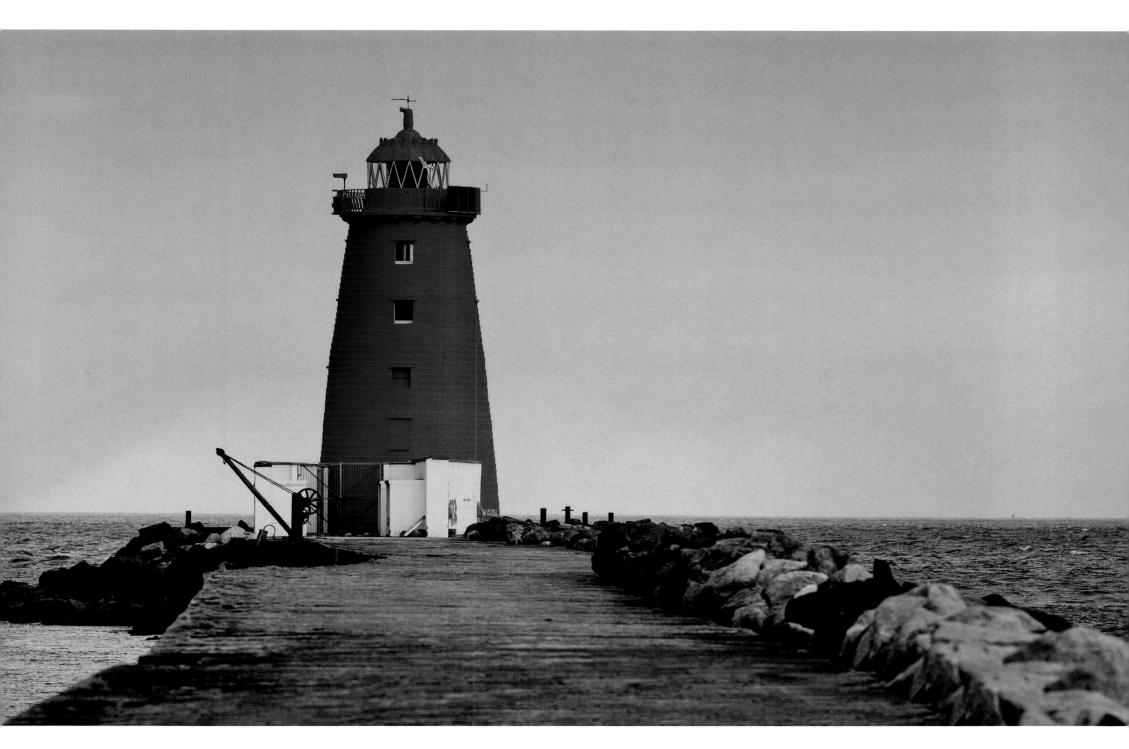

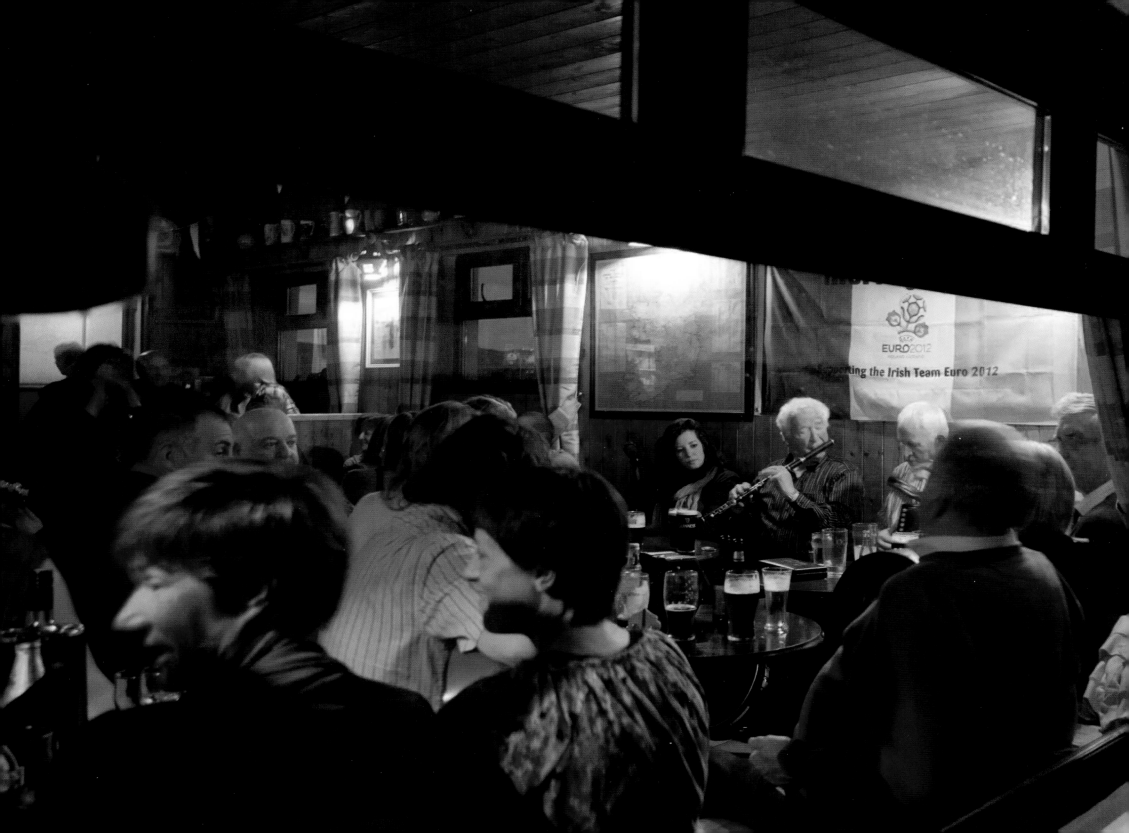

Beyond Dublin, and west of the Shannon, lies Connaught and the west of Ireland: a different Ireland, an Ireland of cliffs, islands, and hill walks, spectacular golf courses, Irish-speaking heartlands, and stunning coastlines. Home to dramatic sea cliffs, tiny harbors, and lush countryside, it forms a backdrop not only for the desolate beauty of deserted famine villages, desecrated abbeys, and ruined Norman tower houses, but also for vibrant villages and bustling towns with exquisite churches, grottos, pubs, and restaurants that support golf courses, hotels, museums, and state parks.

Pages 80 & 81: County Galway coastline

Page 82: Cromwell's Barracks/Don Bosco's fort, Inishbofin Island/Inis Bó Finne (Island of the White Cow) off Galway's coast

Page 83: Inishark Island

Page 84: A mountain sheep

Page 85: Connemara National Park

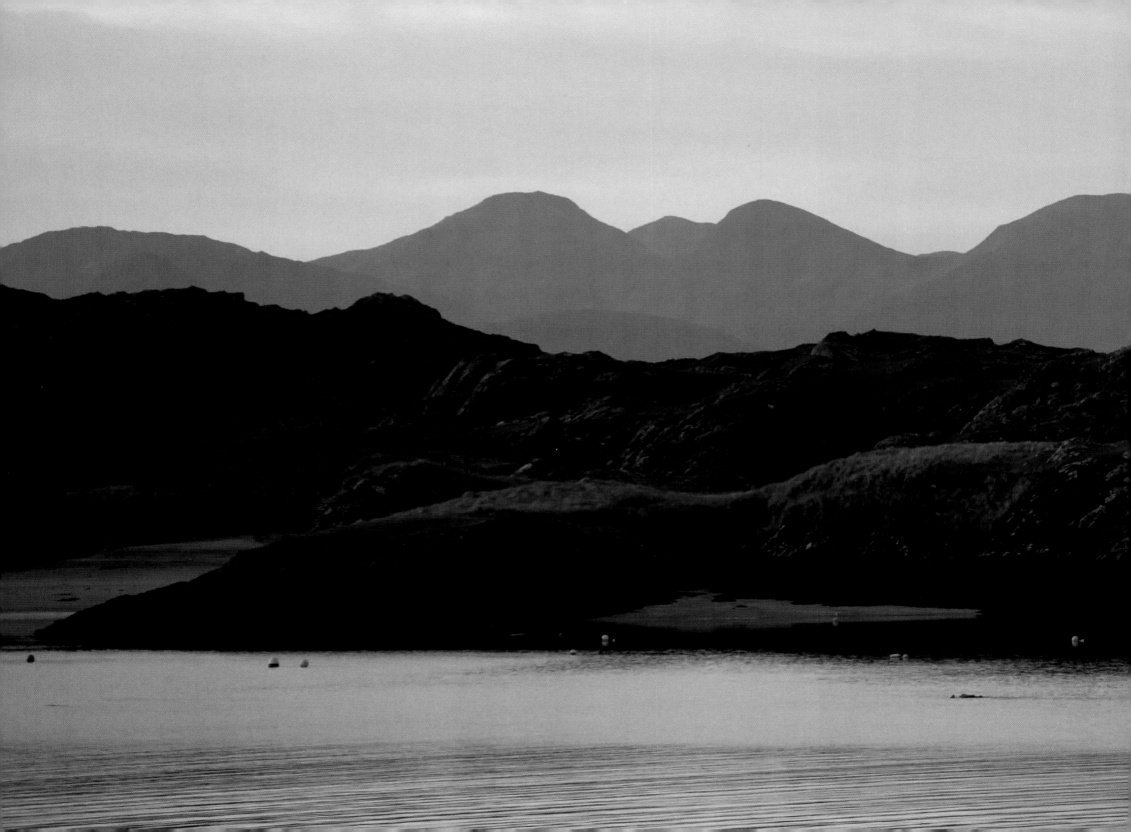

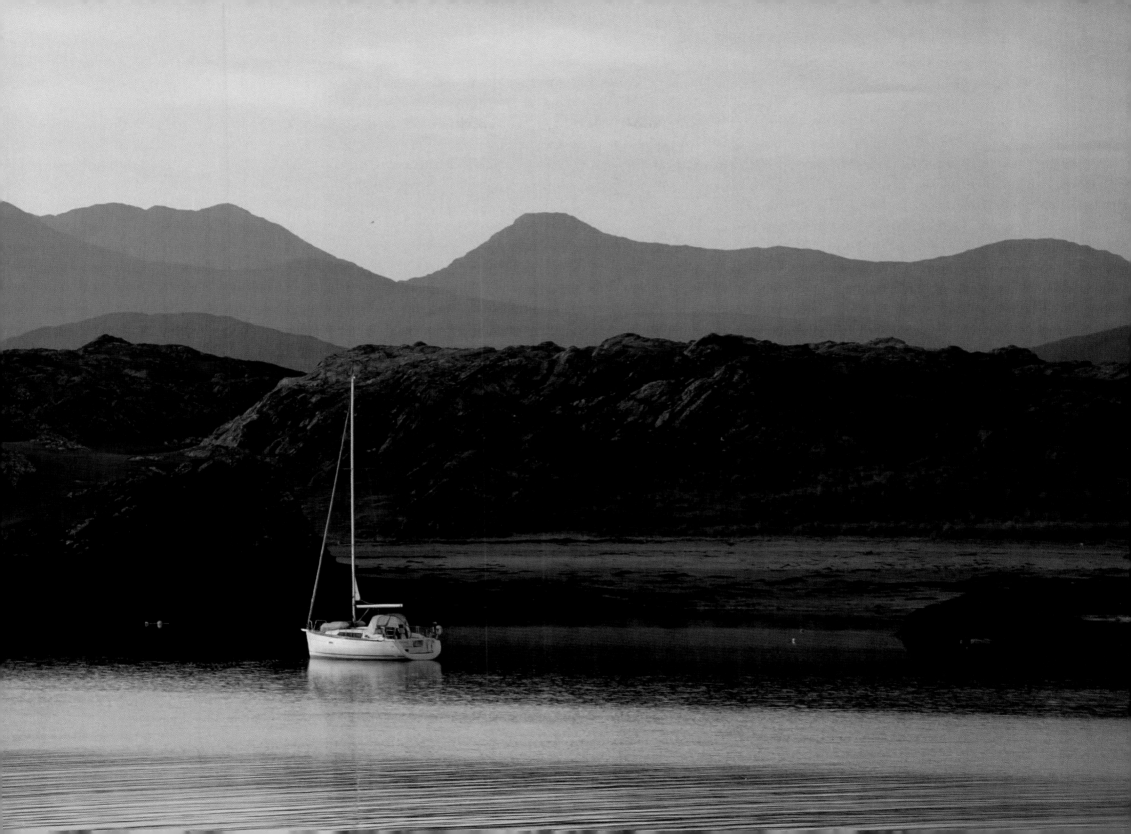

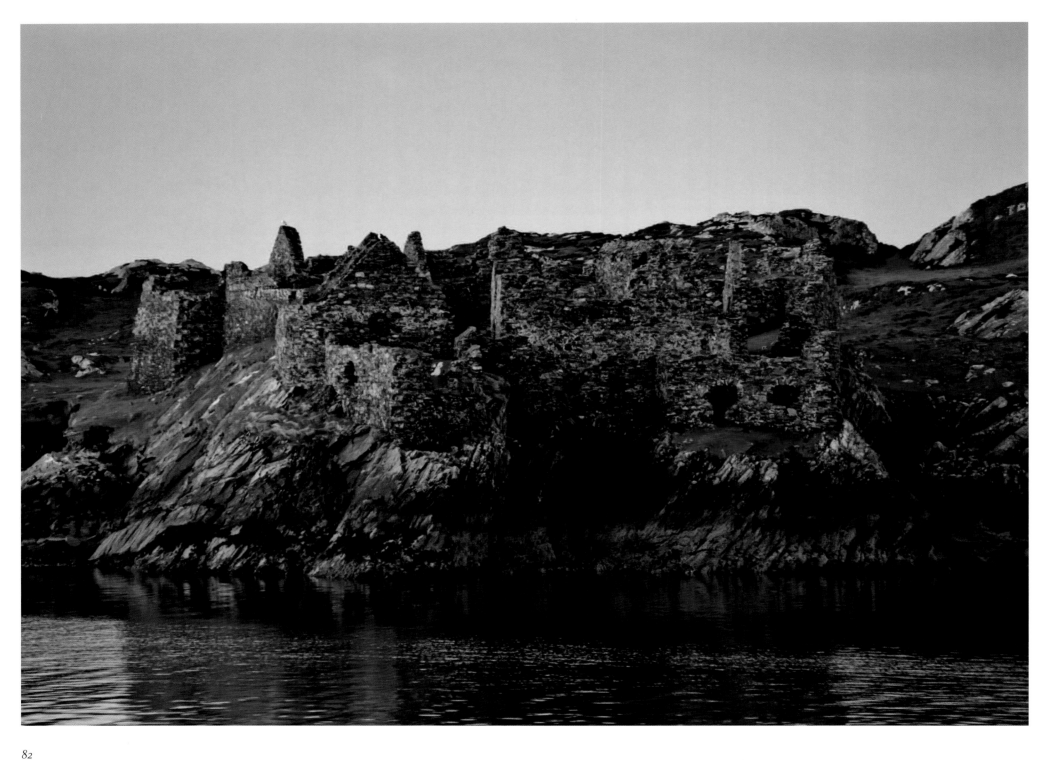

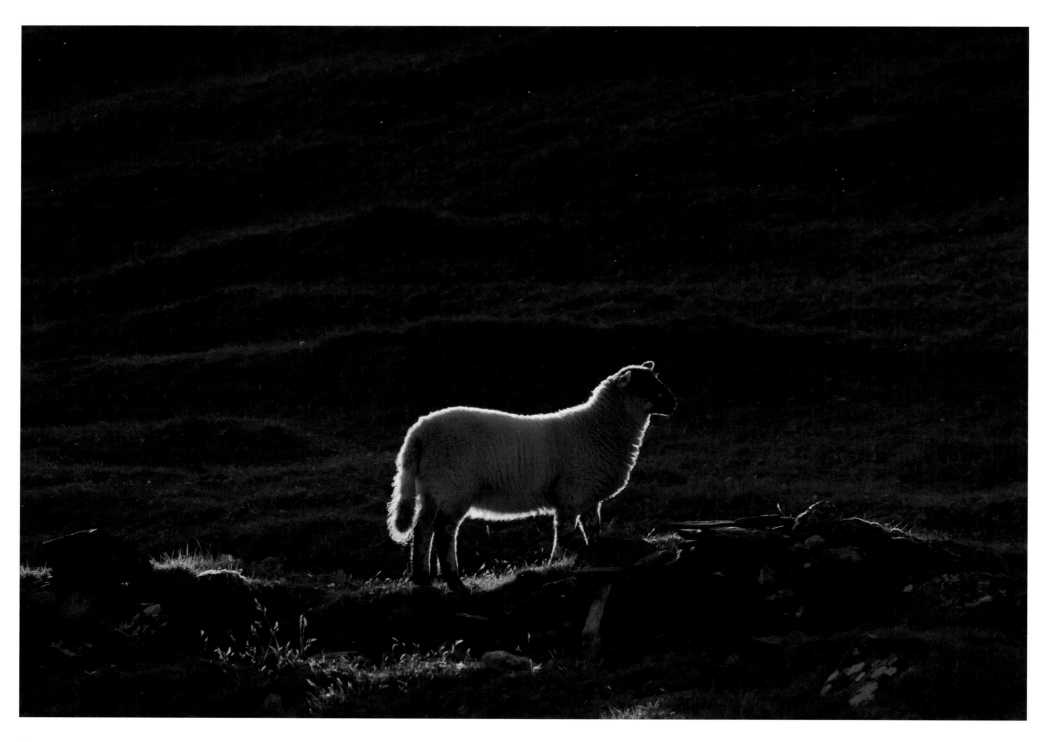

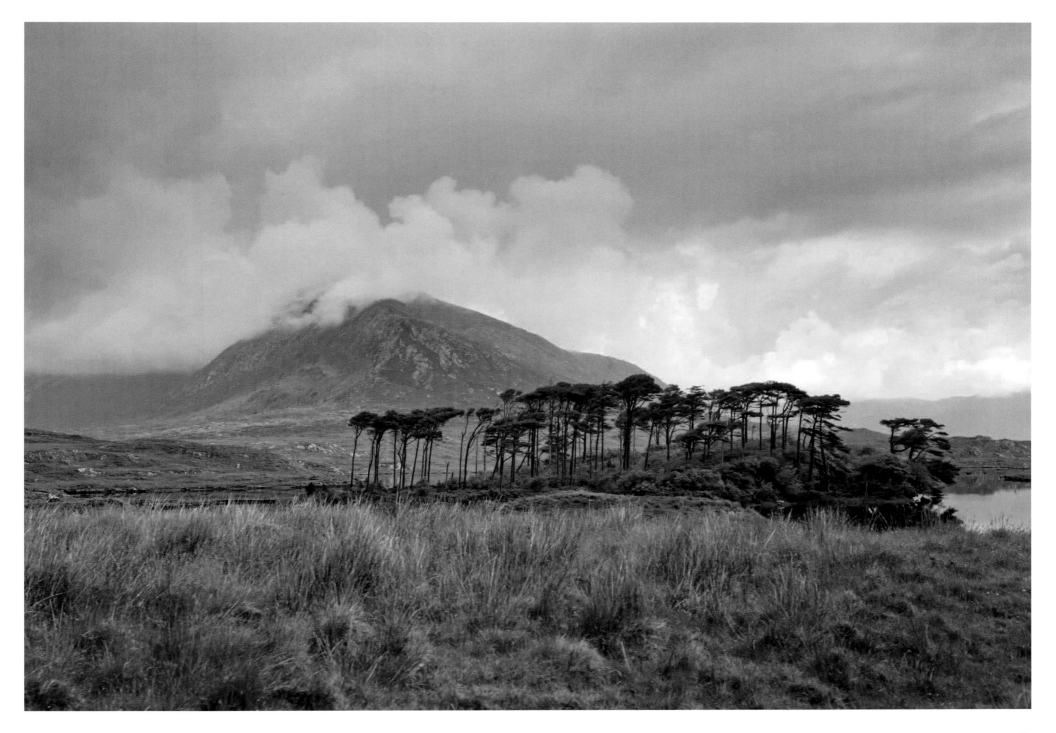

Page 86: A rural grotto for the Virgin Mary

Page 87: Grotto, Saint Mary's Church,
The Claddagh, Galway city

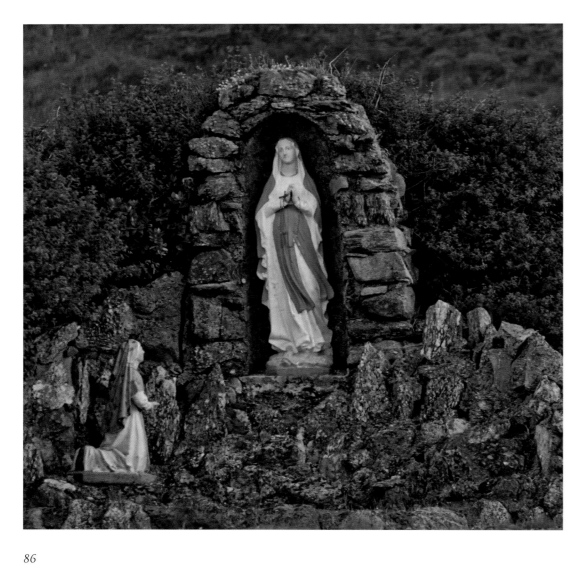

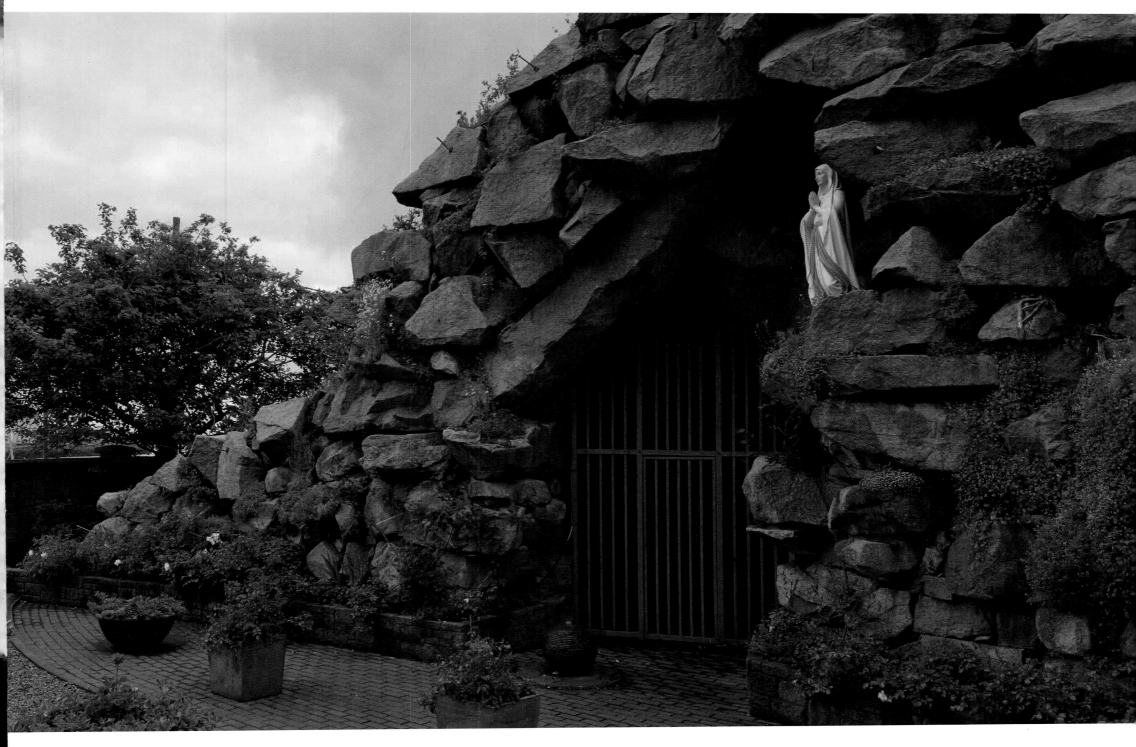

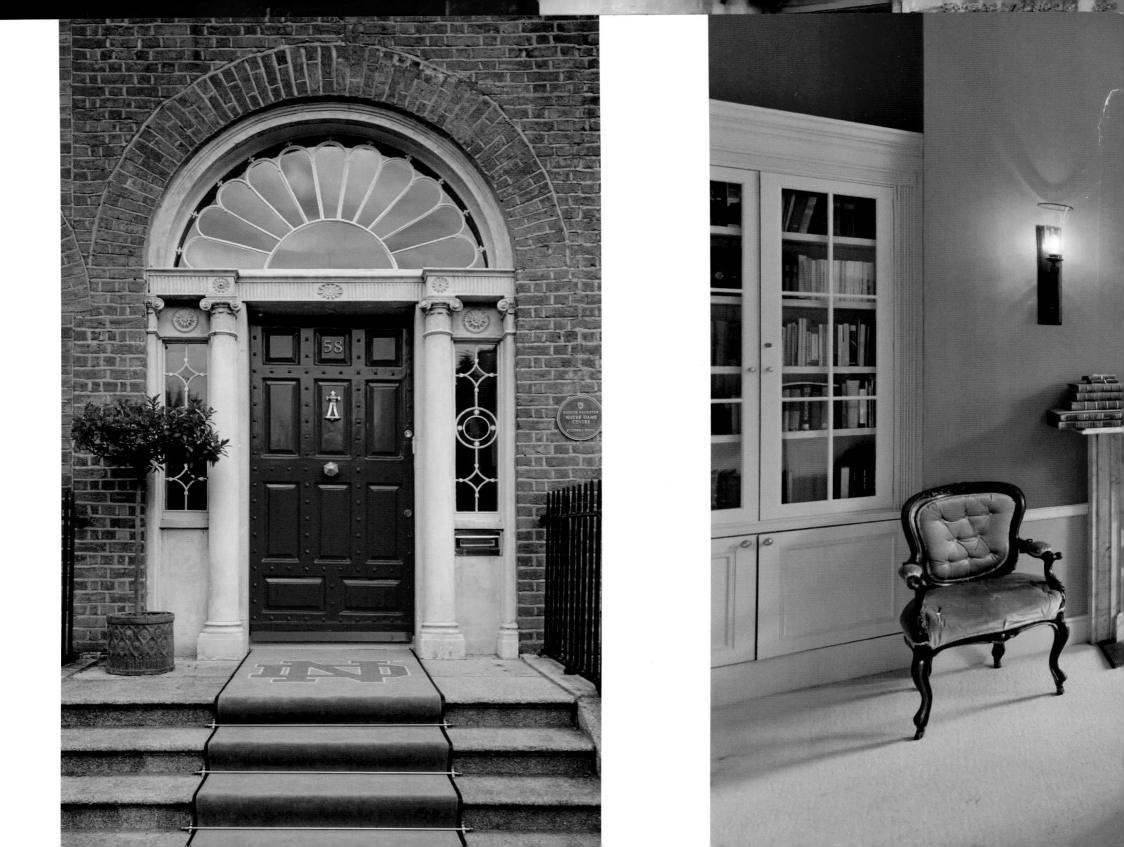

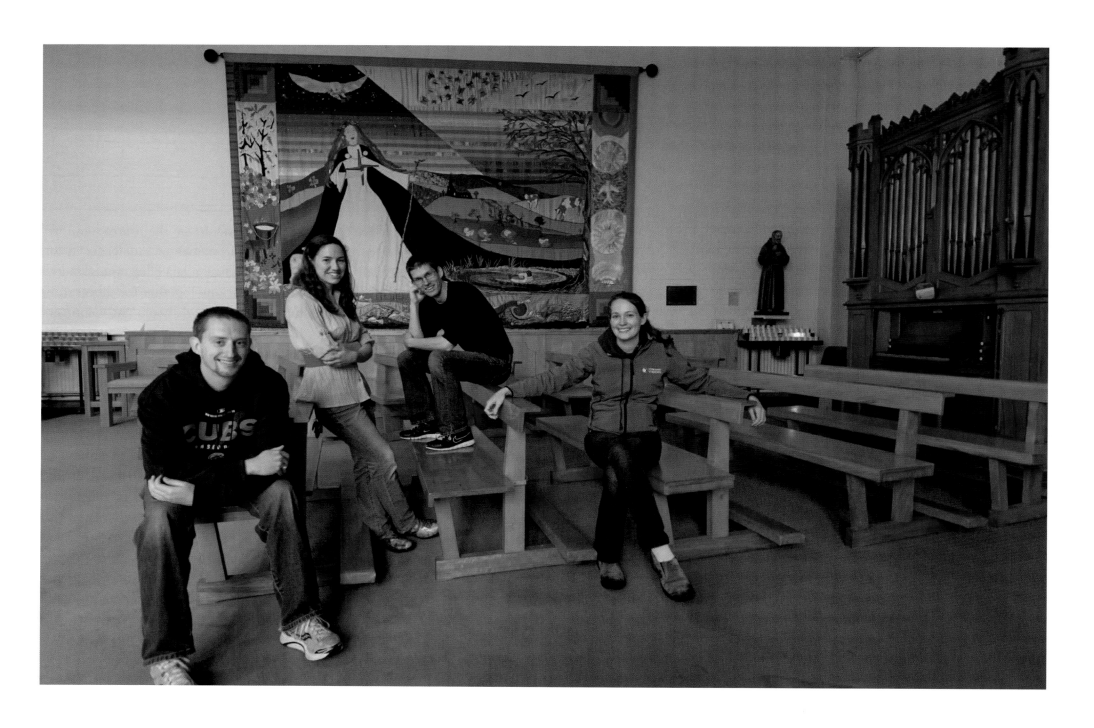

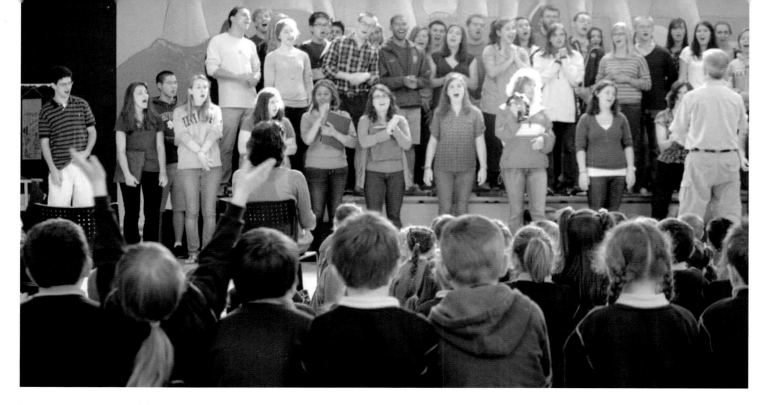

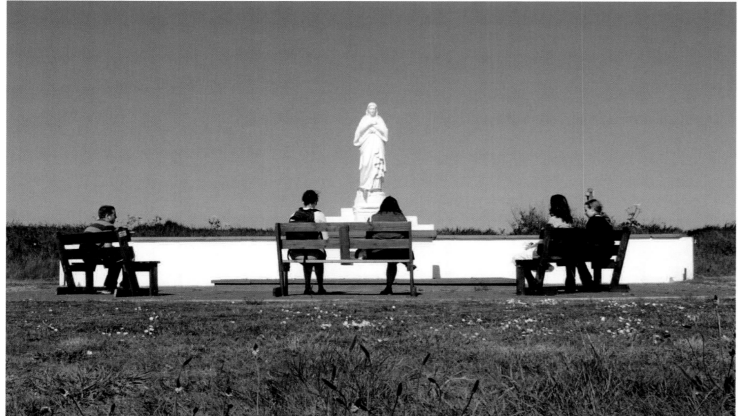

Opposite: Teach Bhríde volunteers in County Wexford with a tapestry of Saint Brigid

Above: The Notre Dame Folk Choir performs at Scoil Mhuire, Coolcotts, County Wexford. This elementary school is connected to the choir through the work of Teach Bhríde.

Below: Our Lady's Island in County Wexford is one of many pre-Christian sacred sites that have been transformed into Christian places of prayer. Members of the Notre Dame Folk Choir make pilgrimages here: walking around the island, reciting the rosary, and praying before a statue of the Virgin Mary.

The IRISH Seminar

The IRISH Seminar is a world-class post-graduate program in Irish Studies that has been presented annually since 1999 by the Notre Dame Irish Studies program at the Keough-Naughton Notre Dame Centre. Typically admitting thirty students each year, the seminar provides an intellectual infrastructure for scholarly collaboration, balancing the theoretically rich with the empirically rigorous.

The seminar draws outstanding faculty and students from all over the world. Past students have come from Berkeley, Princeton, Yale, NYU, Chicago, Dartmouth, Oxford, Cambridge, and the Sorbonne, as well as from countries as diverse as Albania, Brazil, the United States, Ireland, Scotland, Hungary, Israel, France, Italy, New Zealand, the Czech Republic, Canada, and England. The Madden-Rooney Public Lectures associated with the seminar have attracted representatives from over one hundred different universities. Speakers at the seminar have included two Nobel laureates (Seamus Heaney and Derek Walcott); Irish authors John McGahern, Paul Muldoon, Tom Kilroy, and Edna O'Brien; internationally renowned critics Edward Said, Benedict Anderson, Homi Bhabha, Fred Jameson, Perry Anderson, and Tom Paulin; actor Stephen Rea; and artist Bobby Ballagh.

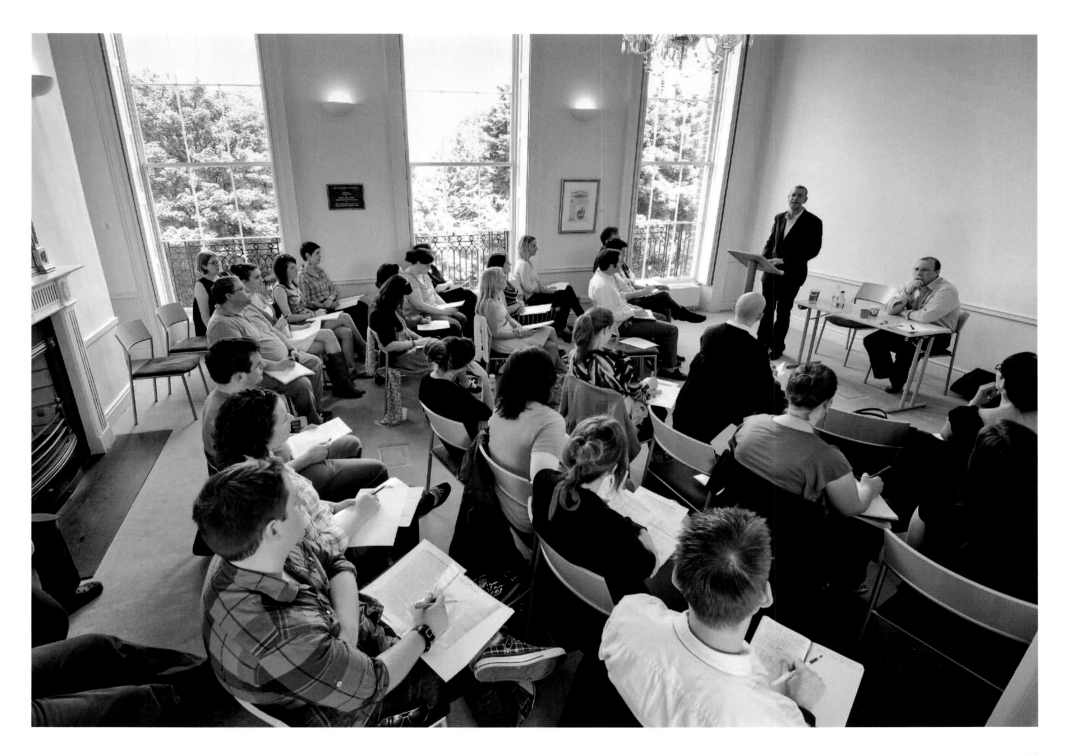

Keough Internships

Keough internships give six to eight Notre Dame rising seniors the opportunity to work in Dublin for a seven-week period during the summer in positions relating to politics, commerce, culture, and society. Recent interns have worked with a variety of organizations, including the Department of Justice, the National Gallery of Ireland, the Abbey Theatre (Ireland's national theatre), Dáil Éireann (Irish Parliament), the head office of Fine Gael (a political party), the Irish Museum of Modern Art, the Irish Film Institute, the Irish Department of Foreign Affairs, the Irish Olympic Council, Foras na Gaeilge (national Irish language promotions authority), Poetry Ireland (nongovernmental organization promoting poetry), Four Courts Press (publisher), An Bord Bia (the food authority), the Environmental Protection Agency, and several social service organizations.

Right: Keough interns on the Ha'penny Bridge, Dublin

Page 102: The 1916 Easter Rising conference held by the Keough-Naughton Institute for Irish Studies at the Royal Irish Academy, Dawson Street

Page 103: "Ireland in Transition: Contemporary Challenges and Opportunities," Examination Hall, Trinity College, Dublin

Page 104: Fr. John I. Jenkins celebrates a private mass in the Merrion Hotel with members of the Irish Council, Notre Dame administrators, and Irish Studies faculty.

Page 105: The Keough-Naughton Advisory Board at Farmleigh House (former residence of the Guinness family), Phoenix Park, Dublin

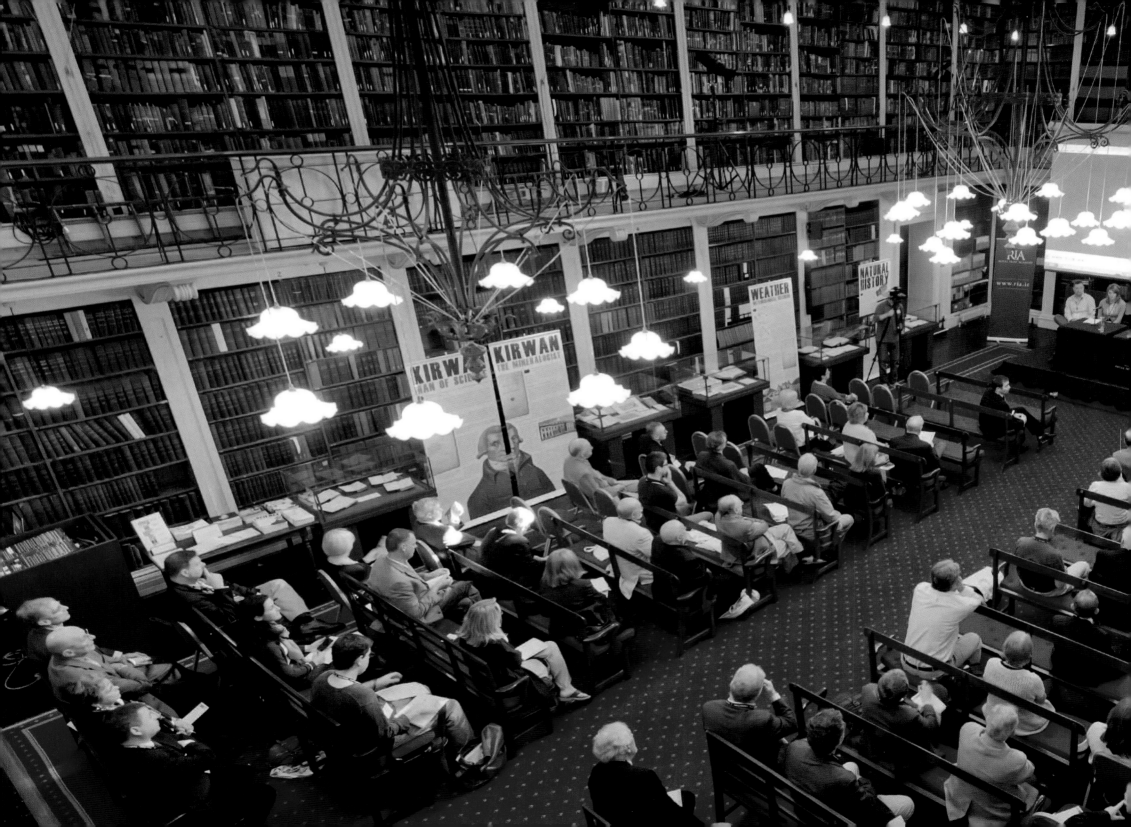

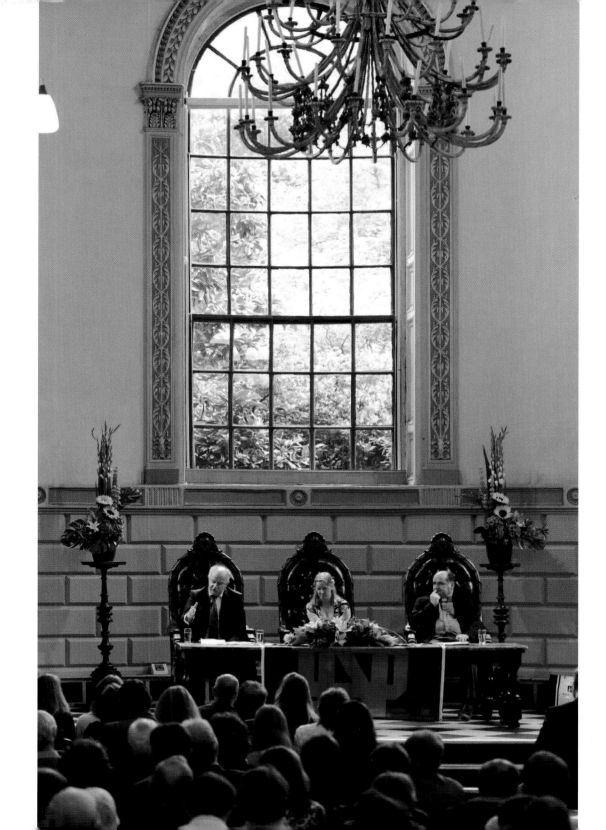

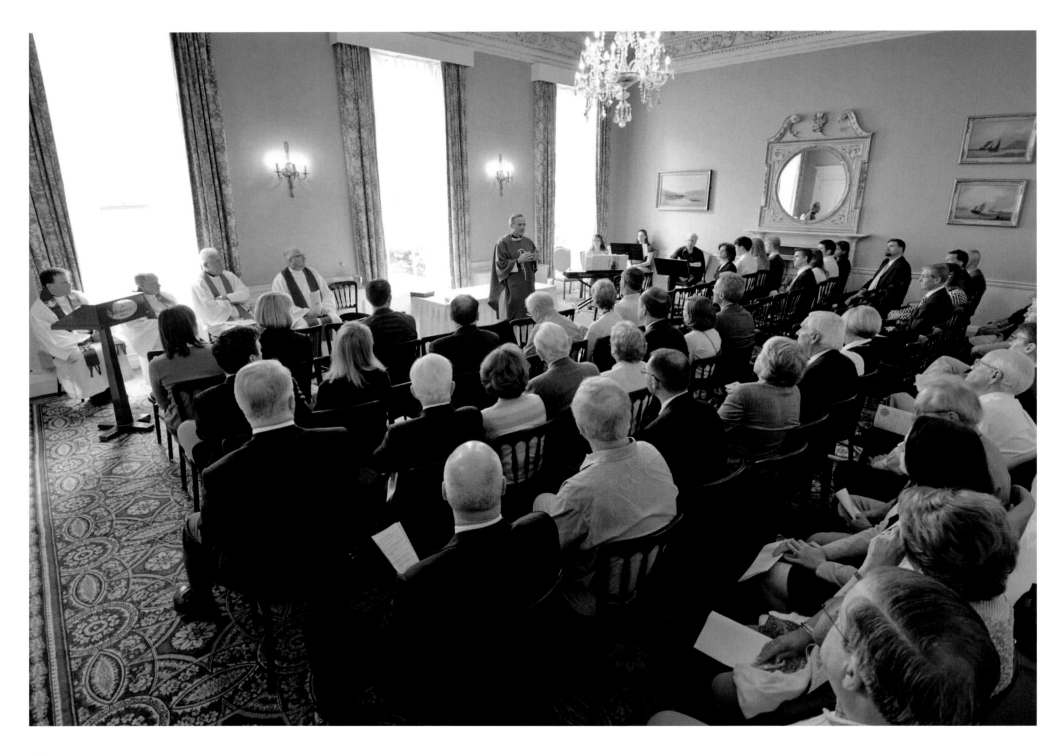

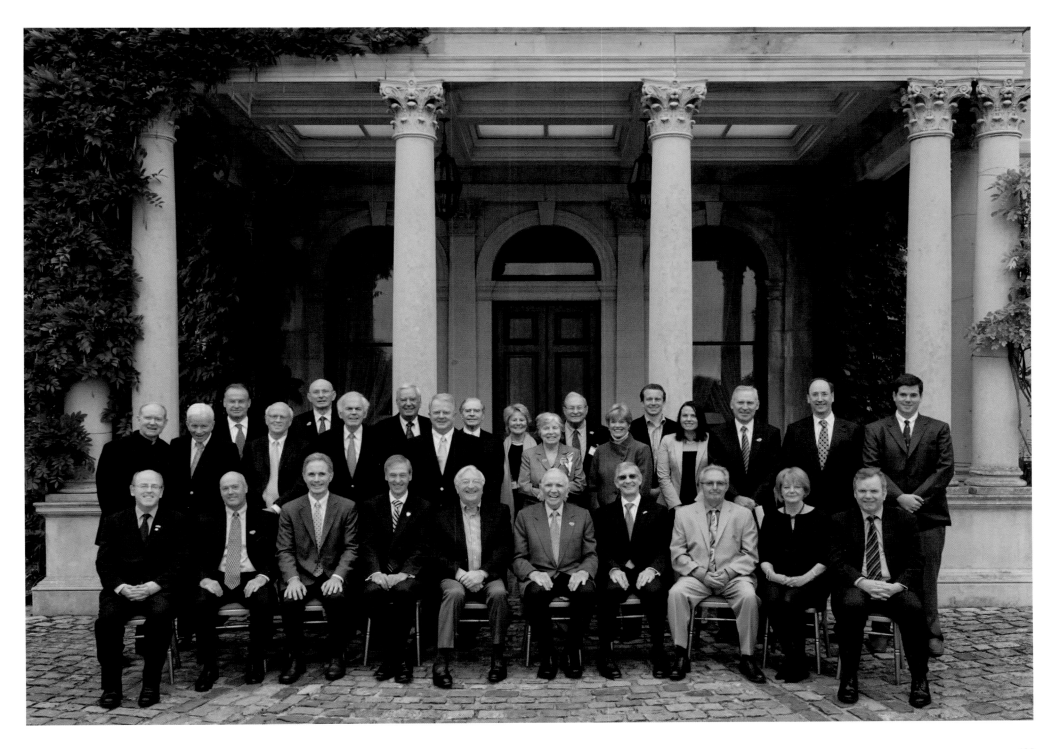

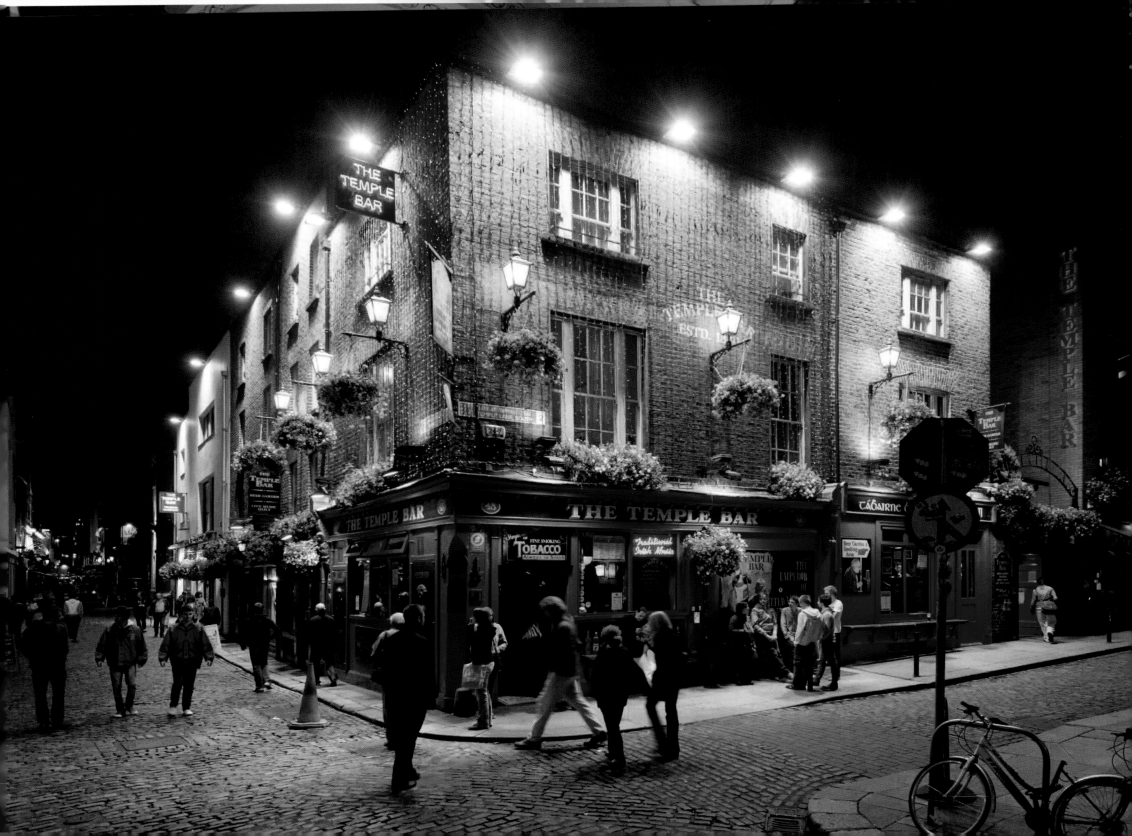

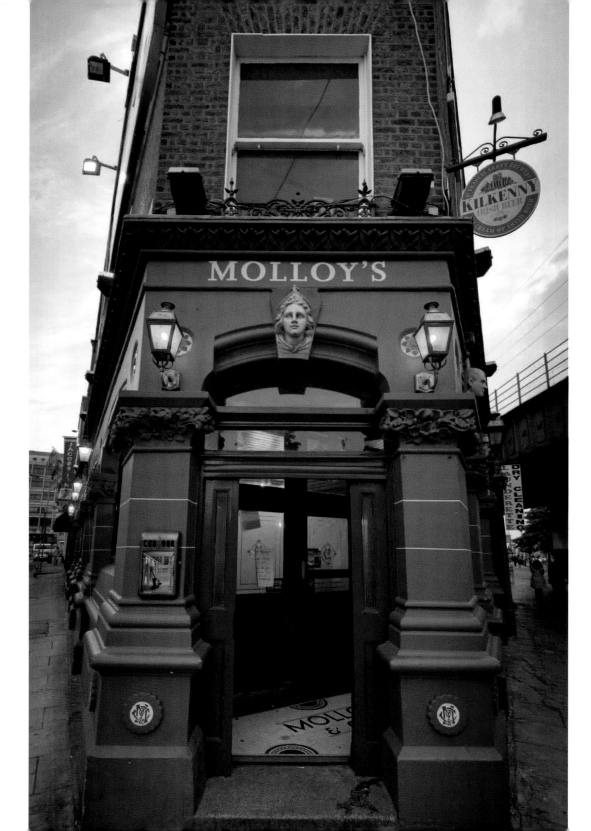

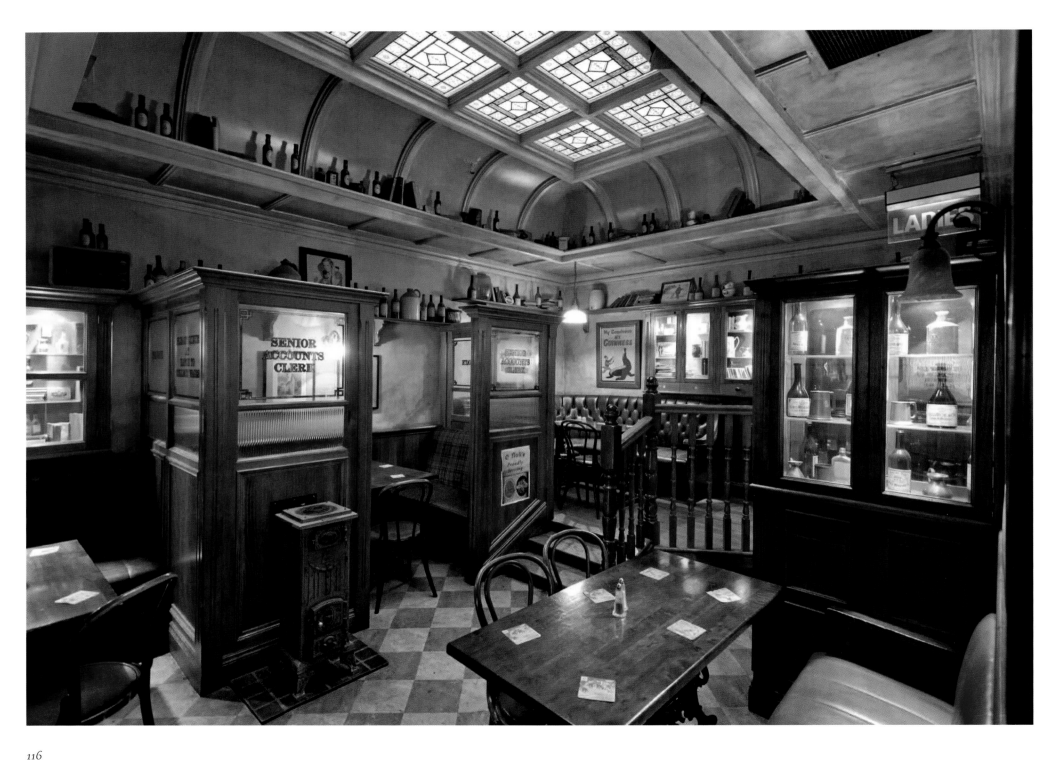

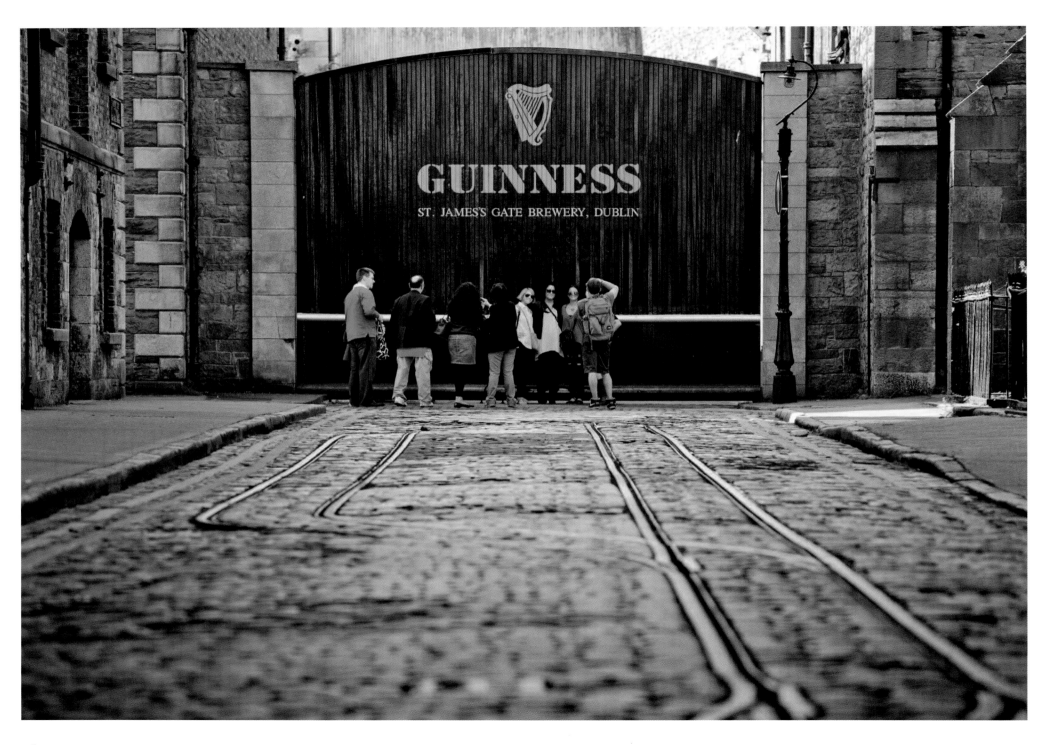

Arthur Guinness established his brewery in 1759 by signing a nine-thousand-year lease at Saint James's Gate for a cost of £45 per annum. The Guinness Storehouse at Saint James's Gate was built in 1904. It was the first multi-story steel-framed building to be constructed in Britain or Ireland. The building was used continuously as the brewery's fermentation plant until 1988, when a new state-of-the-art fermentation plant was built. The Storehouse opened to the public on December 2, 2000.

Guinness is now brewed in almost sixty countries and is available in over one hundred countries. A distinctive feature of the beer is the burnt flavor, which is derived from roasted unmalted barley. The famous thick, creamy head results from combining beer with nitrogen as it is poured.

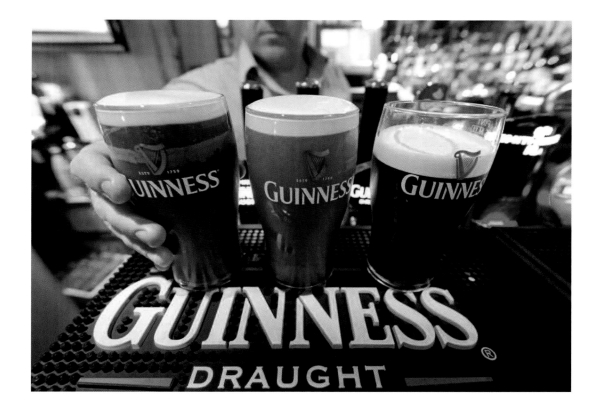

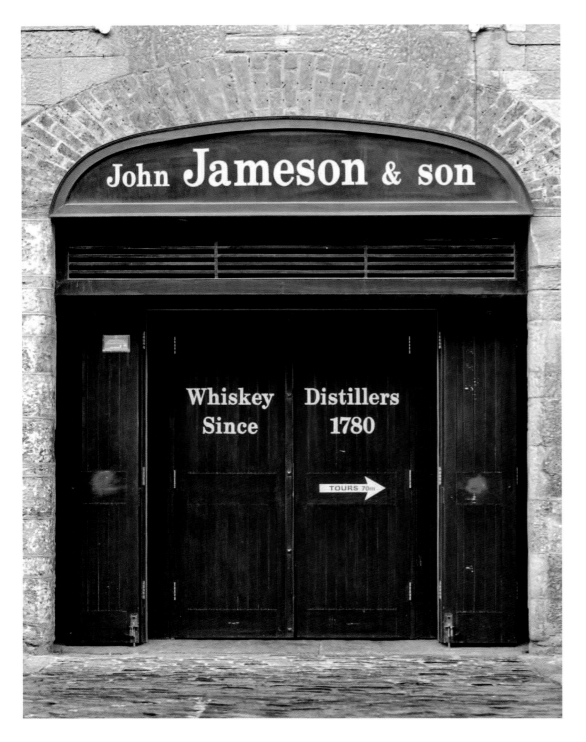

Established in 1780, Jameson is an Irish whiskey, triple distilled for optimum smoothness. Jameson sells 31 million bottles per year globally, making it the best-selling Irish whiskey on the market.

In 1791 James Power established the John's Lane Distillery at Thomas Street, Dublin. In 1886, Powers became one of the first distilleries to bottle its own whiskey rather than sell it by the cask. The distinctive gold label that adorned Powers bottled at John's Lane led to the famous name, Powers Gold Label. In 1966 Powers joined with the Cork Distilleries Company and John Jameson & Son to form the Irish Distillers group.

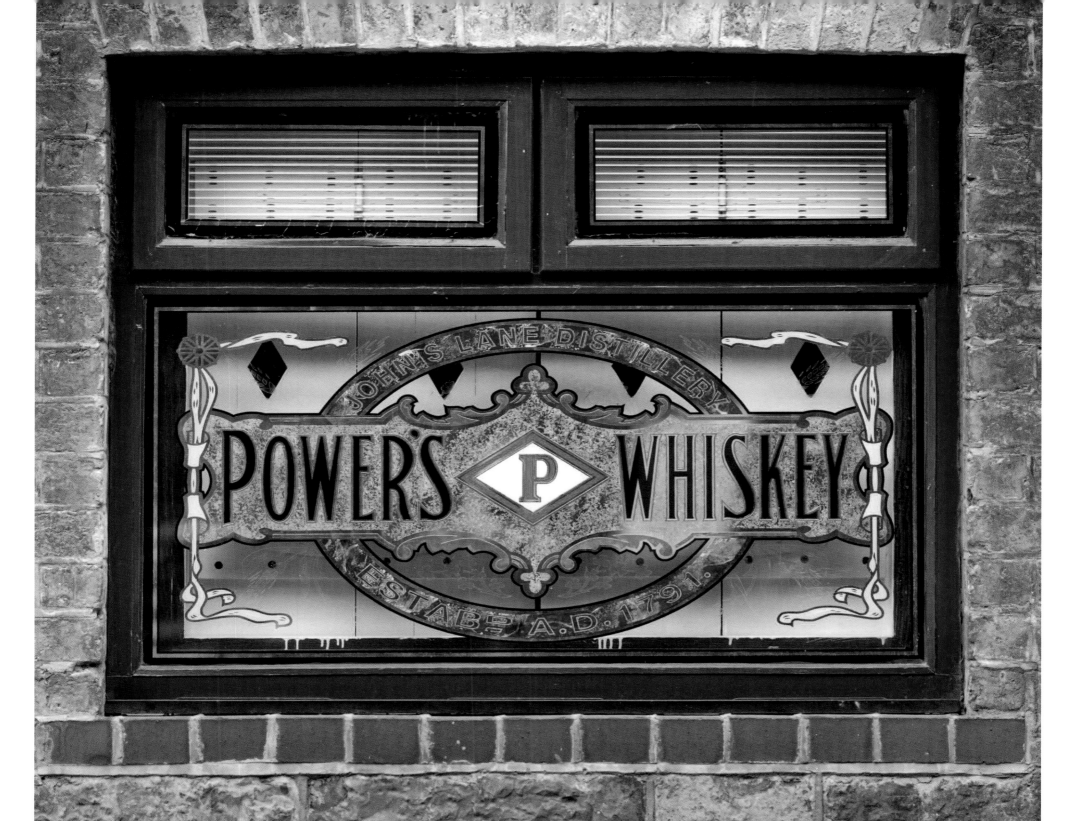

"One & One, please." Folklore contends that fish-and-chips originated in Dublin with Giuseppe Cervi, an Italian immigrant who came to Ireland and began selling fish-and-chips from a handcart outside pubs before opening a store on Pearse Street. In contrast to Britain where such restaurants are referred to as chippies, in Ireland they are known as chippers.

Cooking their fish-and-chips in animal fat and serving them in sheets of paper, Burdocks has been a constant in Dublin since 1913, feeding generations of Dubliners through the 1916 Easter Rising, the War of Independence, the Civil War, and two World Wars, though shortages during World War II caused them to close temporarily. The original Burdocks is located at 2 Werburgh Street beside Christ Church Cathedral.

Right: George Walsh holding Burdock's fish-and-chips

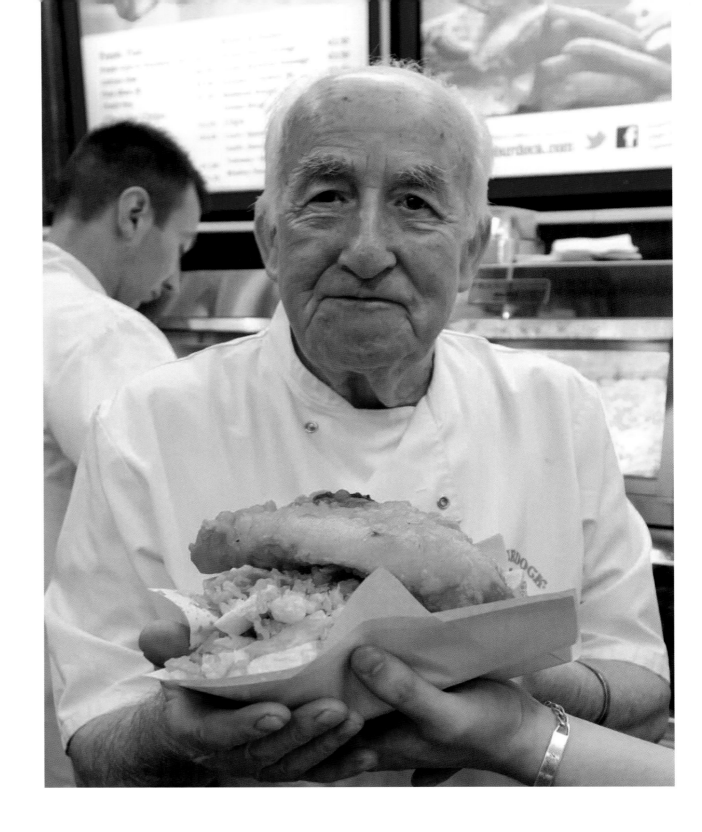

Ivan Beshoff allegedly served as a sailor aboard the famous Russian battleship Potemkin, *whose crew mutinied against its officers in 1905 during the Russian Revolution. When the ship and its crew eventually reached Constanta, the majority of the mutineers remained there in Romania. Some, however, travelled further afield, including Ivan Beshoff who arrived in Ireland in 1913. His family restaurants, most notably on Upper O'Connell Street, have become city landmarks, famous for chips and fresh fish served with bread and butter. Ivan Beshoff, reputed to be the last surviving crew member of the* Potemkin, *died in Dublin in 1987.*

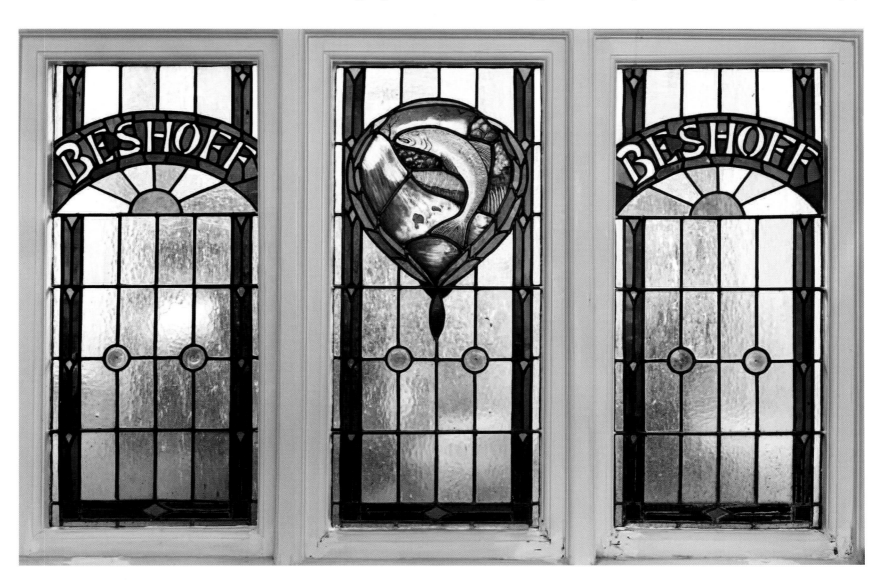

THE GAME

American Football in Ireland: A Brief History

The first recorded game of American football staged in Ireland was the Potato Bowl, played in Belfast on New Year's Day, 1944. The Galloping Gaels and the Wolverines—two teams of U.S. servicemen stationed in Northern Ireland during World War II—played to a 0–0 tie. Following Pearl Harbor and the American entry into the war, the United States had assumed responsibility for Northern Ireland, freeing more British troops to conduct military campaigns in the Middle East and Far East. By May 1942, Northern Ireland hosted some 37,000 American servicemen at bases such as Eglinton, Maydown, Mullaghmore, Derry, Toome, Maghaberry, Cluntoe, and Greencastle. This number would eventually rise to 120,000 U.S. servicemen. Six months after the Potato Bowl, Allied forces, including men who had played in or observed the Belfast game, participated in the D-Day landing in France.

Nine years later, on November 21, 1953, at the American Army final at Croke Park in Dublin in front of some 40,000 spectators, the Burtonwood Bullets (Warrington, Lancashire, England) defeated the Wethersfield Raiders with a score of 27–0. Nine U.S. Air Force transport planes airlifted the two teams and their respective entourages into Dublin (*Irish Times*, October 26, 1953, A3). Before the game began, an American band representing the Third U.S. Air Force "led a procession of teams and supporters from St. Stephen's Green to Croke Park" (*Irish Independent*, November 21, 1953, 9). Five teenage cheerleaders, "tastefully attired in white blouses, blue skirts, and red berets, whipping the bemused Irish spectators into a frenzy of apathy, . . . worked hard, if without much result," and the Third Air Force band wove "intricate patterns of marching musicians on the playing field. There was, in short, an air of carnival strongly

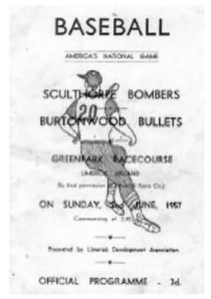
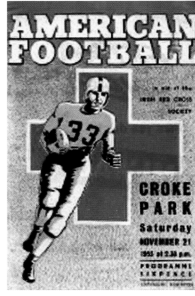

flavoured with the astringent comments which stemmed from Celtic cynicism" (*Irish Times*, November 23, 1953, 1).

According to a front-page article in the *Irish Times*, "22 men, dressed apparently as space-men, took the field to take part in what was a brilliant fund-raising effort on the part of the Irish Red Cross Society . . . [but] it would seem that American football is one aspect of the American way of life which is not going to sell itself easily to people used to the football wizardry of a Jack Kyle or the straight running for the line of a Maurice Mortell" (*Irish Times*, November 23, 1953, 1). (Kyle and Mortell were famous rugby players in Ireland.) The *Irish Independent* reported that "these tough Americans looked like a child's conception of visitors from Mars, as heavily padded and helmeted, they tore into one another with rare abandon, and it seemed as if the ball was of secondary importance and the main idea was to ground the other fellow" (November 23, 1953, 13).

The game was held as a benefit for the Irish Red Cross Society, with music provided by the Artane School Band and the Irish Army's no. 1 band, the Irish Army pipe band. Among the many dignitaries who attended were President Seán T. O'Kelly; the Papal Nuncio, the Most Rev. Dr. G. O'Hara; the American Ambassador to Ireland, William Howard Taft III, and Mrs. Taft; Mrs. Barry, chairman of the Irish Red Cross Society, and Mrs. Hackett, vice-chairman; Lord Killanin, Hon. Secretary; Mr. S. Moran, Hon. Treasurer; Mr. Derrig, Minister for Lands; Mr. Boland, Minister for Justice; Mr. Aiken, Minister for External Affairs; Mr. Traynor, Minister for Defence; Mr. Lynch, Parliamentary Secretary to the Government; Maj.-Gen. F. H. Griswold, Commander of the U.S. Third Air Force; Col. G. P. Maguire, Deputy O/C, U.S. Third Air Force; Col. L. Martin, Assistant Chief of Staff; Lieut.-Col. Edney, U.S. Air Attaché; Col. Spinks, U.S. Army Attaché; Brig.-Gen. T. Millar; and Brig.-Gen. J. C. Selsar. One of the U.S. officers, Lieut.-Col. James C. O'Connor, also

looked forward to meeting old friends such as John Joe Sheehy and Dan Ryan; O'Connor, chaplain of the Third Air Force, was a native of Tralee, County Kerry, who had emigrated from Ireland twenty-two years earlier (*Irish Independent*, November 21, 1953, 9).

Although impressed by the performance of the Texan Jim Simmons, who scored two touchdowns, locals were less taken with the constant interruptions in play, and many fans left the game before the final whistle. The *Irish Times* reported that "the game started in rocket-like fashion and the crowd, estimated at 40 odd thousand, was settling down to a hectic two hours' play. But apart from a few good runs, there was little to enthuse. There was no doubting that the Bullets were going to be a tough proposition to stop, and it was no surprise when they led by 14 points at half-time" (*Irish Times*, November 23, 1953, 9A). The highlight of the game, according to the *Irish Independent*, "was reserved for the closing minutes, when the Bullets scored a touchdown following an interception and a magnificent run by (Bon) Mace" (*Irish Independent*, November 23, 1953, 6). In addition to his stellar performance, Simmons kicked extra points after touchdowns by Harvey Keyes and Wayne Presley. The newspaper reported that "outstanding for the Bullets were Bon Mace and the scorers, (Harvey) Keyes, Presley and Simmons, while Earl Bradley and Al Cartwright were best for Wethersfield" (*Irish Independent*, November 23, 1953, 13).

Following the game, the players and dignitaries enjoyed a dinner at their hotel, the International Hotel in Bray. At the dinner, Maj.-Gen. Griswold, Commander of the Third U.S. Air Force in Britain, stated that "it had been a great pleasure to come to Ireland and to help a good cause." The Dublin game, he claimed, had attracted one of the largest crowds for American football on this side of the Atlantic. He also described Croke Park as "a splendid stadium with wonderful turf" (*Irish Independent*, November 23, 1953,

6). Mrs. Tom Barry of the Red Cross, also the wife of the hero of the Irish War of Independence, presented a shield to the winning team and mentioned that "one hundred children in Dublin hospitals would receive gifts at Christmas from the American Junior Red Cross" (*Irish Independent*, November 23, 1953, 6).

Back in the United States, the *Toledo Blade* reported that an attendance of 60,000, "not in the least daunted by what some foreigners may consider a strange pastime," had attended the game. According to the reporter, "the contest marked the first time in Dublin that an athlete started the game, went to hospital, and came back to play" (*Toledo Blade*, November 22, 1953, 5). The reference was to Harvey Keyes of Newark, New Jersey, who had his face stitched before he returned from the hospital and reentered the fray on the field.

In 1952, before the Croke Park game, the Burtonwood Bullets had played the first American football game against the Fursty Eagles of Fuerstenfeldbrook, Germany, in Wembley Stadium, London, an event captured by the British Pathé film company. The Wethersfield Raiders, of the Twentieth Fighter Bomber Wing based at USAF Station in Essex, England, played their USAF games at the King George V playing field at Cressing Road, Braintree, Essex, which opened in 1951. According to reporters' accounts, "crowds of up to 4000 watched the nearby USAF American Football team 'Wethersfield Raiders' through most of the 1950s. They played other air base teams across the UK and Europe; popcorn, Coca-Cola and cheerleaders were all part of the fun at what was dubbed 'Little Madison Square Garden'" (Mike Bardell, *East Braintree Focus*, no. 17, Autumn 2011).

Thirty-five years after the Croke Park game, on November 19, 1988, the cadets of West Point played the first Emerald Isle Classic against Boston College at the old Lansdowne Road stadium in Ballsbridge,

Dublin. Led by Mark Kamphaus, the Boston College Eagles beat the West Point Cadets 38–24 in the first NCAA-sanctioned game played in Europe. The following year, on December 2, 1989, Pittsburgh defeated Rutgers by a score of 46–29 in the second Emerald Isle Classic, also played at the old Lansdowne Road stadium. Two years later, on November 16, 1991, Holy Cross (Worcester, Massachusetts) defeated Fordham University with a score of 24–19 at Limerick's Gaelic Grounds in the Wild Geese Classic, which celebrated the three hundredth anniversary of the 1691 Siege of Limerick. Repeated in 1993, again at the Gaelic Grounds, the University of Massachusetts defeated the University of Rhode Island 36–14. Attendance at both of these games was poor—a mere 2,000 in 1991 and 5,000 in 1993—and neither game secured a television contract in the United States. On November 29, 1992, some 2,500 spectators saw Bowdoin triumph over Tufts with a score of 7–6 at Galway's Pearse Stadium in the Christopher Columbus Classic—an event that would later be rebranded and renamed the Smurfit Shamrock Classic.

In the first Smurfit Shamrock Classic, held on November 2, 1996 and underwritten by the Smurfit Foundation and Tom Kane, Notre Dame faced off with Navy at the refurbished Croke Park in Dublin. The game had been officially announced in September 1996, when U.S. Ambassador Jean Kennedy Smith presented a football signed by President Bill Clinton to Smurfit's David Austin in Croke Park (*Irish Independent*, September 24, 1996, 16). But preparations for the contest proved to be challenging: Paddy Walsh, Croke Park's head groundskeeper, informed Ryle Nugent that although it took two hours to line the field for a GAA game, it took *three days* to line the field for the Notre Dame–Navy Game (*Irish Times*, November 18, 1996, 8). Tickets for the game ranged from £30 and £20 for seated tickets to £8 standing and £5 for children. The *Kerryman* announced

to readers that the famous Ballybunion golf course was "booked out by a large golfing party who are over for the big American football game" (November 1, 1996, 22).

"Tour companies," according to the *New York Daily News*, sold "more than 8,000 packages to fans and another 3,000 have made arrangements on their own to watch their team play on the Ould Sod. Every hotel room in this capital of close to a half million is booked, which should do wonders for the economy, particularly in the pubs" (October 31, 1996). Having lost their previous game, Notre Dame's hopes of qualifying for a tenth-straight season-ending bowl game depended on defeating the Midshipmen in this contest. Notre Dame was a 17-point favorite, but Navy relied on the same option attack that Air Force had used against Notre Dame in a 20–17 victory in South Bend two weeks earlier. Navy (5-1), the designated home team, brought its best team in years to Dublin: for the first time since 1981, the Midshipmen faced Notre Dame with a

superior record and with dreams of a bowl bid. Navy tackle Scott Zimmerman explained to *Sports Illustrated:* "Sure, we would have rather played at home, in front of our own fans . . . but we knew what we were getting into. We knew there'd be a lot of distractions and a lot of people rooting against us. But we pride ourselves on being able to overcome things like that" (November 11, 1996). The Navy mascot, a billy goat, was unable to travel due to quarantine restrictions, but pub owner Charlie Chawke assisted Navy in locating a goat to serve as their mascot for the weekend (*Irish Independent*, November 4, 1996, 3).

The two schools took different approaches to the game. The *New York Times* reported that Notre Dame (4-2) arrived in Dublin on the Wednesday before the game with 85 players, 125 marching band members, numerous coaches, officials, and cheerleaders, and thirteen trunks of equipment, including their famous locker-room sign, "Play Like A Champion Today." After their

early morning arrival, the Notre Dame team visited Glendalough in County Wicklow to view the ancient monastic ruins. On Thursday, in lashing rain, they trained in a closed session at the Royal Dublin Society (RDS) arena at 12:30, while Navy, also in private, trained at Croke Park from 2:00 to 3:45. Both teams trained at Croke Park on Friday—Navy at 12:00 noon, Notre Dame at 3:00 pm—in sessions open to the public. On Friday the Notre Dame players also toured Trinity College. A joint pep rally was staged at the RDS in Ballsbridge. Raidió Teilifís Éireann (RTÉ), the state TV broadcaster, requested appearances by Coach Holtz and quarterback Ron Powlus for the *Late Late Show*, Ireland's prime time entertainment show, but were informed that the players had a curfew and the coaches were busy.

Instead, the Notre Dame band and cheerleaders, including the leprechaun, appeared on national television. The leprechaun (Ryan Gee from Spokane, Washington) swapped stories with Gay Byrne, Ireland's leading celebrity TV host, and the band played the Notre Dame fight song. Friday night also saw a gala benefit banquet at the Burlington Hotel, hosted by Norma Smurfit, with proceeds going to three charities: the Irish Youth Foundation, First Step, and the Arthritis Foundation.

On game day, Notre Dame made its superior size count and pounded Navy's defensive front. Ron Powlus threw only eleven times (completing six passes), and tailback Autry Denson ran for 123 yards. Fullback Marc Edwards ran for three touchdowns, including a one-yarder with 6:41 left in the game, to make the score 47–21. The two teams exchanged a dozen touchdowns and nearly 800 yards of offense. At the end, Notre Dame won 54–27, setting the record for the longest winning streak over an annual collegiate opponent, with 33 wins— a streak that would eventually extend to 43 games (1964–2006).

Reporter Ian Thomsen informed his *New York Times* readers that "the Fighting Irish conservatively worked up a 14–0 lead before Navy, trying to build on its best record in 17 years, scored one touchdown and was on the verge of another with a pass of about 50 yards late in the first half. But the play was nullified because the quarterback, Chris McCoy, had stepped beyond the line of scrimmage. It was the key play. Notre Dame drove 42 yards in three plays, the last 33 for a touchdown by Autry Denson (125 yards rushing, 2 TDs overall) to lead, 21–7, at halftime." Thomsen continued, "Until then, Notre Dame had looked no more impressive than a bully. Its 300-pound (136-kilogram) offensive linemen hope to graduate to the National Football League; the defensive linemen they were blocking, usually 50 to 70 pounds lighter, intend to become naval officers. Yet the Midshipmen outgained the Fighting Irish slightly, and outpassed the NFL-prospect Ron Powlus by more than twice as many yards." Thomsen further related that Coach Holtz's attempts

at a pair of two-point conversions, while already leading by at least 26 points, irritated Navy Coach Weatherbie, who later confronted Holtz with his complaint (*New York Times*, November 4, 1996).

Writing in the *Navy Midshipmen Examiner*, Tom Flynn recalled that "highlights for the Mids included current-Navy broadcaster Omar Nelson's second touchdown of the day that trimmed a 28–7 Notre Dame lead to 28–14 in the third quarter. Autry Denson (who later would play for the Dolphins, Bears, and Colts) responded with a 24-yard TD sprint to run the lead back to three scores for the Irish. Navy, showing a resolve that would serve them well later that year, then aired it out for 55 yards on a scoring strike from Ben Fay to Corey Schemm to get the deficit back to two scores at 35–21. After that the larger Notre Dame offense took control and rattled off three scores, including a pair by another future NFL running back, fullback Marc Edwards. Navy closed out the scoring for the day on a

15-yard Fay to Schemm TD toss" (November 10, 2008).

"The Fighting Irish insist they left Dublin culturally richer as well. But was the experience beneficial enough to make Notre Dame consider an encore?" Teddy Greenstein of the *Chicago Tribune* asked his readers. "Because the game breaks the rhythm of a regular season, we'll have to evaluate that in terms of how difficult it is to prepare for Boston College next week," stated Notre Dame Athletic Director Mike Wadsworth. "But if we get positive comments from players and coaches, it's something we would certainly consider" (November 4, 1996). The following week, Notre Dame beat Boston College 48–21, and two weeks later they defeated Pittsburgh 60–6. Notre Dame finished the season 8-3, ranking nineteenth in the Associated Press Poll and twenty-first in the Coaches' poll.

Dublin Chamber of Commerce's Noel Carroll declared the 1996 game an "enormous economic success for the city," with £36 million spent by 17,000 visitors, or an average of over £2,000 each on accommodation, food, and entertainment (*Irish Independent*, November 13, 1996, 3).

The success of the Notre Dame–Navy game in Ireland and the favorable impression created by Croke Park's facilities led to a game between the Chicago Bears and the Pittsburgh Steelers in Dublin in 1997. In turn, this led to talk of a Dublin-based team, possibly replacing the Barcelona Dragons, participating in the WLAF (World League of American Football) as early as 1999 or 2000 (*Irish Independent*, July 22, 1997, 23). In May 2004, John Carroll University (Ohio) played an exhibition game against an Irish American Football League team (IAFL) in County Wicklow.

In September 2012, Notre Dame and Navy finally returned to Dublin. The 2012 game was a season opener for the Fighting Irish. Their last game had been an 18–14 come-

from-ahead loss to twenty-fifth-ranked Florida State in the Champs Sports Bowl in Orlando, Florida on December 29, 2011—the culmination of a season that witnessed two early season losses, turnovers, poor second-half performances, and an inability to score in the red zone. Notre Dame alternated between Tommy Rees and Andrew Hendrix at the quarterback position throughout the bowl game, but both struggled within the red zone. The 2011 loss to Florida State snapped a streak of two straight bowl wins for the Irish and dropped their overall bowl record to 15-16. Navy won only five games in 2011 and, for the first time in eight seasons, failed to receive a bowl invitation. Nevertheless, the 2012 season brought new hope for the programs and their supporters. Some 35,000 Notre Dame and Navy supporters transplanted themselves to Dublin for a week at the beginning of the 2012 football season to watch the Fighting Irish of Notre Dame take on the Midshipmen of the U.S. Naval Academy on Saturday, September 1.

The Irish Independent (September 3, 2012) estimated that the Emerald Isle Classic was worth €100 million to the economy. The game was played in front of a sold-out crowd, CBS Sports broadcast the game live in the United States, and ESPN covered the game live in Europe. An additional thirty-six transatlantic flights were added to the schedule at Dublin Airport, and the Dublin Chamber of Commerce described it as the biggest-ever movement of Americans into Ireland. The day after the game was the airport's busiest on record.

On the Wednesday before the game, Irish government minister Jimmy Deenihan opened a conference on the Easter Rising held by Notre Dame's Keough-Naughton Institute for Irish Studies with the theme "1916: What It Means." The conference continued on Thursday at the Royal Irish Academy. Also on Thursday, senior Irish government officials met representatives of Goldman Sachs, IBM, and McDonald's

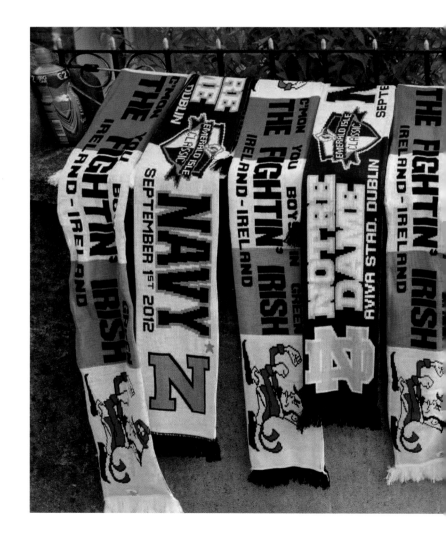

in Government Buildings at an "investment round table" involving U.S. business people who were visiting Dublin for the game. "Ireland in Transition: Contemporary Challenges and Opportunities" was the topic on Friday at a presentation held at Trinity College, which addressed the question of how a rapidly changing Ireland fits into the wider world today. Kevin Whelan delivered the annual Hibernian Lecture, organized by the Cushwa Center, on the unique relationship between Notre Dame and Ireland. Also on Friday, the United States ambassador, H. E. Dan Rooney, former owner of the Pittsburgh Steelers, hosted a reception for Notre Dame and Navy at the United States ambassador's residence by Phoenix Park.

Global Football, a Texas-based sports production group, organized six double-headers in Ireland on Friday evening, involving twelve top U.S. and Canadian high school and NCAA Division III college teams. The teams included Father Judge High School (Philadelphia, Pennsylvania); Hamilton High School (Chandler, Arizona); Jesuit College Preparatory School (Dallas, Texas); John Carroll University (University Heights, Ohio); Kent School (Kent, Connecticut); Loyola Academy (Wilmette, Illinois); Notre Dame High School (Sherman Oaks, California); Notre Dame Preparatory (Scottsdale, Arizona); Oak Park High School (Winnipeg, Manitoba); St. Norbert College (De Pere, Wisconsin); St. Thomas of Villanova College (King City, Ontario); and the United Kingdom U19 All-Stars.

The Notre Dame pep rally, at the O2 Point Depot on the River Liffey, featured Irish political leader An Taoiseach Enda Kenny, who addressed the crowd of 10,000 and informed the audience that "this is the biggest ever overseas mobilization of U.S. citizens for a single sporting event." The pep rally, televised live in Ireland and screened globally on the Internet by Google, was hosted by Miriam O'Callaghan and

consisted of live music and dancing, as well as interviews with Notre Dame President Fr. John I. Jenkins, comedian Martin Short, and Notre Dame Athletic Director Jack Swarbrick. Damien Dempsey and Anúna performed with the Notre Dame Folk Choir. The event concluded with the Notre Dame marching band on stage, joining the entire cast of performers.

On the morning of game day, a mass, televised live in Ireland, was celebrated in Dublin Castle by Papal Nuncio Charles Brown, a Notre Dame graduate; Archbishop Diarmuid Martin; Fr. John I. Jenkins, Notre Dame president; and Fr. Richard Warner, Superior General of the Congregation of Holy Cross. The *Irish Times* reported that "6,000 filled the cobbled courtyards of Dublin Castle for Notre Dame's traditional pre-game Mass on Saturday morning, a novel spectacle in a country grown unaccustomed to such mass public exhibitions of faith. . . . But even the Mass segued into

exuberant, all-American razzmatazz, as ND's mighty brass band, led by its magnetic white-clad director, wound back through the city center, carnival-style, followed by thousands of good-natured Americans, cheered on by locals" (September 3, 2012).

A crowd of 49,000 filled Aviva Stadium on Saturday afternoon to see Notre Dame rout Navy, 50–10. Theo Riddick and George Atkinson both ran for two scores, and defensive end Stephon Tuitt returned a fumble 77 yards. Notre Dame dominated, running the ball with ease against Navy's undersized defense. Riddick scored on an 11-yard run to finish an eleven-play, nearly six-minute opening drive. On the next drive Atkinson broke free and ran untouched for a 56-yard score. Quarterback Everett Golson, making his first start, increased the score further with a 5-yard end-zone jump ball to tight end Tyler Eifert. Golson finished 12 of 18 for 144 yards despite one interception. Even the Irish defense scored.

Tuitt, after a Navy fumble, scooped up the ball and ran unmolested 77 yards to score and record Notre Dame's longest fumble return since 1985 and third longest in school history. In the second half, Atkinson and Riddick accounted for two of Notre Dame's three second-half touchdowns, and Robby Toma scored the third touchdown with a 9-yard run in the final minute. For Navy, quarterback Trey Miller completed 14 of 19 passes for 192 yards, but Notre Dame restricted Navy's triple-option ground threat to 149 yards rushing on 40 carries (Associated Press, September 2012).

Navy coach Ken Niumatalolo said he could take plenty of positives from his team's trip to Ireland. "We received unbelievable support from the people of Ireland. . . . Everything that happened outside of the white lines on the field was great. Unfortunately for us, everything that happened inside of the white lines wasn't as great." The three-day trip "was a great experience for our young men" (Associated Press, September 2012). Notre Dame coach Brian Kelly also enjoyed his time in Ireland, telling reporters during his postgame press conference that Ireland is "such a friendly place. . . . The hospitality was amazing. It just feels welcoming coming to Ireland. . . . We'll be back any time you ask us" (*Observer*, September 12, 2012). It was, indeed, an unforgettable experience for all those who played and took part in the Notre Dame–Navy game in Dublin.

*Below: The O2 Point Depot,
site of the pep rally*

*Right: An Taoiseach Enda Kenny
addresses the crowd at the pep
rally.*

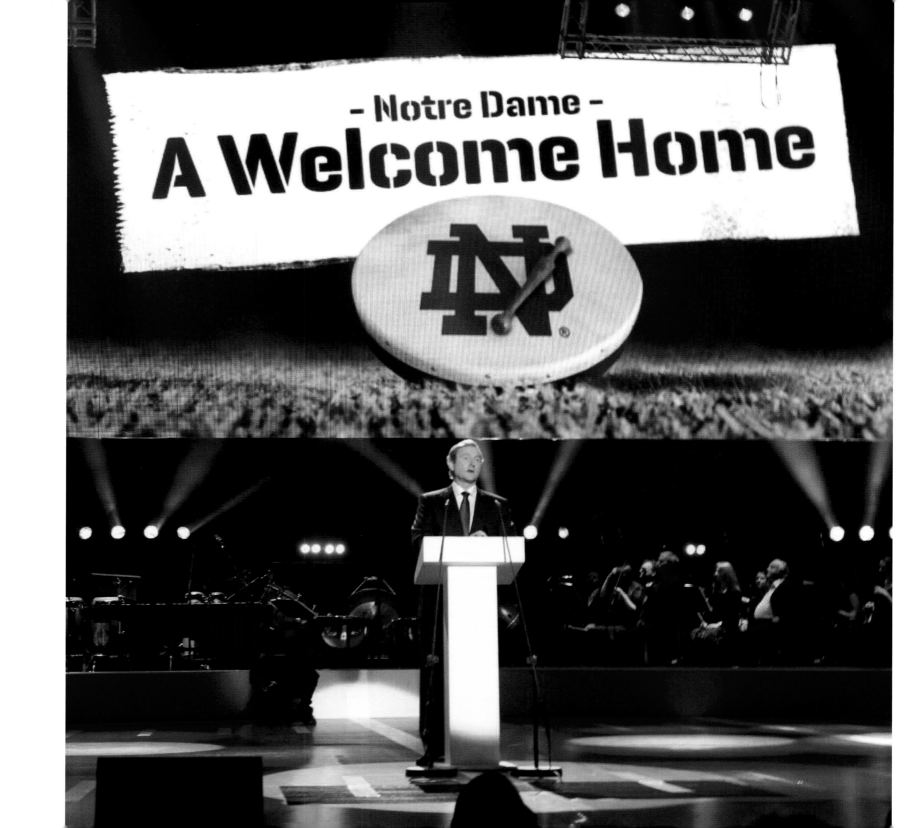

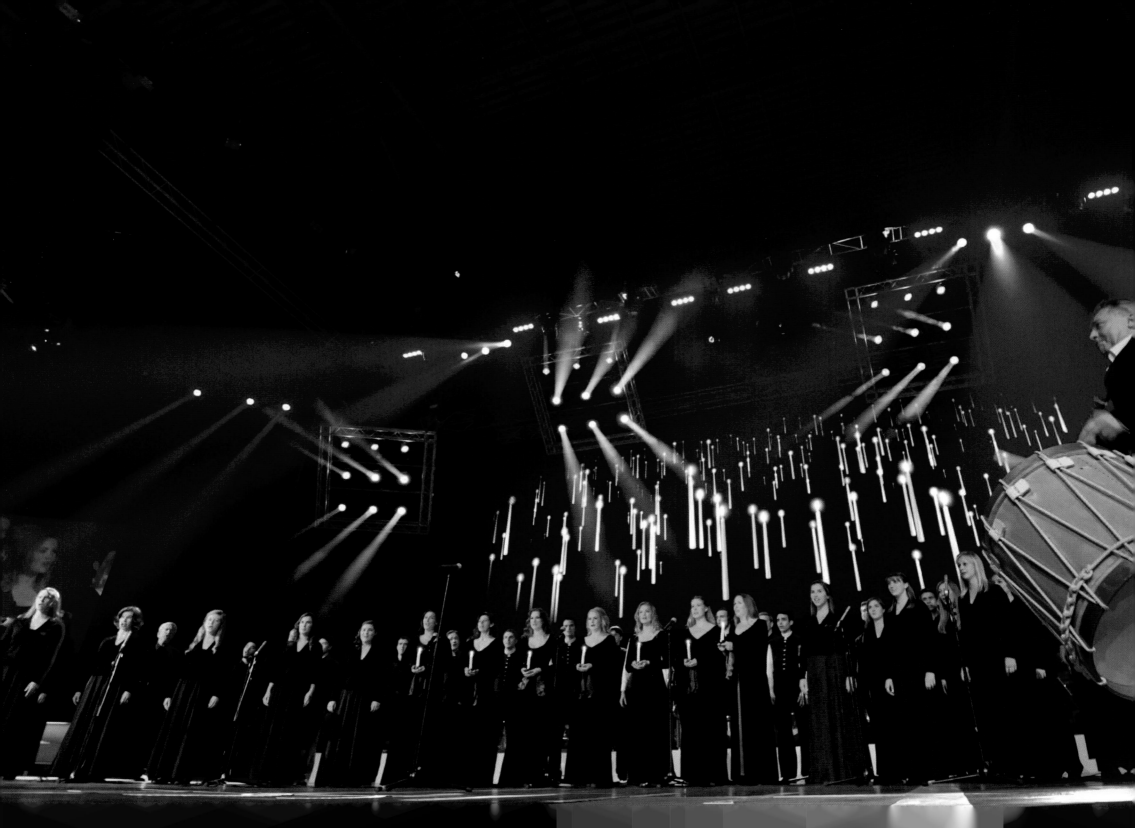

Right: Finale of the pep rally

Pages 144 & 145: Pregame Mass of Thanksgiving at Dublin Castle

Page 146: Archbishop of Dublin Diarmuid Martin celebrates the pregame mass.

Page 147: Notre Dame band performs at the pregame mass in Dublin Castle.

Pages 148 & 149: Notre Dame band marches toward the Temple Bar tailgate.

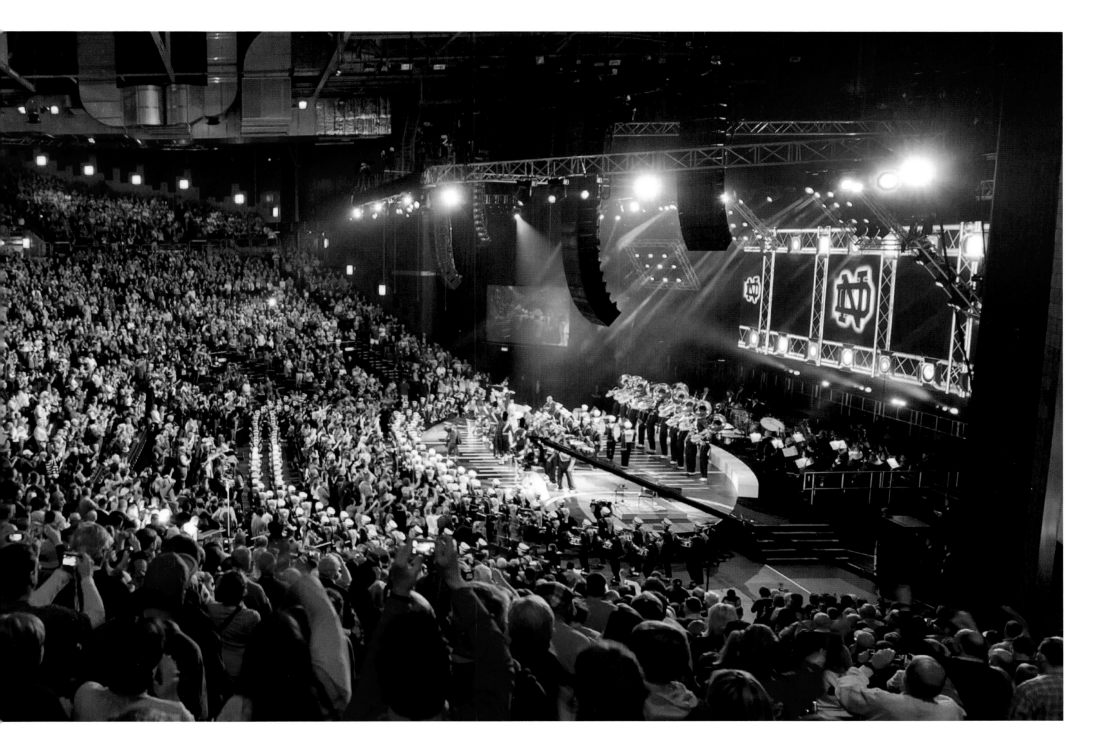

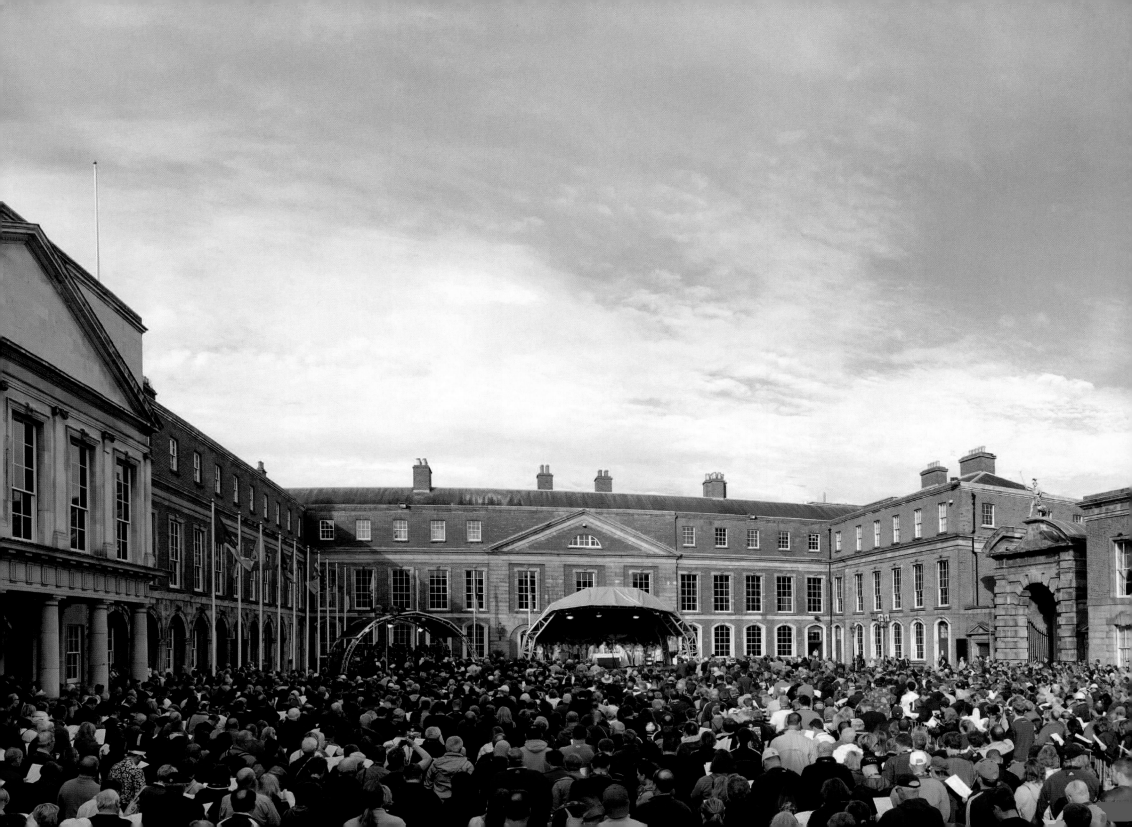

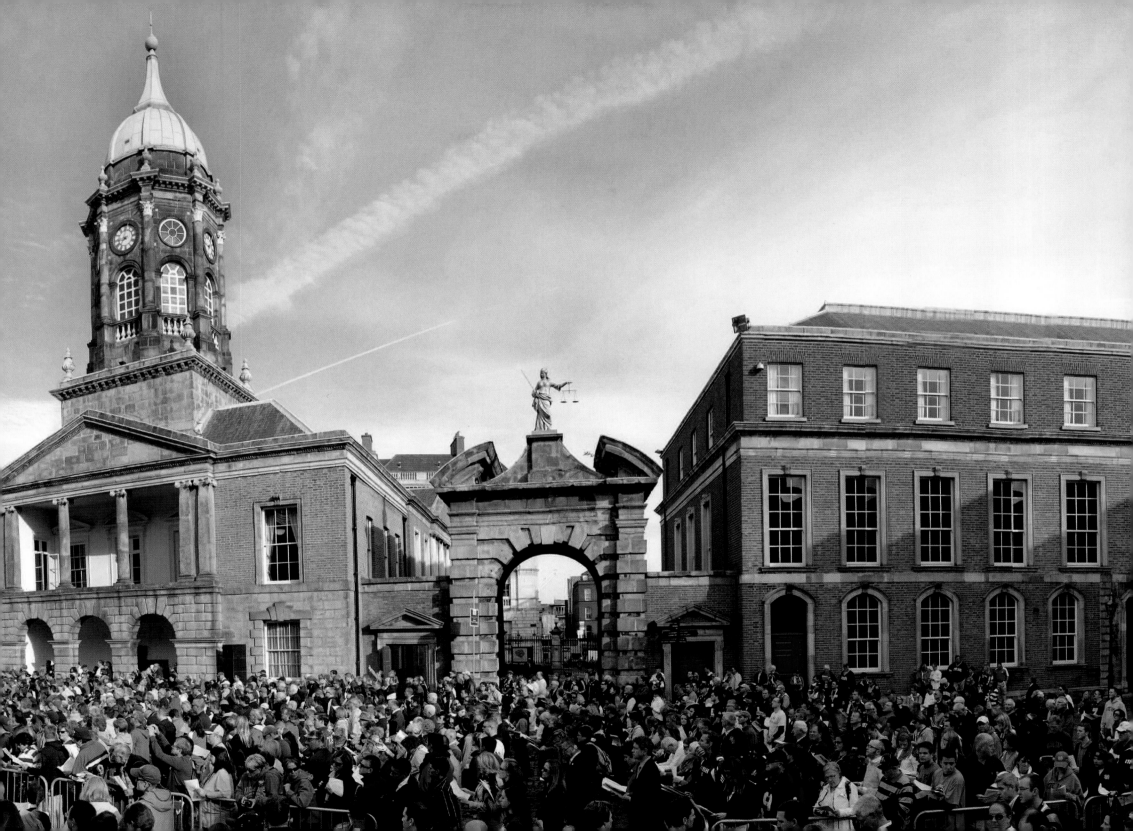

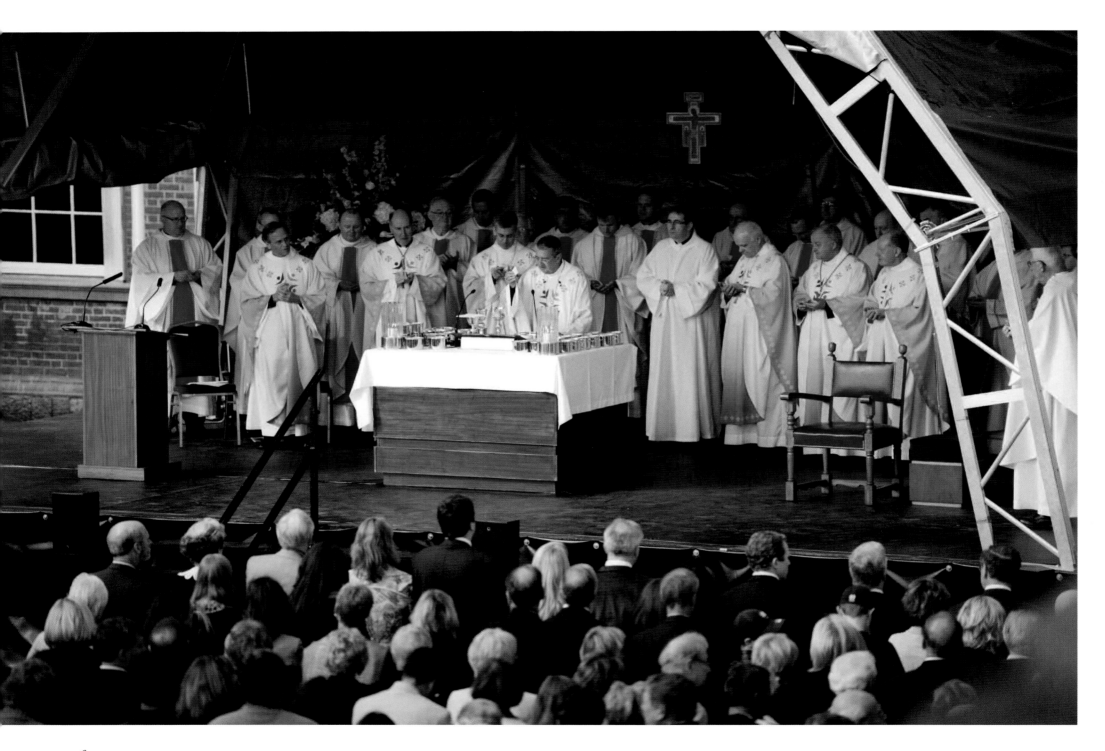

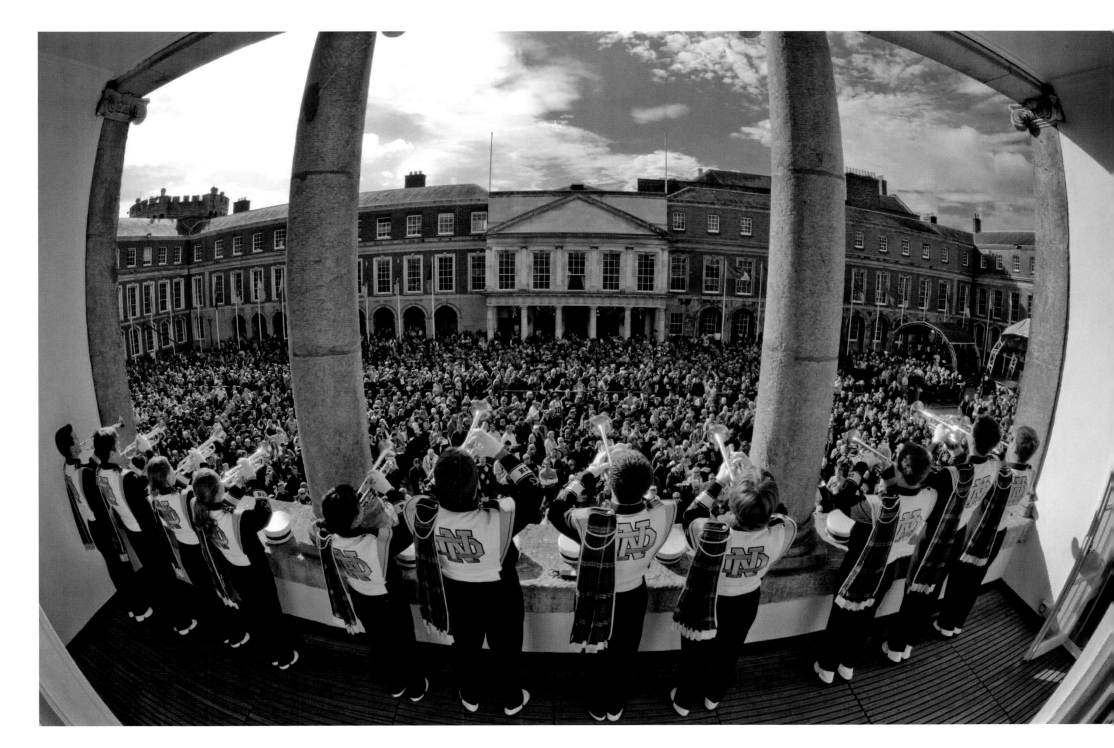

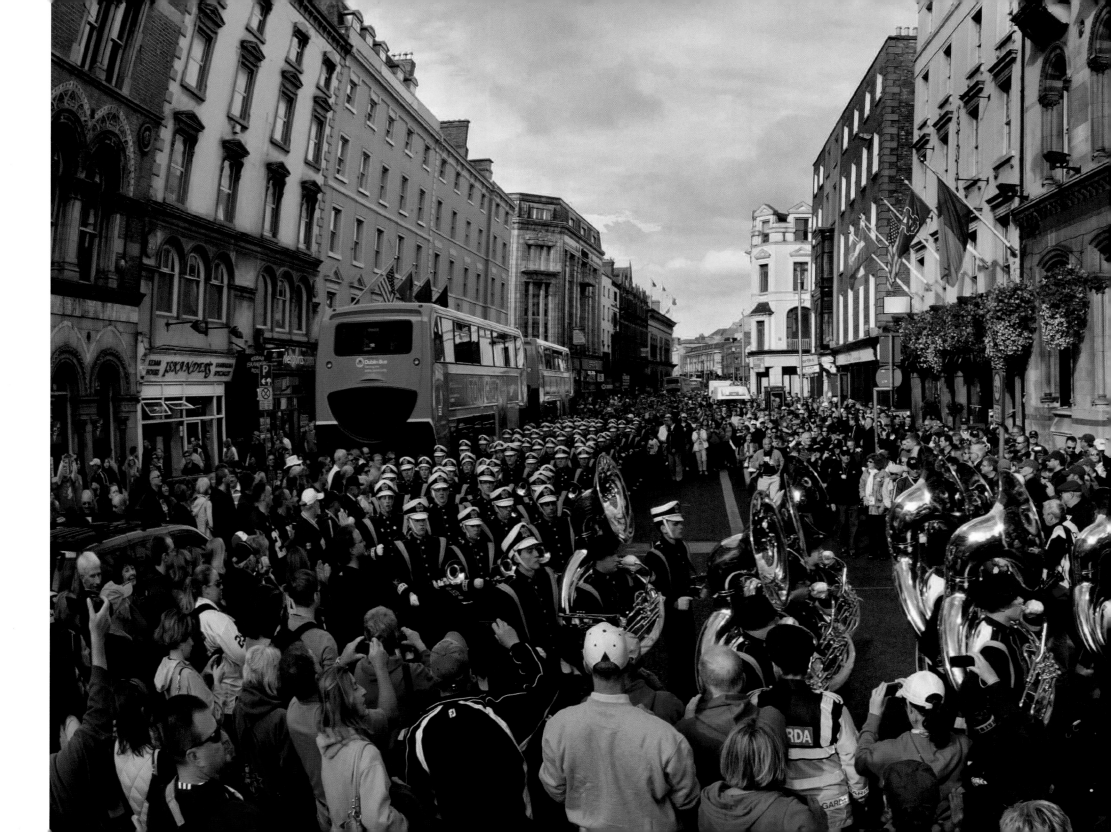

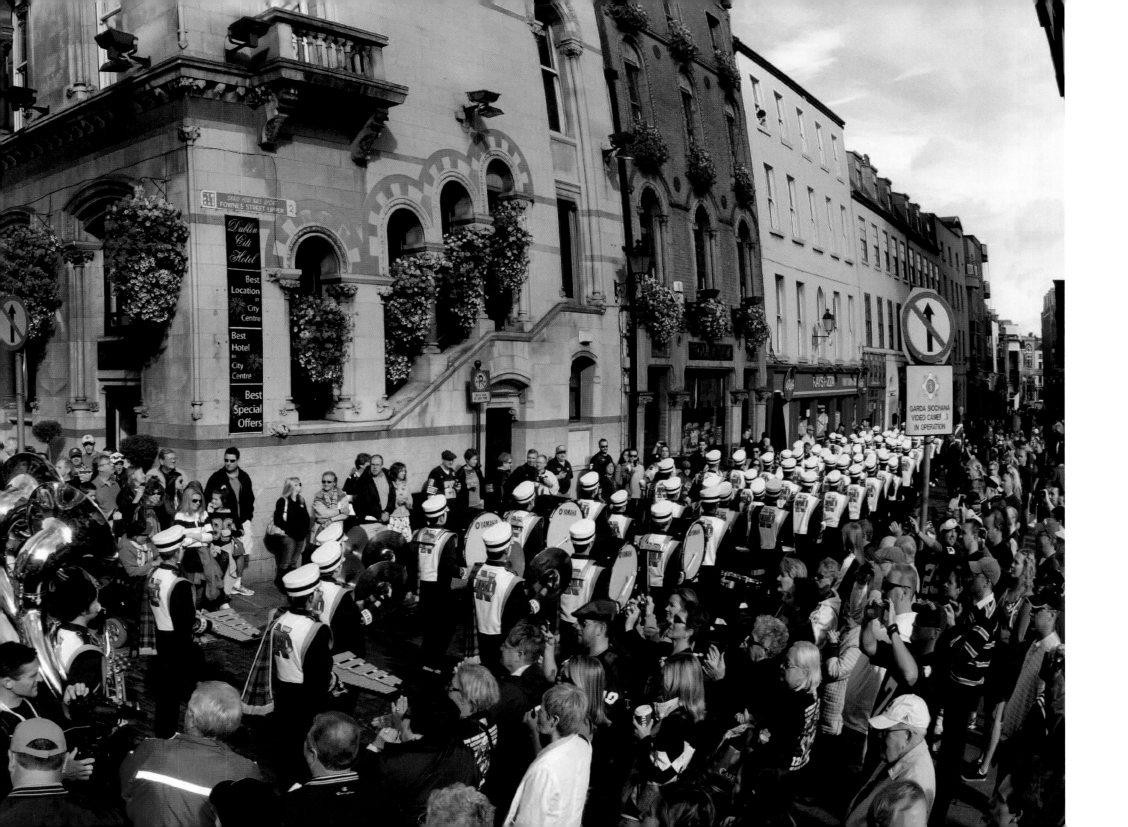

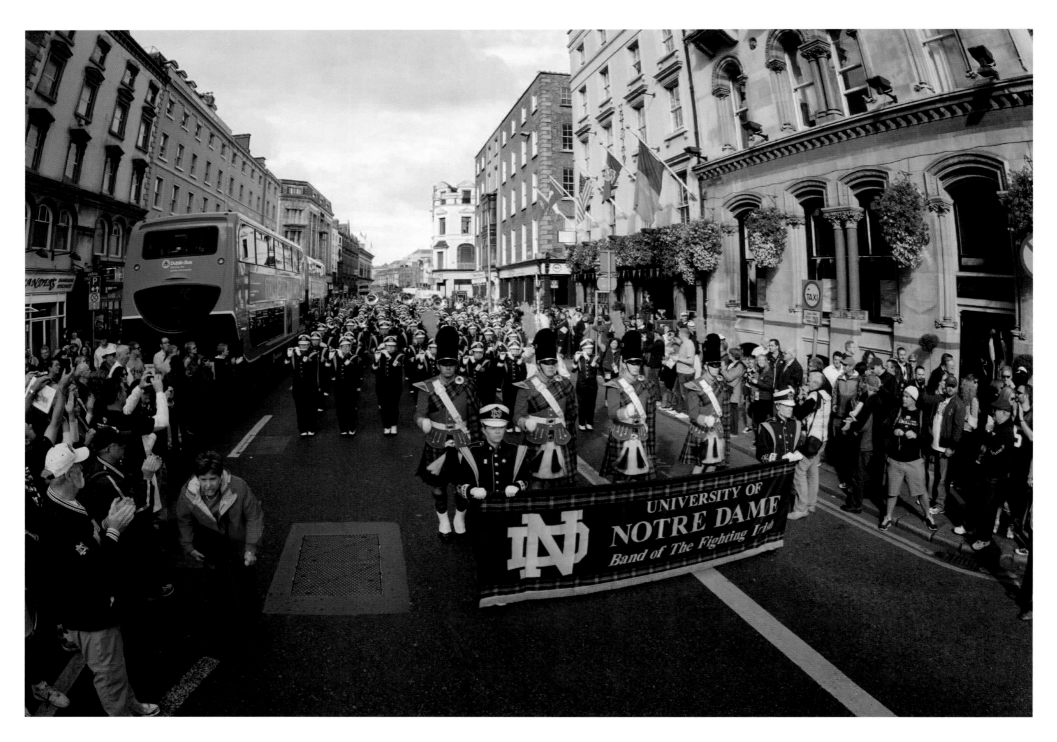

Left: The Irish Guard leads the Notre Dame marching band through the streets of Dublin.

Below: Navy Color Guard

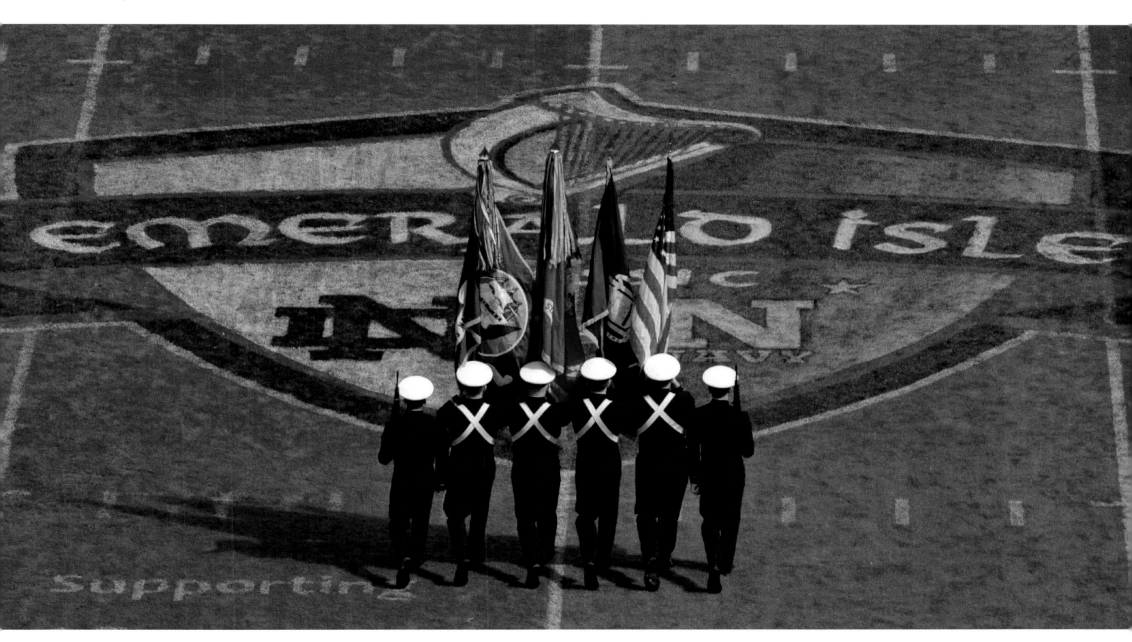

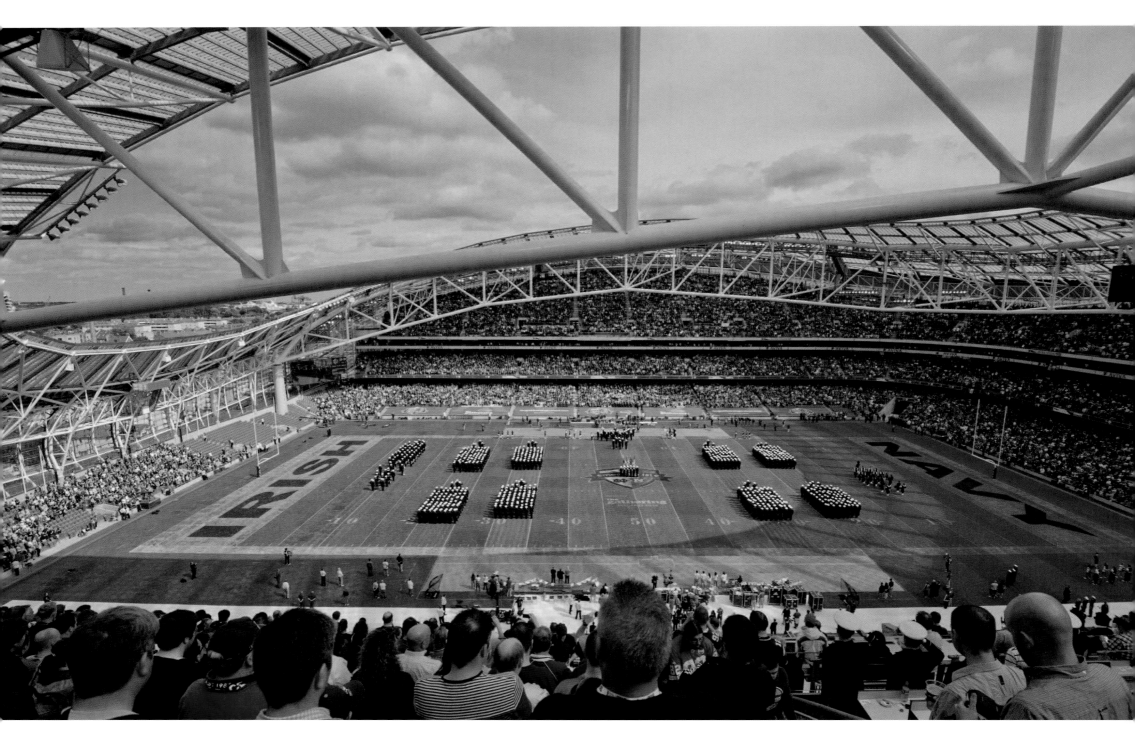

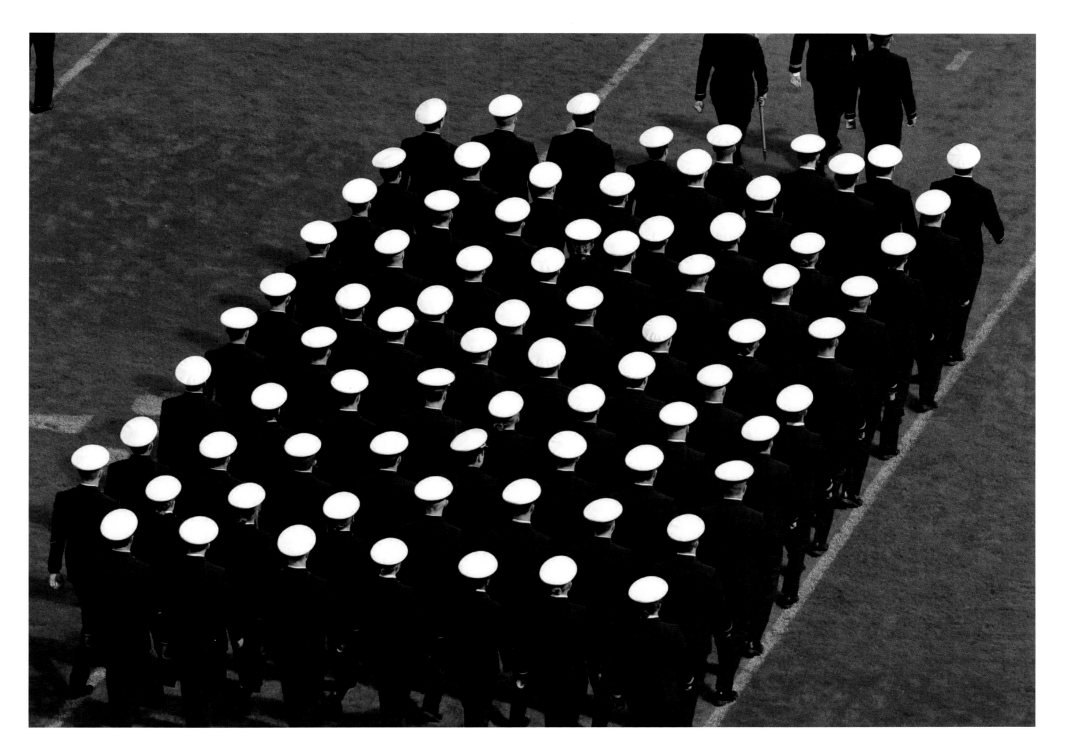

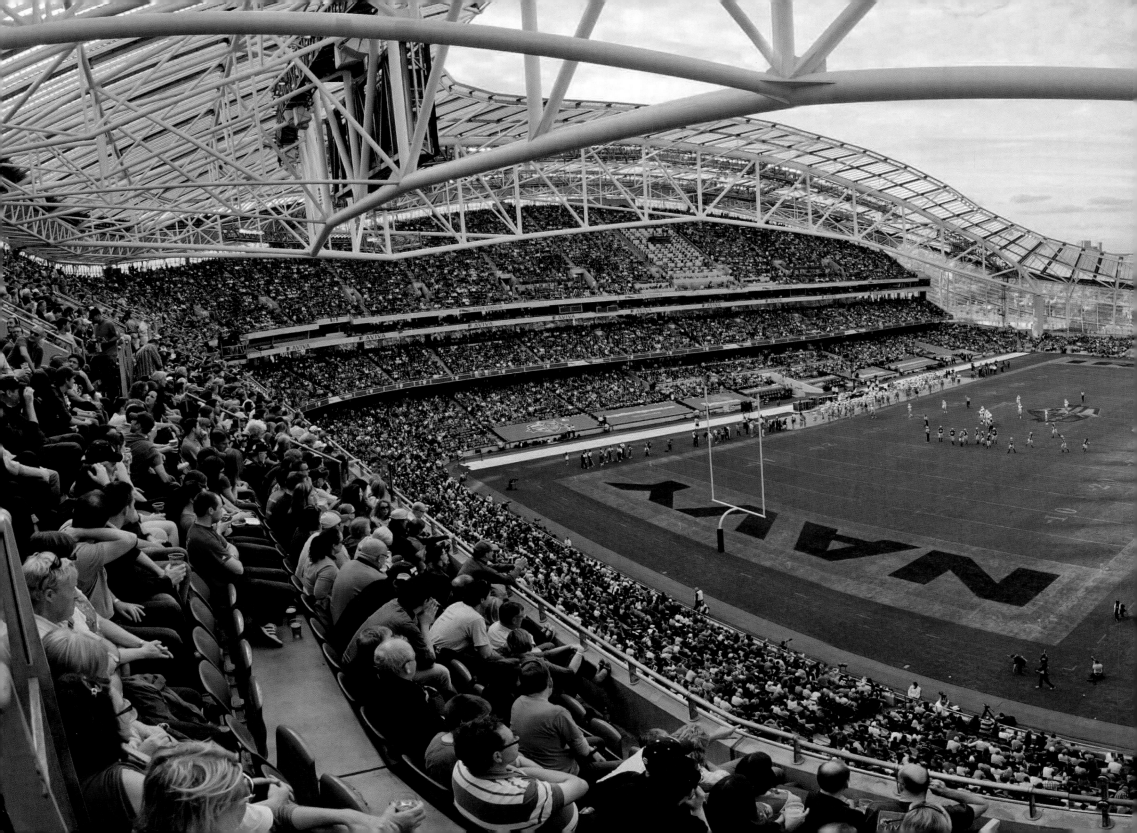

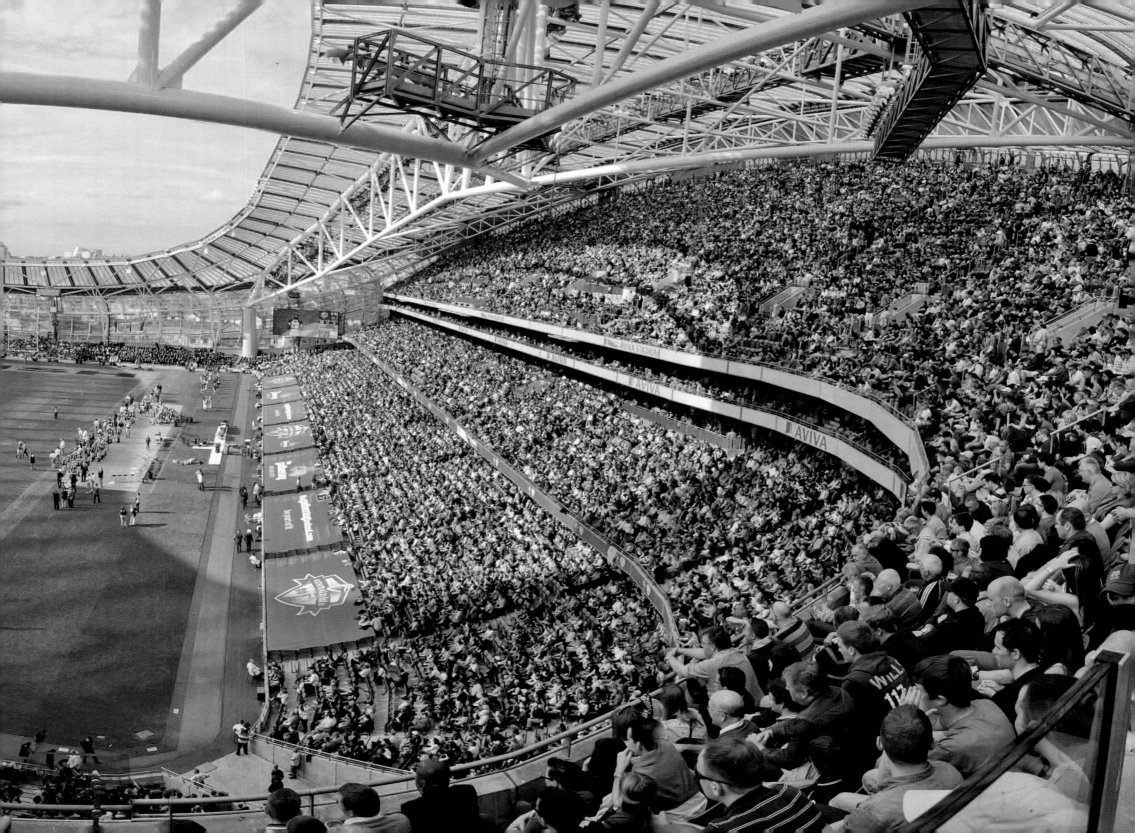

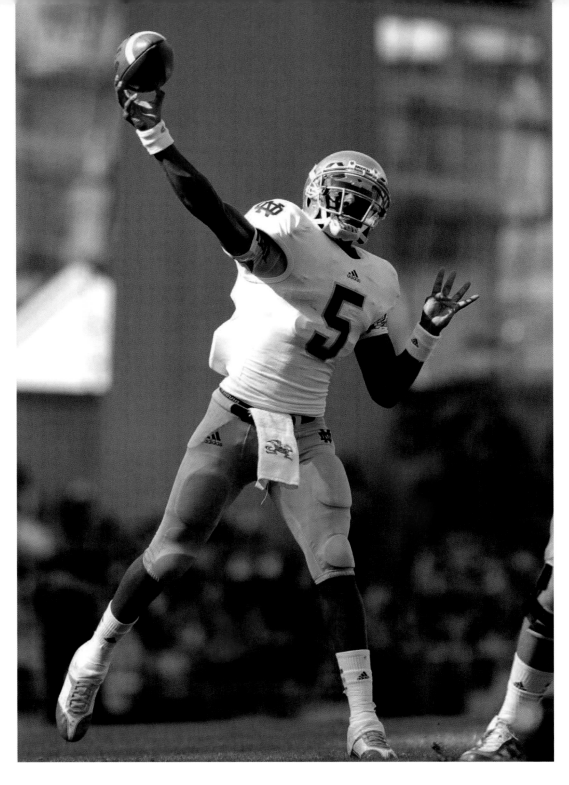

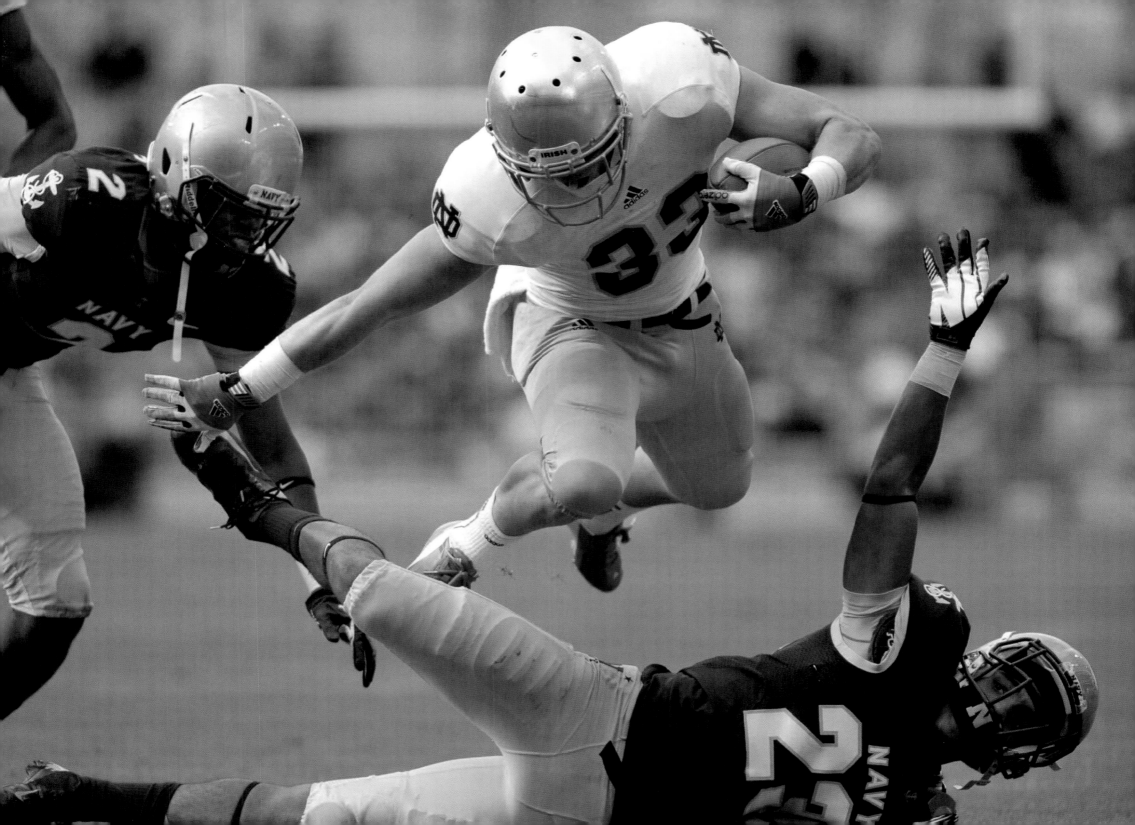

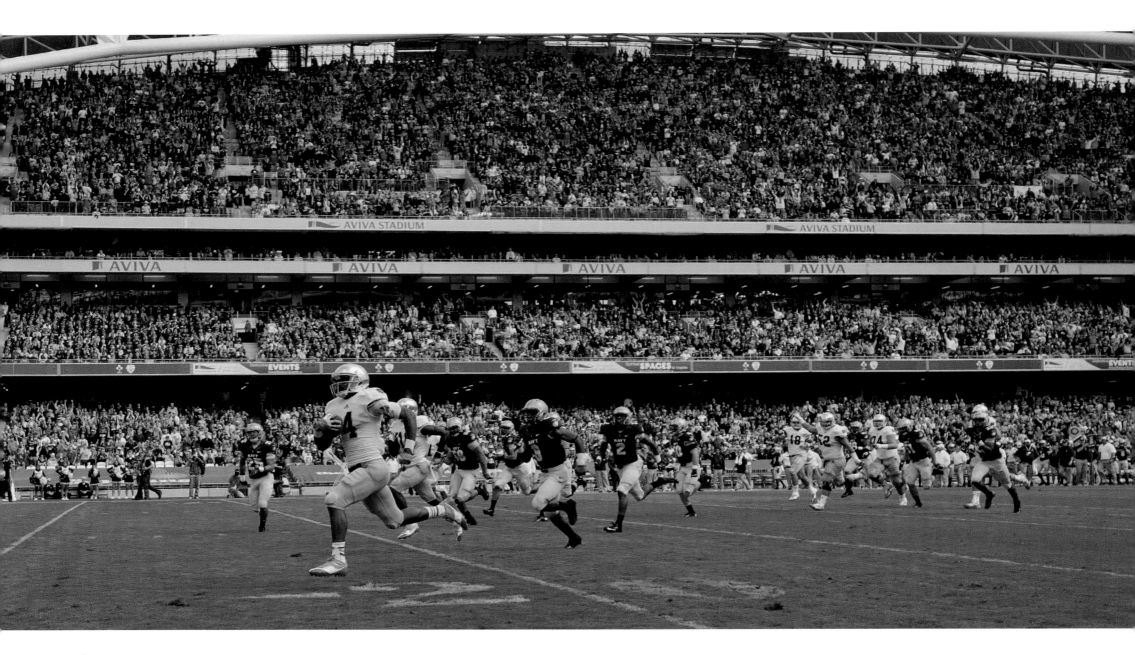

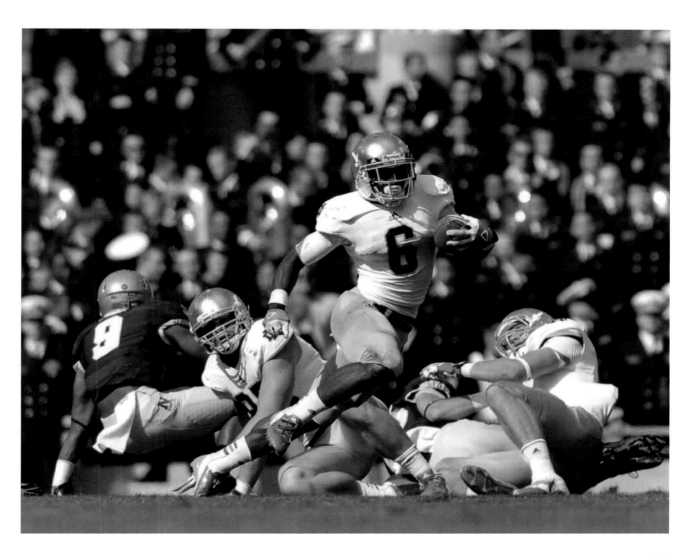

Below: The Irish score.

Right: The Irish celebrate.

Opposite: The Irish, wearing their commemorative cleats, salute their fans.

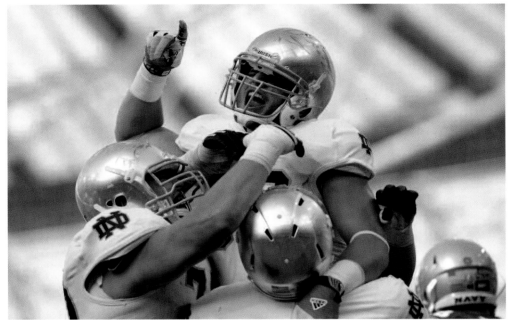

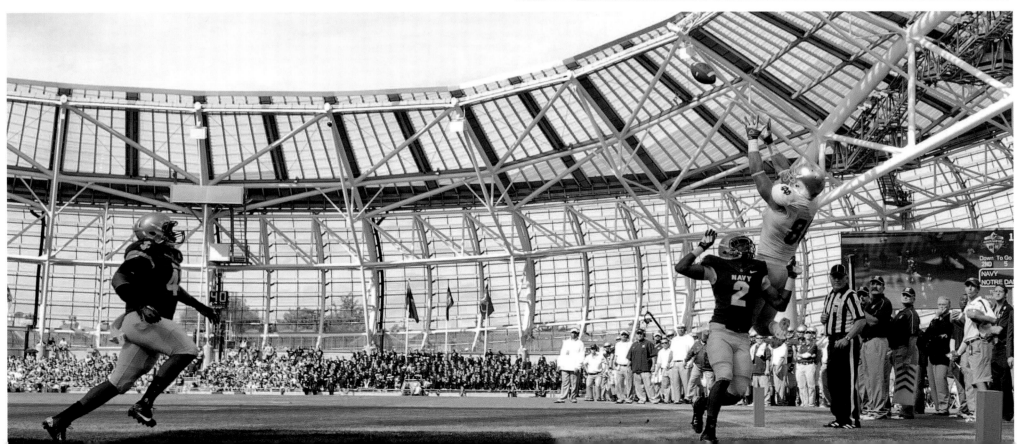

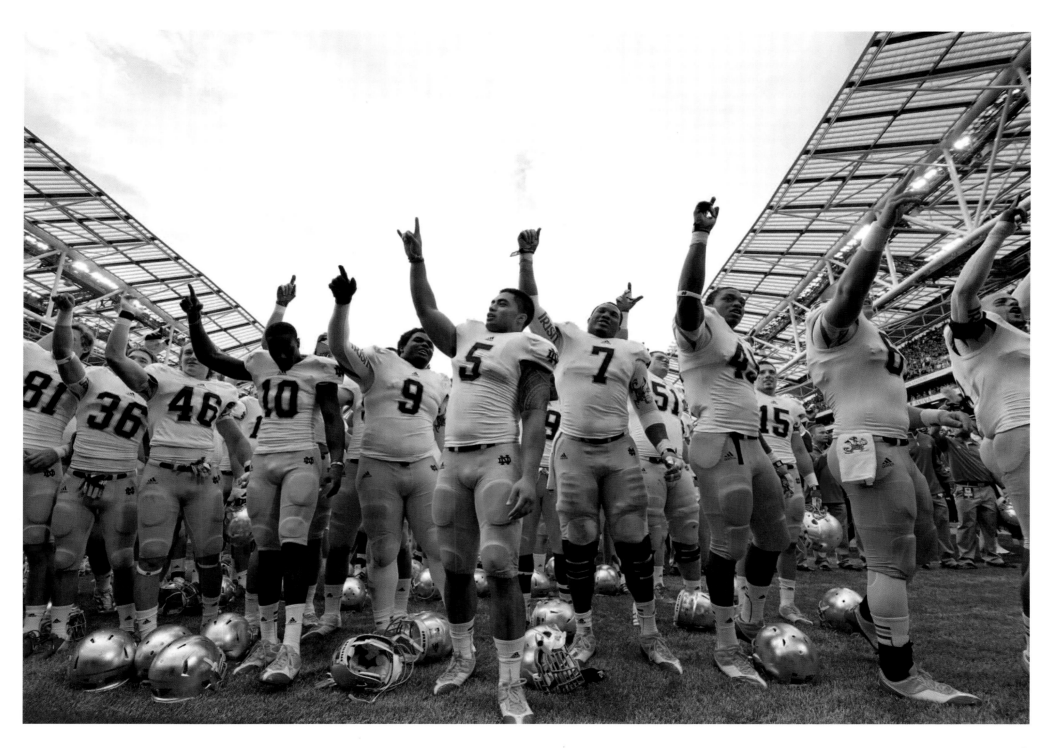

Notre Dame, Our Mother

Notre Dame our mother,
Tender, strong, and true,
Proudly in the heavens
Gleams thy gold and blue,
Glory's mantle cloaks thee,
Golden is thy fame,
And our hearts forever
Praise thee, Notre Dame,
And our hearts forever
Love thee, Notre Dame!

Navy Blue and Gold

Now colleges from sea to sea
May sing of colors true,
But who has better right than we
To hoist a symbol hue?
For sailors brave in battle fair
Since fighting days of old,
Have proved a sailor's right to wear
The Navy Blue and Gold.

So hoist our colors, hoist them high,
And vow allegiance true,
So long as sunset gilds the sky
Above the ocean blue,
Unlowered shall those colors be
Whatever fate they meet,
So glorious in victory,
Triumphant in defeat.

Four years together by the Bay
Where Severn joins the tide,
Then by the Service called away,
We've scattered far and wide;
But still when two or three shall meet,
And old tales be retold,
From low to highest in the Fleet
Will pledge the Blue and Gold.

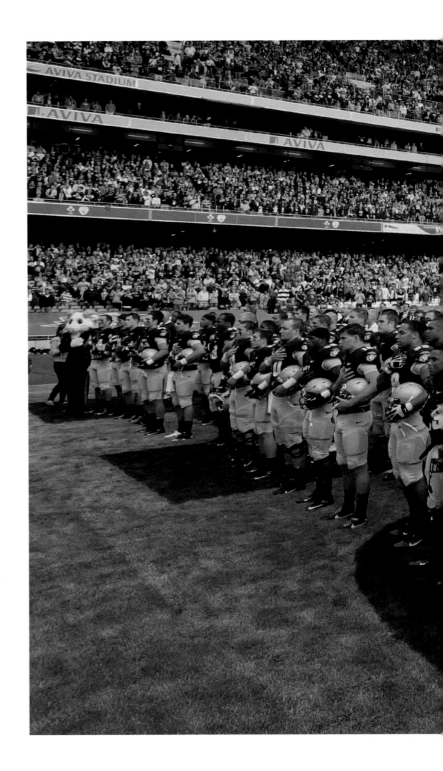

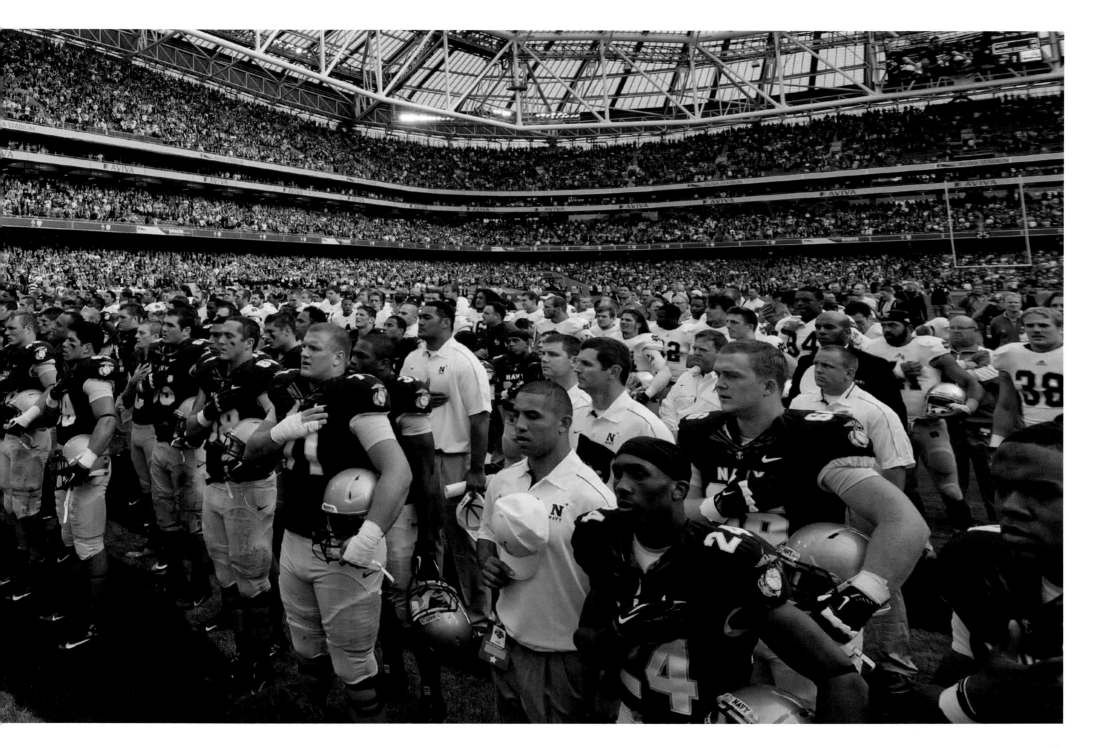

May the road rise up to meet you.

May the wind always be at your back.

May the sun shine warm upon your face,

and rains fall soft upon your fields.

And until we meet again,

May God hold you in the palm of His hand.